Soulful Creatures

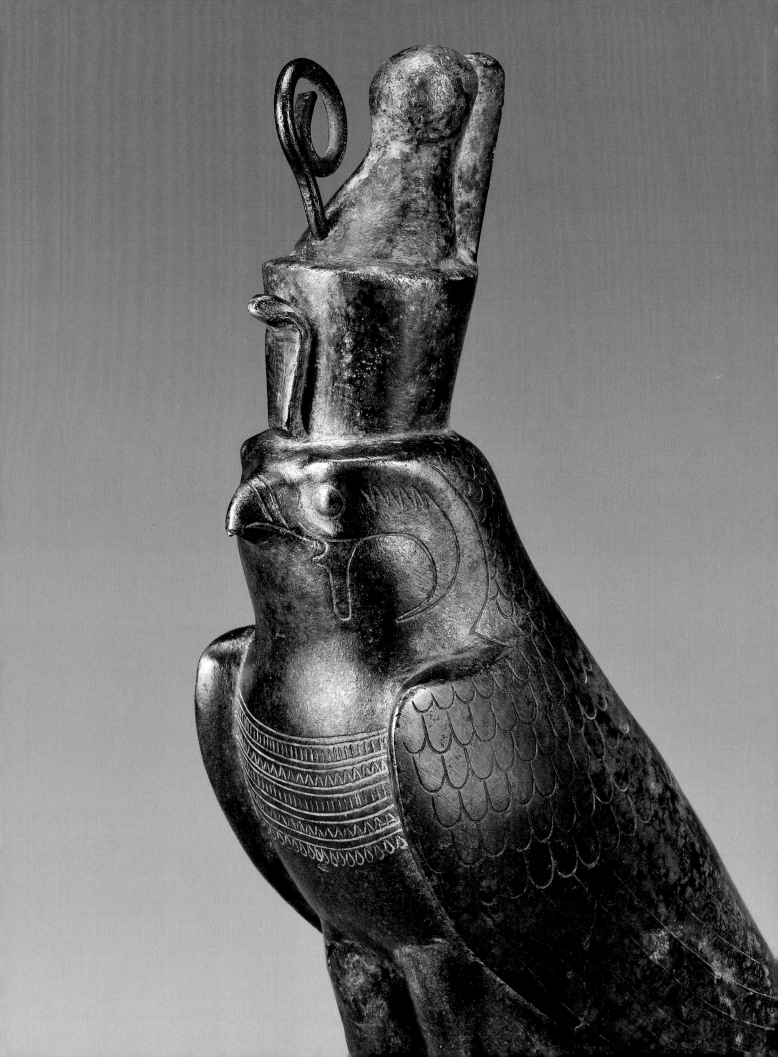

Soulful Creatures

ANIMAL MUMMIES IN ANCIENT EGYPT

EDWARD BLEIBERG

YEKATERINA BARBASH

LISA BRUNO

BROOKLYN MUSEUM IN ASSOCIATION WITH D GILES LTD

A catalogue record for this book is available from the Library of Congress.

ISBN 978-0-87273-174-5 (paperback)
ISBN 978-1-907804-27-4 (hardcover)

For the Brooklyn Museum
Edited by James Leggio, Head of Publications and Editorial Services
New photography of Brooklyn Museum objects by Sarah DeSantis and Christine Gant (Digital Collections and Services, Brooklyn Museum) and by Gavin Ashworth (Gavin Ashworth Photography, New York). Digitization of historical images by Sarah Gentile (Digital Collections and Services, Brooklyn Museum).

For D Giles Limited
Proof-read by Sarah Kane and Elisabeth Merriman
Designed by Alfonso Iacurci
Produced by GILES, an imprint of D Giles Limited, London
Printed and bound in China

All objects are in the collection of the Brooklyn Museum, unless otherwise noted. In the captions, dimensions are usually given in the order of height by width, followed in the case of sculpture by depth, first in inches, then in centimeters. The order of the dimensions given for animal remains reflects a horizontal position, lying flat on an examination table, with the second dimension representing the animal's length; the second dimension of coffins, measured in a horizontal position, also refers to length. All Egyptian dates are approximate. The chronology followed here is based on William J. Murnane, "The History of Ancient Egypt: An Overview," in Jack M. Sasson, ed., *Civilizations of the Ancient Near East*, vol. 2 (New York: Scribner, 1995), pp. 712–14. The captions incorporate the most precise information available about each object, including period, dynasty, and approximate year dates. For a summary of periods and dynasties, see "A Brief Chronology of Ancient Egypt," pages 10–17 in the present volume.

Published on the occasion of the exhibition *Soulful Creatures: Animal Mummies in Ancient Egypt*, organized by the Brooklyn Museum from its collections

Exhibition Itinerary
— Bowers Museum, Santa Ana, California
— Memphis Brooks Museum of Art, Memphis, Tennessee
— Brooklyn Museum, Brooklyn, New York

Copyright © 2013 Brooklyn Museum,
200 Eastern Parkway,
Brooklyn, NY 11238-6052
www.brooklynmuseum.org

First published in 2013
by GILES
an imprint of D Giles Limited
www.gilesltd.com

Front cover:
Detail of *Ibis Mummy*
(see figure 100)

Back cover:
Detail of *Anubis*
(see figure 28)

Frontispiece:
Detail of *Horus Falcon-Form Coffin*
(see figure 15)

Copyright page:
Detail of *Bound Oryx Dish*
(see figure 33)

Page 18:
Detail of *Baboon Appliqué*
(see figure 34)

Page 62:
Detail of *Ibis Coffin*
(see figure 78)

Pages 106, 152:
Detail of *Cat Coffin with Mummy*
(see figure 109)

Page 138:
Detail of *The Child Horus*
(see figure 125)

Page 148:
Detail of wrapping, *Ibis Mummy*
(see figure 100)

Page 150:
Detail of *Stela of Intef and Senettekh*
(see figure 6)

Backgrounds of chapter titles:
Illustrations from *Description de l'Égypte*
(Paris, 1821–30)

Contents

Foreword

The exhibition *Soulful Creatures: Animal Mummies in Ancient Egypt* is part of an ongoing program to share little-known and unexpected treasures from the Brooklyn Museum's Egyptian collection with a wider audience. In this case, we focus on the often puzzling mummies of animals.

At the same time, *Soulful Creatures* represents an innovative, cross-disciplinary approach to understanding the objects in our care. Combining the archaeological expertise of Egyptologists with the scientific knowledge of museum conservators and consulting medical specialists, this exhibition brings to our visitors an art history informed by the latest technology. It presents a fresh view of the meaning of animal mummies within Egyptian society, a view based on fascinating new analytical data gleaned from chemical analysis, carbon-14 dating, and imaging from X-rays and CT scans. The exhibition truly offers a new understanding of the ancient world, through some of the most surprising artifacts to have survived.

I wish to thank managing curator Edward Bleiberg for leading the team of curator Yekaterina Barbash and conservator Lisa Bruno in creating this exhibition and its accompanying book. Each of them brought an original and thought-provoking view to the study of animal mummies, and each worked tirelessly to make the project a reality.

For the ongoing support of the Museum's Trustees, we extend special gratitude to John S. Tamagni, Chairman, and every member of our Board. Without the confidence and active engagement of our Trustees, it would not be possible to initiate and maintain the high level of exhibition and publication programming exemplified by *Soulful Creatures*.

Arnold L. Lehman
Director
Brooklyn Museum

1. **One side of the double statue of** Serapis
(see figure 59)

Preface and Acknowledgments

Soulful Creatures: Animal Mummies in Ancient Egypt originated in the continuing effort to fully catalogue the contents of the Egyptian collection's storage vaults at the Brooklyn Museum. In 2009, Kathy Zurek-Doule, Curatorial Assistant in the collection, uncovered thirty forgotten but neatly packed animal mummies in acid-free boxes. The boxes were on shelves of a small amount of uncatalogued material that the Museum originally purchased from the New-York Historical Society between 1937 and 1948. Although Brooklyn's Egyptian collection is famous for the high quality of its works of art, the animal mummies represented a little-understood class of objects outside the realm of artworks per se. And so it seemed that this rediscovery of unexpected archaeological artifacts demanded its own course of study and exhibition. We are now eager to share the results of this work with Museum visitors.

The exhibition addresses choice examples from among the millions of mummies of birds, cats, dogs, snakes, and other animals preserved from at least thirty-one different cemeteries throughout Egypt. The objects, though numerous, are difficult to understand, because the ancient Egyptians did not leave us any written explanation of the role that animal mummies played in their religion, culture, or society. This exhibition and book therefore propose an interpretation of why the Egyptians made votive animal mummies and what they did with them in rituals. Our first principal essay, by Yekaterina Barbash, explores how animals were viewed in Egyptian thought and mythology, and provides the cultural context for the practice of animal mummy-making. My own essay then takes up the central role that animal mummies played in rituals of petition, as well as the social and economic aspects of these mummies, by examining documents preserved from the ibis sanctuary in Saqqara. Finally, the essay by Lisa Bruno uses scientific evidence derived from CT scans, X-rays, and carbon-14 dating to analyze precisely how animal mummies were made and what they contain, which produced some surprising results.

My co-curators, Yekaterina Barbash and Lisa Bruno, made working on this exhibition a special pleasure. I thank them for their creative engagement with the material, their patience, and their sense of humor.

Anthony Fischetti, DVM, MS, DACVR, of the Animal Medical Center in New York generously contributed his expertise in making and reading the project's CT scans. We thank him for

providing our team with one of our most exciting and fascinating research days as we first saw what was inside the unopened mummy wrappings.

Professor Salima Ikram of the American University in Cairo shared her unparalleled knowledge of animal mummies on several visits to Brooklyn over the last few years. Her insights were a great help to the team throughout the project.

The Brooklyn Museum's Conservation Laboratory, under the leadership of Kenneth Moser, expertly prepared these rarely seen objects for exhibition. Special thanks go to Lisa Bruno, in her role as head Objects Conservator, and to her team, consisting of conservators Kathy Francis, Jakki Godfrey, Kerith Koss, Tina March, Joannie Bottkol, Erin Anderson, and Jessica Lian Pace. Additional important work was performed by the Conservation interns Lisa Ackerman, Kate Fugett, Emily Golan, Sara Levin, Cathie Magee, Alexis North, Anna Serotta, Jessica Walthew, and Victoria Werner.

The Exhibitions Division, managed by curator Sharon Matt Atkins, prepared the exhibition tour with great resourcefulness. Our thanks to Dolores Pukki Farrell for the arrangements she expertly made, and to curator Lisa Small, who worked as point person for the exhibition.

The excellent images in the book are the result of a special campaign of new photography, supervised by Deborah Wythe, Head of Digital Collections and Services, under difficult circumstances. Our thanks go to the photographers Sarah DeSantis, Christine Gant, and Gavin Ashworth for their skill, and to Collections Manager Walter Andersons and his team of art handlers for safely and expeditiously delivering art to the Digital Lab in record time.

James Leggio, Head of Publications and Editorial Services, provided a thoughtful sounding board and masterly editing for both the book and exhibition materials. He possesses an uncanny ability to understand what I mean to say before I know it myself.

Warm thanks go to Kathy Zurek-Doule, Curatorial Assistant to the Egyptian collection, whose invaluable support to the curators was always provided with patience and a smile. The project could not have been done without her.

Finally, I wish to thank Chief Curator Kevin Stayton, Director Arnold Lehman, Board Chair John S. Tamagni, Board President Stephanie Ingrassia, and the entire Board of Trustees for their support during the preparation of this unusual exhibition and book.

Edward Bleiberg
Curator of Egyptian Art
Brooklyn Museum

2. **Detail of** Seated Baboon (see figure 74)

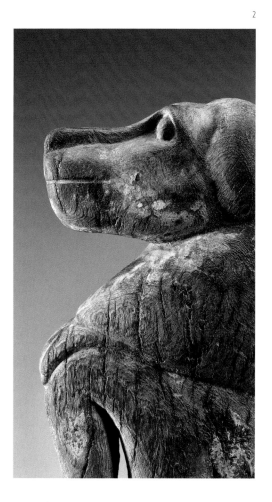

2

A Brief Chronology of Ancient Egypt

Prehistoric Period

Neolithic Period; Omari Culture, Maadi Culture

circa 5000–4400 B.C.E.

This chronology is intended to help readers navigate the vast tract of time known as ancient Egyptian history. The chronology outlines the development of Egyptian civilization through its many periods and comments briefly on the historical features of each principal era.

Egyptologists divide Egyptian history into twelve major periods. Over the centuries, periods of strong central government, or kingdoms, alternate with intermediate eras of weaker central authority and reliance on local rule. In the Prehistoric Period (5000–4400 B.C.E.), most people were farmers and there was no central government. The Predynastic Period (4400–3000 B.C.E.) reveals traits that anticipate classical Egyptian culture and customs. The Early Dynastic Period (3000–2675 B.C.E.) witnessed the first centralized government in Egypt. The next period, the Old Kingdom (2675–2170 B.C.E.), is often called the Pyramid Age and produced the best-known monuments of ancient Egypt. Centralized government dissolved at the end of the Old Kingdom, leading to the First Intermediate Period (2170–2008 B.C.E.), a transitional era that existed "between kingdoms" and was marked by local rule. After it followed the Middle Kingdom (2008–1630 B.C.E.), a time of renewed central government and impressive artistic and literary production. A second gradual breakdown of central government, however, led to the Second Intermediate Period (1630–1539/1523 B.C.E.), which was dominated by West Semitic foreigners ruling in the north of Egypt while local princes of Thebes controlled the south. Egypt began to look outward with the beginning of the New Kingdom (1539–1075 B.C.E.), when a strong, wealthy central government held sway over the ancient northeast African and Near Eastern world. A Third Intermediate Period (1075–656 B.C.E.) followed, and foreign rulers from Libya and Nubia commanded the scene. The centralized government led by Libyans introduced the Late Period (664–332 B.C.E.), when foreign rule by Persians added to the rich mix of peoples living in Egypt. Alexander the Great's invasion resulted in the Ptolemaic Period (332–30 B.C.E.), which saw the blending of Egyptian and Greek culture. The Romans took control of Egypt in 31 B.C.E. with the defeat of the Egyptian navy of Cleopatra VII and Marc Antony at the Battle of Actium. Rule from Rome and subsequently from the Eastern Roman Empire's capital of Constantinople officially continued until the arrival of Arab rulers in Egypt in 642 C.E.

People lived in farming settlements. Nearly nothing is known of the political system.

Predynastic Period
Badarian Period, Naqada Period, and Dynasty 0

circa 4400–3000 B.C.E.

Early Dynastic Period
Dynasties 1 and 2

circa 3000–2675 B.C.E.

The Predynastic Period witnessed the earliest villages in Egypt in prehistoric times, and it stretched to the very beginnings of recorded history in Dynasty 0 about 1,400 years later. At first, Egyptians experienced numerous localized cultures. Archaeological evidence indicates the beginnings of international trade with the Near East and Nubia and the first writing in Dynasty 0.

Badarian Period: circa 4400–3800 B.C.E.
Naqada I Period: circa 3850–3650 B.C.E.
Naqada II Period: circa 3650–3300 B.C.E.
Naqada III Period: circa 3300–3100 B.C.E.
Dynasty 0: circa 3100–3000 B.C.E.

Upper and Lower Egypt (i.e., southern and northern Egypt) were unified during the First and Second Dynasties. Monumental architecture appeared in tombs, and King Narmer founded the national capital at Memphis.

Dynasty 1: circa 3000–2800 B.C.E.
Dynasty 2: circa 2800–2675 B.C.E.

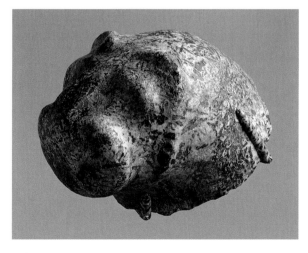

3. Lion
The king was associated with the lion from earliest times. Lion burials were found near the oldest royal burials in Hierakonpolis.

From Egypt
Predynastic, Naqada III Period, circa 3300–3100 B.C.E.
Pegmatite
9 3/4 × 7 7/8 × 12 13/16 in. (24.8 × 20 × 32.5 cm)
Charles Edwin Wilbour Fund, 73.26

4. Scorpion
The Egyptian scorpion is feared because of its paralyzing sting. Two kings of the Early Dynastic Period were named "Scorpion" to inspire awe.

From *Description de l'Égypte, ou, Recueil des observations et des recherches qui ont été faites en Égypte pendant l'expédition de l'armée française* (Paris: Imprimerie de C.L.F. Panckoucke, 1821–30), book 32: *Histoire naturelle*, vol. 2, pl. 8, no. 3. Brooklyn Museum Libraries—Special Collections; Wilbour Library of Egyptology

Old Kingdom
Dynasties 3 through 6

circa 2675–2170 B.C.E.

First Intermediate Period
Dynasty 7 through first half of Dynasty 11

circa 2170–2008 B.C.E.

The Old Kingdom saw the centralization of political power in Memphis, the national capital. King Djoser completed construction of history's first stone buildings, at Saqqara. The peak of this centralized power came in the reigns of Khufu, Khafre, and Menkaure, Fourth Dynasty kings who built their pyramids at Giza. Fifth and Sixth Dynasty kings allowed power to devolve gradually to the provinces, resulting in a new period of localized political control.

Dynasty 3: circa 2675–2625 B.C.E.
Dynasty 4: circa 2625–2500 B.C.E.
Dynasty 5: circa 2500–2350 B.C.E.
Dynasty 6: circa 2350–2170 B.C.E.

The First Intermediate Period included the last years of the Memphis royal house and the rise of rival kings of the Ninth and Tenth Dynasties in Herakleopolis, southwest of modern Cairo, and of the Eleventh Dynasty in Thebes. Local control was stronger than central government influence.

Dynasties 7 and 8: circa 2170–2130 B.C.E.
Dynasties 9 and 10: circa 2130–1980 B.C.E.
First half of Dynasty 11: circa 2081–2008 B.C.E.

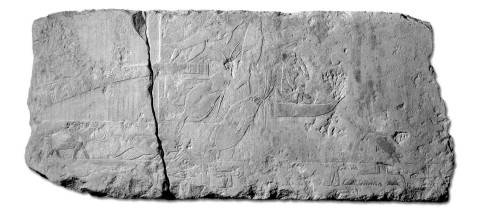

5. Swamp Scene
Beginning in the Old Kingdom, scenes of daily life in this world decorated tombs, magically ensuring that the next world would resemble this one. The swamps along the Nile with their teeming animal life, shown here, were an important source of food for Egyptians.

From Giza, Egypt
Old Kingdom, Dynasty 5 to Dynasty 6, circa 2500–2170 B.C.E.
Limestone
larger block: 14 ¹⁵/₁₆ × 25 ⁹/₁₆ × 1 ³/₁₆ in. (38 × 65 × 3 cm);
smaller block: 14 ¹⁵/₁₆ × 12 ³/₁₆ × 1 ³/₄ in. (38 × 31 × 4.5 cm)
Charles Edwin Wilbour Fund, 69.115.2a–b

Middle Kingdom

Latter half of Dynasty 11 through Dynasty 13

circa 2008–after 1630 B.C.E.

Second Intermediate Period

Dynasties 14 through 17

1630–1539/1523 B.C.E.

The Middle Kingdom was a period of high achievement in the arts, architecture, and letters. In the Eleventh Dynasty, political power remained in Thebes, the home of the ruling dynasty. In the Twelfth Dynasty, the seat of power shifted northward to Lisht, located southwest of modern Cairo. The Twelfth Dynasty was the apex of centralized power in the Middle Kingdom. The Thirteenth Dynasty witnessed the gradual infiltration of West Semitic-speaking peoples into the eastern delta of the Nile and increased local control.

Latter half of Dynasty 11: circa 2008–1938 B.C.E.
Dynasty 12: circa 1938–1759 B.C.E.
Dynasty 13: circa 1759–after 1630 B.C.E.

Northern Egypt was dominated by western Semites, so called from the Egyptian words meaning "Rulers of Foreign Lands." Native Theban princes ruled the south. Most of these dynasties overlap with each other in time.

Dynasty 14: uncertain but contemporaneous
with late Dynasty 13
Dynasty 15: 1630–1523 B.C.E.
Dynasty 16: 1630–1523 B.C.E.
Dynasty 17: 1630–1539 B.C.E.

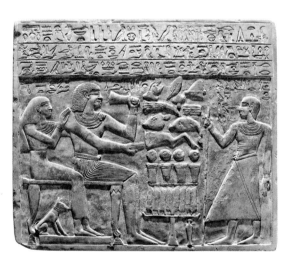

6. Stela of Intef and Senettekh
During the Eleventh Dynasty the Egyptians first depicted hunting dogs and pets on stelae. Here, Intef's dog waits under the chair as his master and mistress eat and drink. The offering table contains a cow's head and haunch of beef as a typical selection of offerings. These are also mentioned in the inscription.

Possibly from Qurnah, Egypt
First Intermediate Period to Middle Kingdom, Dynasty 11, reigns of king Intef II to Intef III, or Mentuhotep II, circa 2065–2000 B.C.E.
Limestone
11 5/8 × 13 7/8 in. (29.6 × 35.3 cm)
Charles Edwin Wilbour Fund, 54.66

New Kingdom
Dynasties 18 through 20

circa 1539–1075 B.C.E.

Theban princes reasserted control over all of Egypt, founding the Eighteenth Dynasty. Pursuit of the defeated Hyksos rulers into the Near East resulted in long-term Egyptian interest in dominating the area. Further expansion of Egyptian borders also occurred southward in Africa into modern-day Sudan. Kings grew rich and patronized vast architectural and artistic projects. For seventeen years near the end of the dynasty, a religious revolutionary and king named Akhenaton, together with his wife Nefertiti, worshipped only the sun disk, which they called the Aten. This brief time span is called the Amarna Period.

After restoration of religious traditions, the Eighteenth Dynasty family was replaced by the Nineteenth and Twentieth Dynasty family of kings called Ramesses. These kings maintained foreign possessions until the invasion of foreigners known as Sea Peoples. Egypt might have then lost its foreign possessions. The priests of Amun ruled southern Egypt.

Dynasty 18: circa 1539–1295/1292 B.C.E.
Dynasty 19: circa 1292–1190 B.C.E.
Dynasty 20: circa 1190–1075 B.C.E.

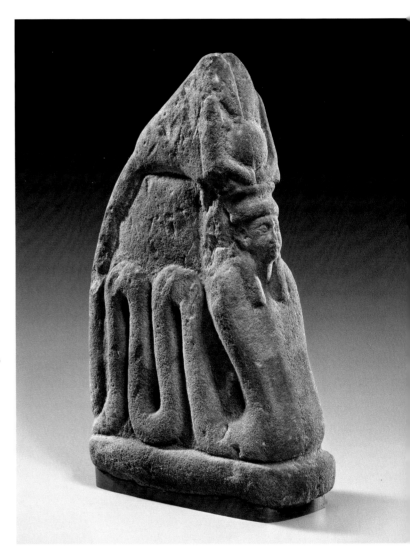

7. Meretseger
The Egyptians believed that dangerous animals protected the king. Here, the snake goddess Meretseger protected the tombs in the Valley of the Kings during the New Kingdom.

From Saqqara, Egypt
New Kingdom, Dynasty 18, reign of Thutmose III to Thutmose IV, circa 1479–1400 B.C.E.
Sandstone, paint
14 × 3 3/8 × 8 7/8 in. (35.6 × 8.5 × 22.5 cm)
Charles Edwin Wilbour Fund, 37.1749E

Third Intermediate Period
Dynasties 21 through 25

circa 1075–656 B.C.E.

This period witnessed overlapping local dynasties and kings of foreign origin from both Libya and Nubia. Yet the arts flourished in this era.

Dynasty 21: circa 1075–945 B.C.E.
Dynasty 22: circa 945–712 B.C.E.
Dynasty 23: circa 838–712 B.C.E.
Dynasty 24: circa 727–712 B.C.E.
Dynasty 25: circa 760–656 B.C.E.

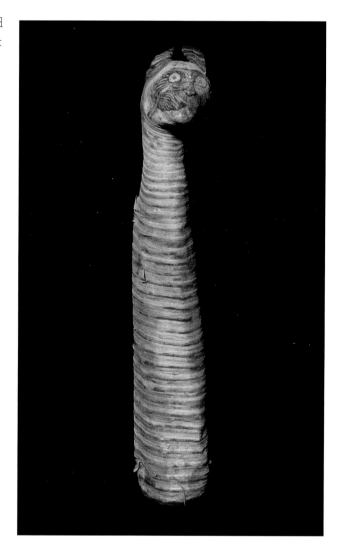

8. Cat Mummy
The first votive animal mummies appear in the archaeological record during the Third Intermediate Period. This mummy of a cat could date as early as that period, according to carbon-14 dating.

From Egypt
Carbon-14 dated to 750–400 B.C.E.
Third Intermediate Period or later,
Dynasty 22 to Dynasty 27, 1075–404 B.C.E.
Animal remains, linen
4 ³/₄ × 23 ¹³/₁₆ × 6 ¹/₄ in. (12.1 × 60.5 × 14 cm)
Charles Edwin Wilbour Fund, 37.1988E

Late Period
Dynasties 26 through 31

664–332 B.C.E.

Though foreigners ruled the country at this time, Egyptian culture was more likely to conquer them than be conquered. Libyans and Persians alternated rule with native Egyptians, but traditional conventions continued in the arts.

Dynasty 26: 664–525 B.C.E.
Dynasty 27: 525–404 B.C.E.
Dynasty 28: 404–399 B.C.E.
Dynasty 29: 399–381 B.C.E.
Dynasty 30: 381–343 B.C.E.
Dynasty 31: 343–332 B.C.E.

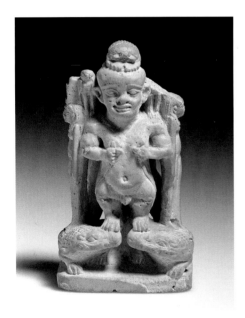

9. Figure of Pataikos
Animal cults and animal mummies became increasingly important in the Late Period. Here, the god Pataikos wears a scarab beetle on his head, supports two human-headed birds on his shoulders, holds a snake in each hand, and stands atop crocodiles.

From Egypt
Late Period to Ptolemaic Period, Dynasty 26 or later, 664–30 B.C.E.
Faience, glazed
2 15/16 × 1 11/16 × 1 in. (7.5 × 4.3 × 2.5 cm)
Charles Edwin Wilbour Fund, 37.949E

Ptolemaic Period

332–30 B.C.E.

Alexander the Great conquered Egypt in 332 B.C.E. Following his death, his general Ptolemy established a family dynasty that ruled until the death of Cleopatra VII after the Battle of Actium in 31 B.C.E. Egypt maintained a dual culture encompassing both native Egyptian and Greek elements.

Macedonian Dynasty: 332–305 B.C.E.
Ptolemaic Dynasty: 305–30 B.C.E.

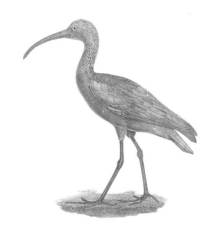

10. Ibis
This lithograph of an Egyptian ibis represents the bird sacred to the god Thoth. The Archive of Hor, detailing the workings of the sacred animal necropolis in Saqqara and written in the Ptolemaic Period, refers often to the ibis cemetery.

From *Description de l'Égypte: Histoire naturelle*, vol. 1, pl. 7, no. 2.

Roman and Byzantine Periods

30 B.C.E.–642 C.E.

Islamic Period

642 C.E. to Present

During the early years of Roman rule the country was directly administered as the property of the emperor. In the fourth century C.E. the Roman Empire split into two halves and Egypt was now part of the Eastern Roman Empire, ruled from Constantinople (modern Istanbul). Egyptians increasingly converted to Christianity and created art that reflected the influence of the new religion.

Roman Period: 30 B.C.E.–395 C.E.
Byzantine Period: 395–642 C.E.

Arab Muslims conquered Egypt in 642 C.E. and founded the city of Cairo in 969 C.E. Subsequently, the Arabic language gradually replaced ancient Egyptian, which disappeared in the eighteenth century. Egypt became an important center of Muslim scholarship in the medieval period. Today, Islam is the majority religion of Egypt.

11. **Detail of** Frieze of Animals in Plant Scroll
(see figure 56)
Representations of animals remained popular in Late Antiquity, a time when many Egyptians had converted to Christianity.

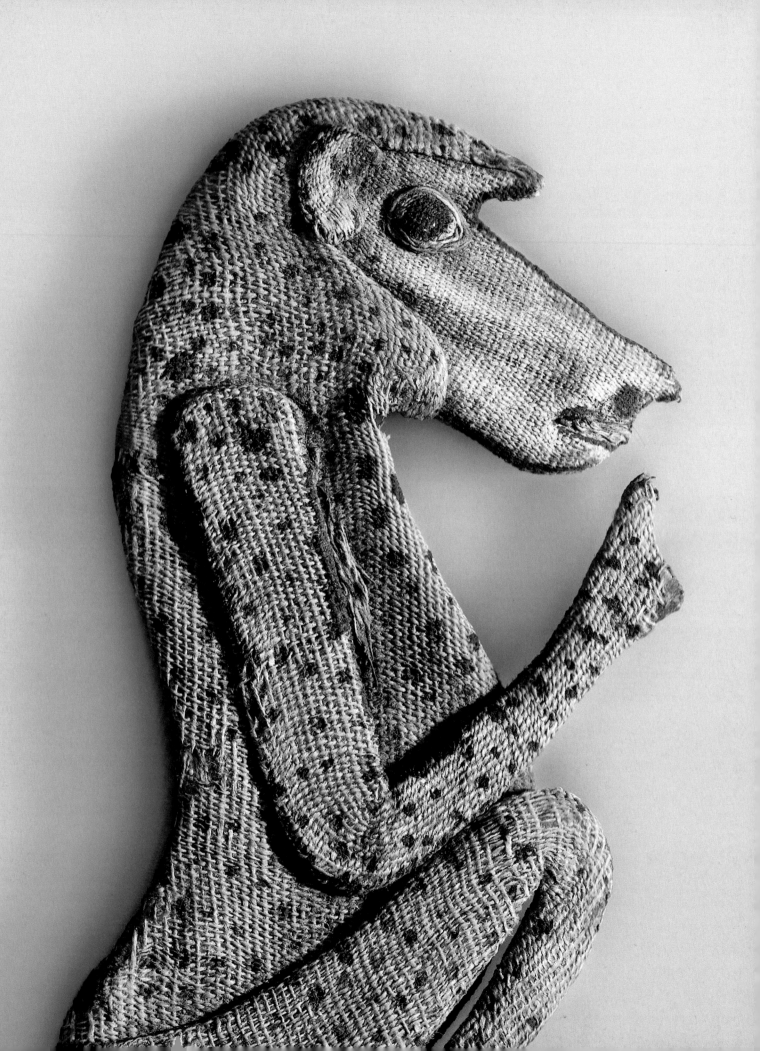

How the Ancient Egyptians Viewed the Animal World

YEKATERINA BARBASH

12. Hawk-Headed Handle

The hunting skills, keen sight, and soaring flight of falcons were representative of the sun god Re, Horus, and the king. All three dominated the gods and the Egyptian populace, symbolized by their flying above everyone else.

From Lahun, Egypt
Middle Kingdom, Dynasty 12, circa 1938–1759 B.C.E.
Wood, garnet(?), gold, paint
3 3/8 × 1 9/16 in. (8.5 × 3.9 cm)
Museum Collection Fund, 14.660

12

It was his Majesty that did this in accordance with ancient writings.
Inscription of Amenhotep III[1]

History reveals the ancient Egyptians' inclination to follow the traditions of their predecessors. Royal inscriptions, such as the one just above, frequently express the pharaohs' veneration for the past, and their desire to preserve and enhance it. This may be the reason behind the often-noted lack of change in Egyptian civilization for virtually three millennia.

Nonetheless, the Late Period of Egyptian history did witness a significant change—a great surge of animal cults and the mummification of animals. The surge is often explained by scholars as a novel innovation, detached from earlier Egyptian culture or religion. In spite of such assertions, however, animals had remained enduring, essential symbols of nature, the domestic sphere, and the supernatural throughout the long history of Egypt. The Egyptians' determination to continue and advance the traditions of their predecessors suggests that the sudden rise in popularity of animal cults in the Late Period may in fact have grown out of earlier practices and beliefs concerning the animal world.

With that possibility in mind, let us examine the prevailing views of animals in traditional pharaonic culture in more detail, and see what kinds of longstanding beliefs may have prepared the way for the later rise of animal mummification.

Beliefs about Individual Species

Animals were believed to have been created at the same time as humans. And after their death, animals, like deceased humans, were referred to as "Osiris," enjoying a semi-divine status.

In the earthly realm, Egyptians saw animals as an integral part of their environment: fish were abundant in the life-giving waters of the Nile; gazelles, lions, and scorpions roamed the desert's edges; birds of prey flew overhead (figure 12), and waterfowl chirped in the marshes. Naturally, many animals performed roles familiar to modern Western societies: they were hunted, consumed, bred, or kept as pets. Domesticated goats, sheep, and cattle were used in farming and as a source of food. In addition to providing companionship, cats helped keep vermin away, and dogs assisted in hunting.

13

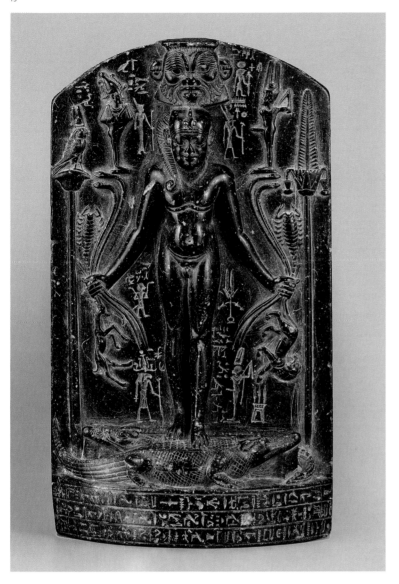

13. **Cippus of Horus on the Crocodiles**
This *cippus*, or magical stela, depicts the child Horus controlling a variety of animals associated with the dangerous margins of the Egyptian universe. Such stelae were believed to provide protection and heal snake and scorpion bites.

From Egypt
Ptolemaic Period, 3rd century b.c.e.
Steatite
9 ⅛ × 5 ⁵⁄₁₆ × 2 ³⁄₁₆ in. (23.2 × 13.5 × 5.6 cm)
Charles Edwin Wilbour Fund, 60.73

The Egyptians keenly observed local creatures in their habitats, and quickly gained an appreciation for the diversity of animals and the specific qualities of each species. Many held a deep significance, being honored for their strength, power, speed, fertility, and other discernible features. Because attributes such as these manifested more strongly in animals than in humanity, they were regarded as evidence of an animal's link to divinity, possessing qualities of the deity's character. As a result, some species came to represent specific deities or symbolize particular forces of nature. For example, the aggressive, uncontrollable lioness could embody the violent goddess Sakhmet, and a crocodile could personify the annual inundation. Wild animals that inhabited the threatening desert or the perilous parts of the Nile valley symbolized the dangers associated with these locations (figure 13). Gazelles and scorpions likely represented the desert. The Nile and its surrounding marshes were characterized by both beneficial and potentially destructive animals like fish,

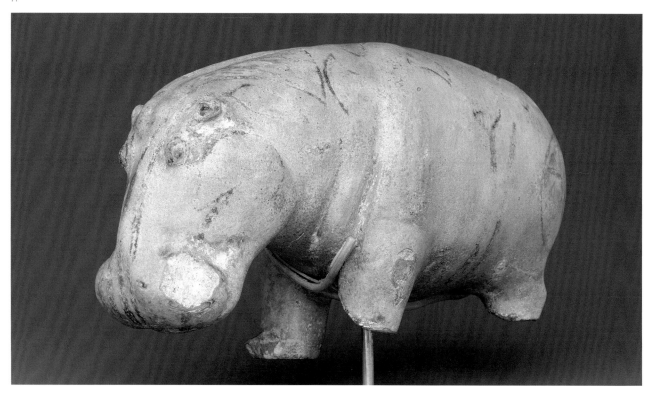

14. Hippopotamus
Because the hippopotamus could be aggressive and dangerous, breaking the legs of hippo statuettes placed in Egyptian tombs was a form of magical control over all potential threats. At the same time, the violent power of this animal was turned toward protection of the deceased.

From Egypt
Middle Kingdom to Second Intermediate Period, Dynasty 12 to Dynasty 17, circa 1938–1539 B.C.E.
Faience, painted
4 1/8 × 3 1/8 × 7 3/8 in. (10.5 × 7.9 × 18.8 cm)
Gift of the Ernest Erickson Foundation, Inc., 86.226.2

turtles, crocodiles, and hippos. These were seen as symbols of the chaotic abyss known as Nun—the fertile, watery state of the universe before creation.

The profound complexity of animal nature is reflected in Egyptian mythology, supplying many creatures with dual, often opposing, roles that illuminate the sacred and the mundane, the benevolent and the dangerous. Thus, cattle were an everyday source of beef and milk, but a bull with certain markings became a "divinity." In addition, virtually every animal was recognized to have both benign and malicious aspects. For example, the hippopotamus's preferred Nile habitat associated it with the life-giving waters of the inundation, yet its aggressiveness when with young epitomized danger and evil. Because of this, the female hippo became a strong symbol of fertility as the goddess Taweret, who protected mothers and newborn babies, while the animal's hazardous aspect was turned against the dangers of the Netherworld, protecting the reborn deceased in Middle Kingdom tombs (figure 14).

With their varied qualities, some animals represented more than one god. For instance, the falcon symbolized Egyptian kingship, but was also a manifestation of the sun god (figure 15). A falcon's soaring flight and keen eyesight embodied essential aspects of the god Horus, who often appears as this bird of prey. In another example, the venomous bite of the cobra associated it with the sun god's arch-enemy, the serpent Apep, and at the same time allowed it to be a powerful protector of the king and the deceased as the *uraeus,* a form seen on royal headgear (figure 16).

15

16

15. Horus Falcon-Form Coffin
The falcon god Horus wears the double
crown of Upper and Lower Egypt. With this
crown, Horus and the king preside over a
unified Egypt.

From Egypt
Late Period to Ptolemaic Period, Dynasty
26 or later, 664–30 b.c.e.
Bronze, gold
11 5/16 × 2 5/8 × 8 3/16 in. (28.8 × 6.6 × 20.8 cm)
Charles Edwin Wilbour Fund, 05.394

16. Uraeus
An image of the coiled cobra on the forehead
of the king protected him by spitting fire
against all potential enemies.

Possibly from Akhmim, Egypt
Late Period to Ptolemaic Period, Dynasty
26 or later, 664–30 b.c.e.
Bronze
1 9/16 × 11/16 × 1 1/4 in. (4 × 1.8 × 3.2 cm)
Gift of Evangeline Wilbour Blashfield,
Theodora Wilbour, and Victor Wilbour honoring
the wishes of their mother, Charlotte Beebe
Wilbour, as a memorial to their father, Charles
Edwin Wilbour, 16.580.181

**17. Single-Strand Necklace
with Taweret Amulets**
The hippopotamus inhabited the fertile waters of the Nile and aggressively protected its calves, evoking both fecundity and security. Images of the goddess Taweret functioned as protective amulets for mothers and newborn babies.

Possibly from Malkata, Thebes, Egypt
New Kingdom, Dynasty 18, reign of Amunhotep III, circa 1332–1292 B.C.E.
Faience
³/₁₆ × 7 ¹⁵/₁₆ in. (0.5 × 20.2 cm)
Gift of Mrs. Lawrence Coolidge and Mrs. Robert Woods Bliss, and the Charles Edwin Wilbour Fund, 48.66.42

Animal Imagery

As we have seen, commonly encountered animals figured prominently in Egyptian mythology. The image of a cow giving birth to a calf translated into a symbol of fertility, maternal protection, and the daily birth of the sun from the sky goddess.[2] Deities in animal or combined human-animal form proliferated in official Egyptian religion, with their own temples or shrines throughout the country. On a private level, images of animals appeared on objects of worship and amulets. Scribes kept small images of seated baboons, representing their patron god, Thoth, and pregnant mothers used amulets of the hippo Taweret for protection at home (figure 17).

Representations of domesticated cattle, sheep, and goats emerged around 5000 B.C.E. at sites like Merimde, one of the earliest settlements in the Nile Delta. Depictions of animals as figures and on palettes, ritual combs, and knives were already common in Predynastic times.

Images of Royal Authority
Predynastic images of wild-animal hunts show a desire to capture and control creatures associated with the margins of creation, for use in protective temple rituals. One of the most important Predynastic settlements of Hierakonpolis, dated to Naqada II–III (circa 3500–3100 B.C.E.), revealed a variety of ritually buried animals, including cattle, hippopotami, donkeys, dogs, baboons, gazelles, crocodiles, and elephants, among others.[3] Their healed bone fractures suggest that some wild and rare animals remained in captivity for a certain time before being sacrificed.

In the Predynastic and Early Dynastic Periods, the iconography of royal authority included lions, bulls, and other large, powerful creatures. Like these fierce animals, the early rulers subdued neighboring chiefs and kept them at bay. At the same time, the ability to capture and effectively control large wild animals served as a display of supremacy for Predynastic chiefs. Interestingly, the names of early rulers, like Narmer, whose name means "catfish," and his likely predecessor Scorpion, refer to dangerous and aggressive, if smaller, animals.

By the time the Egyptian state formed, the significance of certain animals was firmly established in the culture. Under a government that was newly stable and powerful, symbols of overarching control gained special importance. Although rarely

17

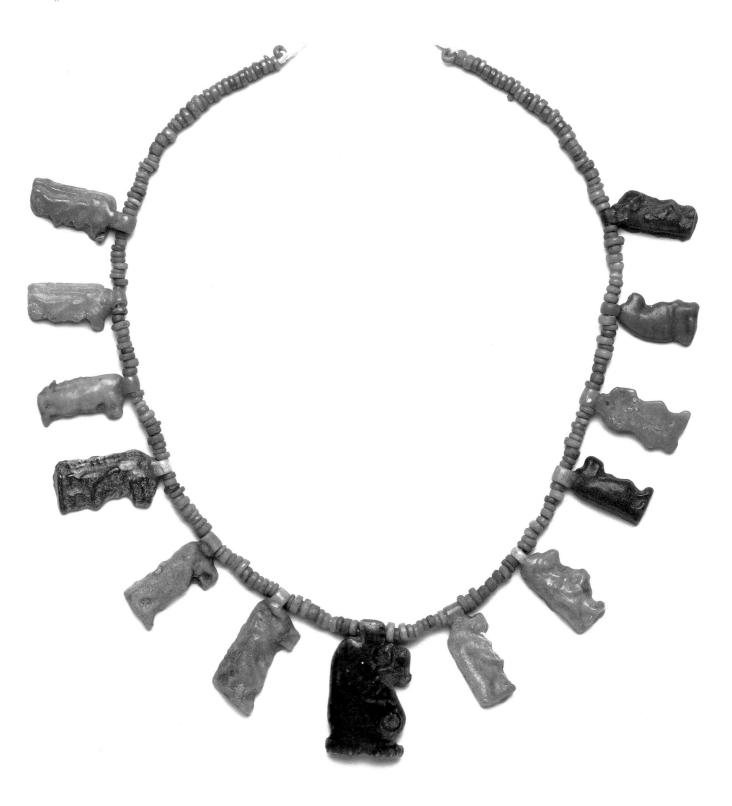

18. **Pepy I with Horus Falcon**
The Horus falcon perched on the back of the throne merges with the crown of king Pepy I, emphasizing the link between kingship and that god.

Possibly from southern Egypt
Old Kingdom, Dynasty 6, reign of Pepy I,
circa 2338–2298 b.c.e.
Egyptian alabaster
10 7/16 × 2 3/4 × 6 3/16 in. (26.5 × 6 × 15.7 cm)
Charles Edwin Wilbour Fund, 39.120

depicted in the Predynastic, the falcon appeared at the pinnacle of Early Dynastic iconography, identified as the god Horus, the symbol and protector of Egyptian kingship (figure 18). And with the development of writing and the standardization of art, the integral place of animals in the Egyptian worldview became more apparent. The Egyptian conception of creation described animals as an equal part of creation, along with humans, as a New Kingdom hymn to the god Aten emphasizes: "August God who fashioned himself, who made every land, created what is in it, all peoples, herds, and flocks, all trees that grow from soil; they live when you dawn for them."[4] Despite this seeming equality, however, evidence points to captured wild animals kept in a zoo-like enclosure in the New Kingdom palace of Amenhotep III. Similarly, Old Kingdom and later tombs abound in images of domesticated cattle and goats, while scenes of fishing, hunting, and bird netting represent the margins of the surrounding universe in the tombs' lower registers.

Animals in Ritual
Animal cults focusing on the worship of a singular, "sacred" animal persisted from the First Dynasty into the Roman Period. Each was a distinct, individual beast with special markings, revered as the chosen embodiment of a specific god. After death, such sacred animals were embalmed and buried with great pomp, becoming the earliest precursors of later animal cults. The role of each sacred animal as the earthly manifestation of a god parallels that of the king, who became Horus when crowned. Both kings and sacred animals functioned as intermediaries between humanity and the gods. At death, both were interred in designated necropolises, next to their predecessors.

The sacred Apis bull played a part in rituals of royal renewal from early on. Coinciding with changes to the Apis cult and establishment of the Serapeum (figure 19), the veneration of more than one representative of a species associated with a god appeared in the Eighteenth Dynasty, and intensified by the Twenty-sixth Dynasty (figure 20).

The archaeological context of Predynastic animal images points to early rituals associated with divinities and their use as votives, another practice akin to later animal mummies.[5] By the Late Period, the connection between animals and religious rituals had become more common, as more animals joined the

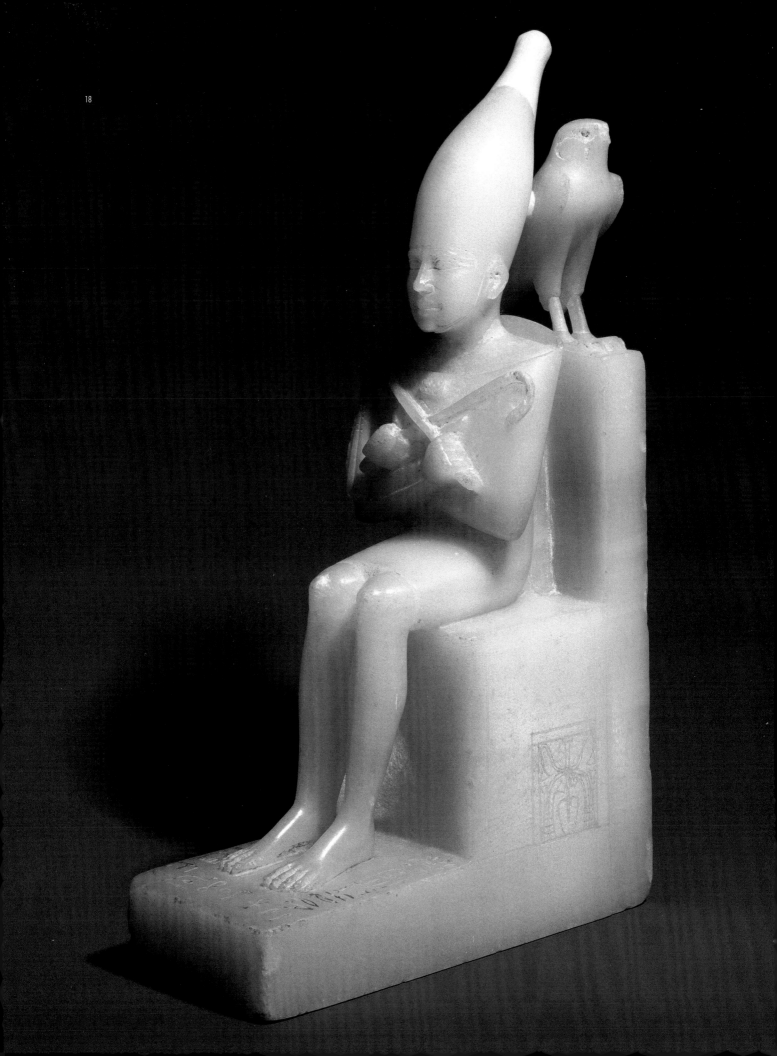

19

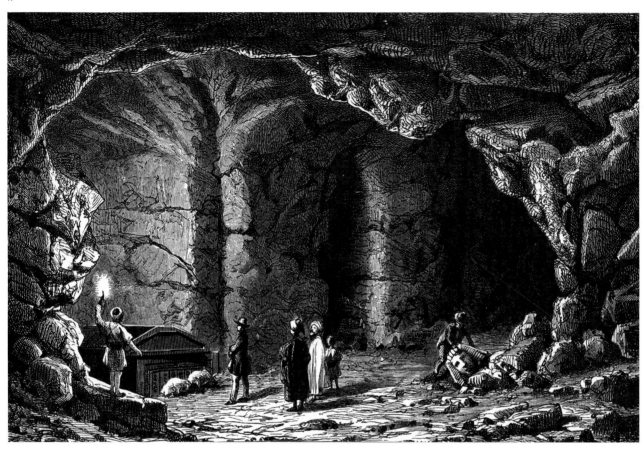

19. The Serapeum, Memphis
The Serapeum was named for the god Serapis in 1853, when it was discovered. Subsequently, it was learned that this was the Apis bull cemetery. This early engraving shows a tourist looking at one of the stone sarcophagi made for an Apis bull.

From Thomas W. Knox, *Backsheesh, or, Life and Adventures in the Orient* (Chicago: A.D. Worthington & Co., 1875). Private collection

20. Bull's Head
Descriptions of the sacred Apis bull, chosen for its markings, mention its black hide, straight horns, and a white diamond shape on its forehead.

From Giza, Egypt
Late Period, Dynasty 26 to Dynasty 31, 664–332 B.C.E.
Wood, glass, ivory
11 ³⁄₄ × 15 × 14 in. (29.8 × 38.1 × 35.6 cm)
Charles Edwin Wilbour Fund, 37.1532E

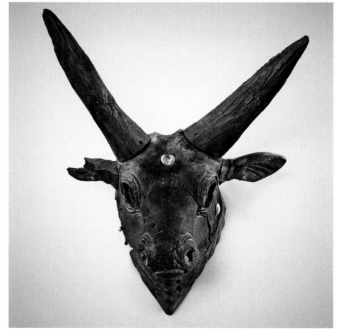

20

ranks of semi-divine creatures capable of embodying a god. The gradual growth of animal cults does not have much inscriptional or archaeological evidence, likely because their initial surge took place among the popular, rather than official-temple religion. Eventually, this phenomenon picked up royal support in the reigns of Ahmose II, Nectanebo I–II, and Ptolemy I. At the same time, the taxation of cult centers and offices serving animal cults must have financially benefitted the state in a substantial way.[6]

Mummified Animals: A Brief Bestiary

As the popularity of animal cults grew in the Late Period of Egyptian history, more species were mummified, and in greater numbers. To better understand the phenomenon, let us examine some of the specific kinds of animals that were mummified, their roles in everyday life, and their selected religious associations from preceding periods.

In this brief bestiary, mammals are discussed first (agricultural, then domesticated, then wild), followed by birds, reptiles, fish, and finally insects.

Cattle

Domesticated around 5000 B.C.E., cows and bulls were used as a food source and helped work the fields. Possession of large cattle herds indicated the status of their owner. Scenes of cattle-counting and of assisting in the birth of calves frequently appear in Old Kingdom and later tombs. Models of daily life representing cattle stables and slaughterhouses are numerous in the Middle Kingdom. Beef was part of elite menus, and haunches of beef are typically included as funerary offerings.

Bovines were among the first animals to acquire strong associations with specific divinities, and the first large animals to be venerated and mummified after death. One of the most prominent goddesses, Hathor, depicted as a cow or a cow-headed woman, possessed the cow's motherly qualities as a producer of milk and protector of calves. Regarded as the daughter of Re and one of the goddesses of the Eye of the Sun, Hathor represented the peaceful, protective aspect of female divinities. Such musical instruments as the sistrum are decorated with faces of Hathor because of her associations with music, love, and sexuality. She was one of the few goddesses with temples throughout Egypt.

Hathor, whose name means "House of Horus," was believed to protect and nurse the young Horus. She is the mother of Horus in Pyramid Text 303, paragraph 466: "You are Horus, son of Osiris. You, Unis, are the eldest god, the son of Hathor."⁷ Following Horus's link with kingship, Hathor was seen as the divine mother of each king, a notion frequently evoked in scenes of the goddess suckling the king. Also known as the "Lady of the West," she received and protected the setting sun, and by association, the deceased. Other goddesses, including Nut, Isis, and Bat, were also represented as a woman with cow horns and ears (figure 21).

The bull's strength and fertility became symbolic of royal power during the early Egyptian state. Images of bulls depict the sun god, primordial time, and creation; the fore part of a bull represents a constellation in Egyptian astronomical maps. Predynastic and Early Dynastic images of charging bulls symbolized the ruler. Later pharaohs wore bull's tails in association with the might and virility of this animal, and New Kingdom pharaohs adopted the epithet "Mighty Bull." Nonetheless, records from the First Dynasty king Aha refer to kings spearing bulls as part of a ritual royal hunt. The choicest parts were subsequently offered to a god, and consumed, allowing the king to assimilate the animal's strength. The bull's fertility symbolized one of the most important features of the Egyptian landscape: the annual inundation that brought fertile soil to the Nile valley.

Several bulls were considered to be sacred animals as offspring and representatives of a specific god. The most prominent of these was Apis, venerated since the Early Dynastic Period.⁸ Each Apis bull was chosen by its markings: "black with a white diamond on the forehead, a likeness of vulture wings on his back, double hairs on its tail and a scarab-shaped mark under its tongue,"⁹ according to Herodotus (figure 22). Believed to be the replication and manifestation (*ba*) of Ptah, Apis had his principal sanctuary at the temple of Ptah in Memphis. Apis's importance to kingship is reflected in its role in the royal renewal ceremony of the *Sed*-festival, where it conveyed its power to the king. After death, each Apis was embalmed, mourned, and buried in places like the Serapeum of Saqqara, with equipment similar to elite human burials. As the bull sacred to the west, the location of most cemeteries, deceased Apises became associated with Osiris as the god Osiris-Apis (Oserapis), and held the epithet "*ba* of Osiris." As a direct manifestation of a god, the crowned Apis bull was believed to provide oracles during life and after death. Apis's oracular abilities

21. **Bird Coffin of Iihetek**
The goddess Isis, the sister and wife of Osiris, stands on one side of this coffin. She is represented with cow horns and a sun disk on her head, associating her with the cow's motherly qualities. For an image of the remains found inside this coffin, see figure 106.

Possibly from Saqqara, Egypt
Late Period to Ptolemaic Period, Dynasty 26 or later, 664–30 B.C.E.
Bronze, animal remains (2 individuals), linen
14 ¹⁵⁄₁₆ × 3 ⁷⁄₁₆ × 2 ¹⁵⁄₁₆ in. (38 × 8.8 × 7.5 cm)
Charles Edwin Wilbour Fund, 37.1391Ea–b

22

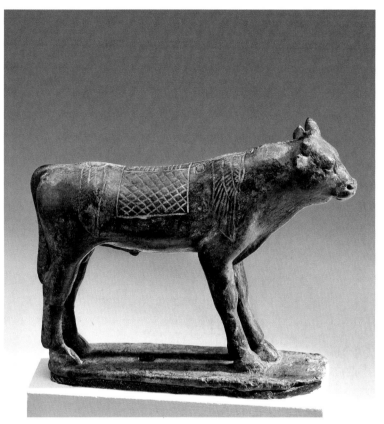

23

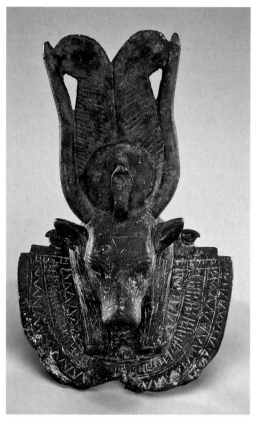

22. Apis Bull
The historian Herodotus described the
sacred Apis as a black bull with the likeness
of vulture wings on his back.

From Egypt
Late Period to Ptolemaic Period, Dynasty
26 or later, 664–30 B.C.E.
Bronze
3 3/8 × 1 1/8 × 4 7/16 in. (8.6 × 2.9 × 11.2 cm)
Charles Edwin Wilbour Fund, 05.397

23. Isis, the Mother of Apis
Mothers of Apis bulls, the Sechathor cows
were elevated to divine status and became
associated with the goddess Isis.

From Egypt
Third Intermediate Period to Late Period,
late Dynasty 25 or later, circa 670–332 B.C.E.
Bronze
4 1/2 × 2 3/4 × 3 3/8 in. (11.5 × 7 × 8.5 cm)
Charles Edwin Wilbour Fund, 73.25

24

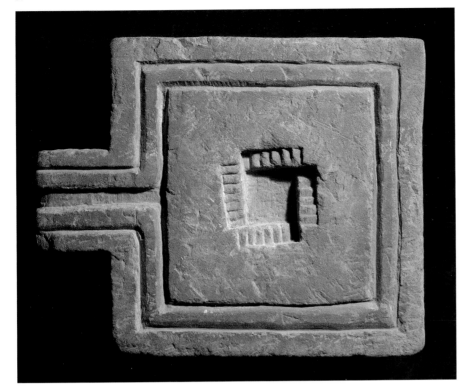

24. Buchis Bull Offering Table
The Buchis bull was sacred to the god Montu,
whose main center of worship was located in
Armant, south of Thebes. This offering table,
excavated at Armant, was part of the funerary
equipment of a Buchis bull burial.

From Armant, Egypt
Late Ptolemaic Period to Roman Period,
200 B.C.E.–300 C.E.
Sandstone
4 5/8 × 13 11/16 × 17 1/4 in. (11.8 × 34.7 × 43.8 cm)
Gift of the Egypt Exploration Society, 32.2088

likely affected the economic development of North Saqqara, which became the focus of numerous animal cults in the Late Period.[10]

Due to the "divine nature of his birth," the mothers of Apis (figure 23) were deemed manifestations of the goddess Isis and awarded lush burials in the Iseum in North Saqqara, as were Apis calves. A myth from the time of Nectanebo II refers to Thoth as the father of Apis, perhaps explaining why baboons and ibises, closely associated with Thoth, were also buried in the vicinity of the Serapeum.[11]

The sacred bull of Heliopolis known as Mnevis was identified by its completely black color, which alludes to inundation, pre-creation, and rebirth.[12] Linked with the creator god Atum, and regarded as the *ba* of the sun god, Mnevis was represented with a sun disk and *uraeus* between its curved horns. According to the Greek historian Plutarch, the Mnevis bull was second to Apis, and also consulted as an oracle. References to Mnevis bulls date back to the Pyramid Texts, and Mnevis burials are known from the Ramesside period. Mnevises were mummified like humans and received analogous offerings. A boundary stela at Amarna states: "Let a cemetery for the Mnevis bull be made in the eastern mountain of Akhetaten that he may be buried in it."[13] The mothers of Mnevis bulls enjoyed their own cult as the cow goddess Hesat, and their calves were also entombed in Heliopolis.

A later addition to bull cults, attested from Ramesses II's reign, was the Buchis, sacred to the god Montu in Hermopolis (Armant) and closely linked with Amun and Min (figure 24). Each Buchis was likely a wild bull, distinguished by its white body

25

25. Ram-Headed God

Rams were revered for their virility, and thus creative power, among other qualities. The solar creator god Khnum-Re could take the form of a ram-headed god such as this one.

From Egypt
Late Period, Dynasty 26 to Dynasty 31, 664–332 B.C.E.
Bronze
3 1/16 × 7/8 × 1 9/16 in. (7.8 × 2.3 × 4 cm)
Charles Edwin Wilbour Fund, 37.682E

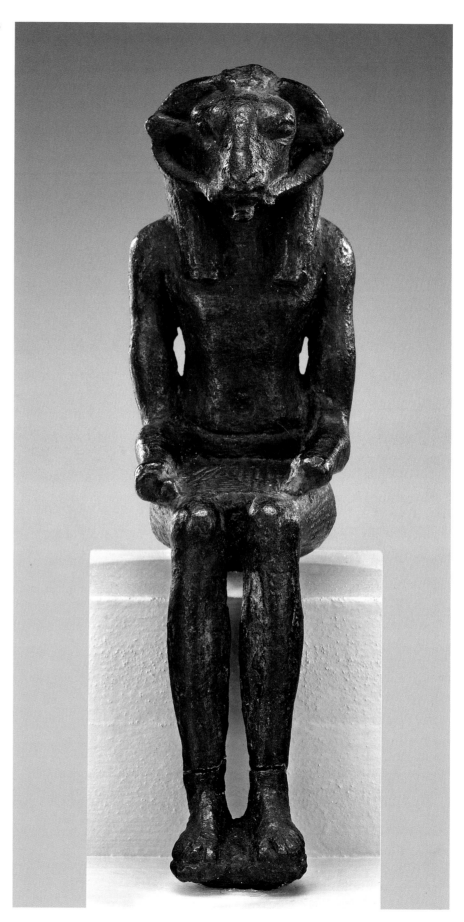

26

27

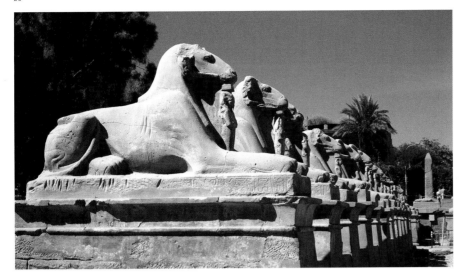

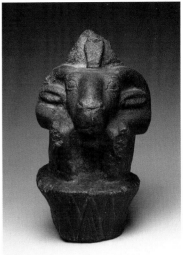

and black head.[14] The Roman writer Macrobius (circa 400 C.E.) described the belief that the Buchis bull changed color every hour and its hair grew backwards. As it was deemed to be the *ba* of Re and Osiris, the bull's name means "Who Makes the *Ba* Dwell within the Body." The deceased Buchis was mummified and buried in sandstone sarcophagi in catacombs called Bucheum. Mothers of Buchis were subsequently interred at Baqariyyah, in Armant, in the Late and Greco-Roman periods. Other localities also worshipped sacred bulls that are less well documented.[15]

Ram

Domesticated in the early Predynastic Period, large herds of sheep were kept for agricultural use and as a source of food. Noted for their aggression and virility, ram deities held epithets like "Coupling Ram that Mounts the Beauties" (figure 25). According to Plutarch, certain taboos against sheep products were in place for priests of ram deities: "because they revere the sheep, abstain from using wool as well as its flesh." Two types of ram occur in Egyptian art. A ram with short, curved horns (*Ovis platyura aegyptiaca*), appearing in Egypt around the Twelfth Dynasty, came to be one of the manifestations of the principal Egyptian god, Amun (figures 26, 27), and was particularly revered in this form in Nubian temples. The god Khnum, represented as a ram with long, wavy horns (*Ovis longipes palaeoaegypticus*, now extinct) or a ram-headed human, was worshipped throughout Upper Egypt with prominent cult centers at Esna and Elephantine. Attested from the earliest periods, Khnum was believed to have created humans, animals, and the universe on a potter's wheel.

The similarly represented god Banebdjedet was venerated as the united *ba* of Re and Osiris from the Second Dynasty on. The pure-white sacred ram of Mendes resided in the temple and offered daily oracular statements on the functioning of the state. The roots of the similar Egyptian words *sr* ("ram") and *sr*

26. Ram Sphinxes
Ram sphinxes were hybrid animals with lion's bodies and the head of a ram. Here they decorate the processional way to a temple dedicated to the god Amun, sometimes represented as a ram.

Temple of Luxor, Egypt
New Kingdom, Dynasty 18, reign of Amenhotep III, 1390–1353 B.C.E.
(Photo: © Marina Kryukova; used under license from Shutterstock.com, 5236555)

27. Ram-Headed Lotus Column
A symbol of the god Amun, the ram-headed lotus with a *uraeus* likely functioned as an offering presented to the god by a king or priest.

Possibly from Dendera, Egypt
Third Intermediate Period or later, Dynasty 22 or later, circa 945 B.C.E. or later
Black granite, traces of red paint
11 1/4 × 5 9/16 in. (28.6 × 14.1 cm)
Gift of Mrs. George D. Pratt, 35.932

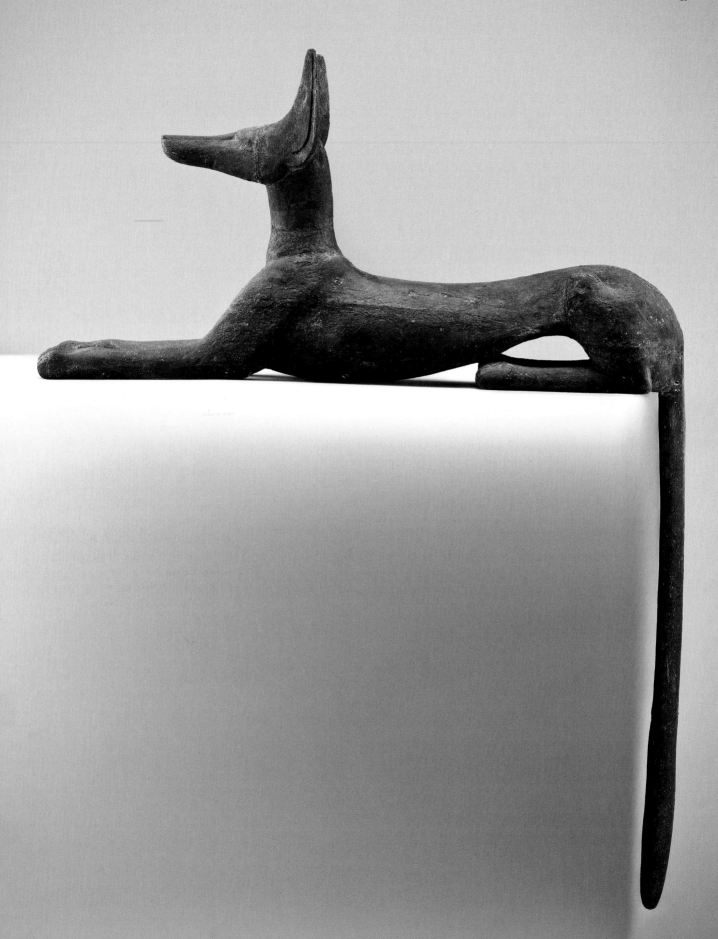

("to foretell") likely fostered belief in this ram's clairvoyance. Another ram deity, Heryshef, who may have originally been a fertility god, was worshipped at Herakleopolis Magna as early as the First Dynasty. Sacred rams were mummified and buried in catacombs at these and other cult centers of the later periods as well.

Dog, Jackal

As in modern society, already in Neolithic times dogs were used as domestic pets, guardians, herders, and police assistants. Several dog breeds could be found in ancient Egypt, the most popular being the greyhound, basenji, and saluki, all well suited to hunting; an Egyptian vessel from about 4500 B.C.E. in the Pushkin Museum, Moscow, shows a hunter with four dogs. Dogs were depicted as pets under their owner's chair, and some were buried with or next to their owners. Early rulers of Abydos were buried with their dogs, while the Eleventh Dynasty king Wahankh Intef II included names of his dogs on his funerary stela.

From the First Dynasty, Egyptians venerated several jackal deities. The most prominent of these was Anubis, represented as a canine or a canine-headed human (figure 28). Traditionally, the Anubis animal 𓃥 (*sab*) has been identified as a jackal, but its generally black coloring, symbolic of the afterlife and rebirth, is not typical of jackals and may instead denote a wild dog. The numerous canine mummies of later periods were buried in the Anubieion catacombs, named after Anubis by later authors. According to myth, Anubis was responsible for embalming the

28. **Anubis**
Anubis escorted the deceased to the Netherworld and guarded the mummy. Such figurines of Anubis, placed on a lid of a coffin, served a protective purpose for the spirit.

Possibly from Saqqara, Egypt
Late Period to Ptolemaic Period, Dynasty 26 or later, 664–30 B.C.E.
Wood, painted
16 1/8 × 3 9/16 × 19 7/8 in. (41 × 9 × 50.5 cm)
Charles Edwin Wilbour Fund, 37.1478E

29. **Wepwawet**
Emblematic images of the jackal were carried by priests in royal or Osirian temple processions as symbols of Upper Egypt. The characteristic representations of Wepwawet on a standard indicate the origin of this image in military contexts.

From Egypt
Late Period, Dynasty 26 to Dynasty 31, 664–332 B.C.E.
Bronze
2 1/4 × 2 3/4 in. (5.7 × 7 cm)
Gift of Evangeline Wilbour Blashfield, Theodora Wilbour, and Victor Wilbour honoring the wishes of their mother, Charlotte Beebe Wilbour, as a memorial to their father, Charles Edwin Wilbour, 16.580.168

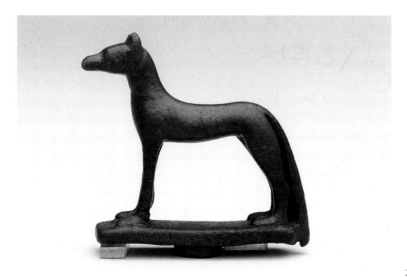

29

god Osiris, and was venerated throughout Egypt as patron of embalmers. His epithets include "Foremost of the Divine Booth" (that is, the embalming tent or burial chamber) and "He Who Is in the Mummy Wrappings." Because dogs and jackals roamed the desert's edge, where the dead were generally buried, they were seen as protectors of cemeteries; alternatively, the use of a canine image in funerary contexts may have reflected a desire to prevent wild canines from disturbing corpses, which they likely did. The so-called seal of Anubis, representing a jackal above nine bound captives, was stamped on tomb entrances in the Valley of the Kings, symbolically protecting the tombs and their occupants. As a funerary deity, Anubis assisted Osiris's judgment by weighing the heart of the deceased, in the Book of the Dead, Spell 125, while the Pyramid Texts refer to him as the judge of the dead.

The god Wepwawet was similarly depicted as a jackal-headed human, or a jackal with a gray or white head (figure 29). Wepwawet's cult was especially prominent in Abydos, where he was one of the earliest deities worshipped. His epithets include "Lord of Abydos" and "Lord of Necropolis." Wepwawet was also worshipped in Asyut, known to the ancient Greeks as Lycopolis ("wolf-town"). The meaning of Wepwawet's name, "Opener of the Ways," primarily refers to his role as protector and guide of the deceased through the Netherworld. As such, he performed the traditional Opening of the Mouth ceremony, revivifying the deceased. Wepwawet was also venerated as a royal messenger and the deity who facilitated royal conquests of foreign lands, by opening the ways for the king.

Cat, Lion

Domesticated considerably later than dogs, felines are one of the most iconic species in Egyptian culture. Cat mummies are common in later periods (see figure 109), although lion burials are rarely attested. Two types of smaller cats commonly appeared in ancient Egypt: the jungle cat (*Felis chaus*) and the African wild cat (*Felis silvestris libyca*). The latter were kept as pets from the Predynastic Period onward. The house cat's knack for catching mice and snakes in homes or granaries was highly valued, and was translated into mythology. With their ability to see in darkness and fight off dangerous creatures, various cats regularly appear on Middle Kingdom magical knives and figurines. In the Book of the Dead, the sun god takes the form of a tomcat to defeat the serpent Apep. Tomb scenes of hunting and fowling

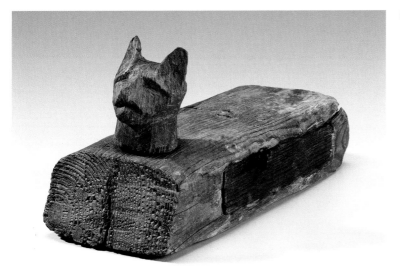

30

30. Cat Coffin with Mummy
The common misconception that ancient
Egyptians believed cats to be divine probably
stems from the abundance and popularity of
their feline images. The cat's fertility and gentle
care for kittens associated it with the peaceful
and motherly qualities of the goddess Bastet.

From Egypt
Ptolemaic Period (probably), 305–30 b.c.e.
Wood, animal remains
3 7/16 × 2 3/4 × 6 5/8 in. (8.8 × 7 × 16.8 cm)
Charles Edwin Wilbour Fund, 37.1363E

with the participation of smaller cats symbolically refer to such
mythological episodes.

The domestic context and motherly qualities of cats closely
link them to the goddess Bastet, who was depicted as a cat or a
cat-headed woman (figure 30). Attested since the Second Dynasty,
in her early lion-headed form, Bastet was regarded as a protective
mother goddess and the daughter of Re. Small cats frequently
appear under women's chairs on reliefs, evoking fertility and
sexuality. Cats' mythological associations (figure 31) likely
explain the use of cat fur, feces, and fat in magic and medicine.
The cult of Bastet and her center of worship, Bubastis, the origin
of numerous later cat mummies, rose in popularity by the Third
Intermediate Period. Accordingly, the Twenty-second Dynasty
pharaoh Pamiw's name means "Tomcat."

Having retreated south around the Predynastic Period,
lions were rare in pharaonic times, but they played a tremendous
role in Egyptian iconography. As in many cultures, lions
became firmly established as symbols of royal authority for their
aggressive nature and their power. Rulers organized lion hunts
demonstrating their control of the fierce animal. Lion bones found
in the First Dynasty tomb of king Aha suggest that captured
lions were kept in royal complexes. Lions often represented the
horizons, where the sun rises and sets every day, as the desert
habitat mythologically links them with the eastern and western
margins of the universe. Lion images on funerary furniture
illustrate this animal's link with the cycle of death and rebirth,
akin to the sun. The sun god himself appears as a lion with yellow
ruff in the Book of the Dead, Spell 62, and the lion god Aker
guards the entrance to the Netherworld. The aggressive power of
lions was adopted as a symbol of forceful protection.

The lioness's motherly instinct, manifested in gentle
nurturing and fierce protection of her cubs, represented the

31

31. Cat and Mouse
Scenes of animals performing human tasks
may have functioned as illustrations of
popular fables or been used in satire.

Possibly from Thebes, Egypt
New Kingdom, Dynasty 19 to Dynasty 20,
circa 1292–1075 B.C.E.
Limestone, pigment
3 1/2 × 6 13/16 × 7/16 in. (8.9 × 17.3 × 1.1 cm)
Charles Edwin Wilbour Fund, 37.51E

32. Sakhmet
In some myths, the fierce lioness, who
embodies the wandering Eye of Re, went
off into the desert, leaving her father
unprotected from evil forces and rebels.
But, having been tricked and placated, she
resolved to return home and assumed the
shape of an innocent cat at peace.

From Egypt
Late Period, or later, Dynasty 26 to Dynasty
31, 664–332 B.C.E., or later
Bronze
3 7/8 × 1 × 2 1/8 in. (9.8 × 2.5 × 5.4 cm)
Charles Edwin Wilbour Fund, 37.405E

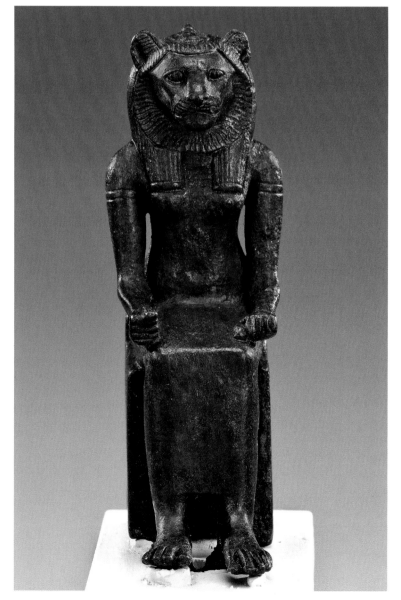

32

mystical duality of fury and care. Although male deities assumed lion shape at times, most lion divinities were female (figure 32). Sakhmet, Bastet, Wadjet, Mut, Shesemtet, Pakhet, Tefnut, and others took the form of a lioness or a lion-headed woman. Many of these goddesses were also closely linked with other animals. The leonine goddesses were daughters of Re, and were connected with the myth of the Eye of the Sun; in one version of this myth, Re sends Sakhmet to slaughter humans, but having changed his mind, Re impedes the slaughter and Sakhmet is transformed into a peaceful cat. The dual role of feline goddesses inextricably links cats and lions, as a myth in the temple of Philae states: "She rages like Sakhmet and is peaceful like Bastet."[16] The powerful protection of leonine goddesses is frequently used in amulets during life and after death.

Antelope

Egyptians attempted to domesticate the antelope (specifically, the gazelle and the oryx) at an early time, when the climate was damper and antelopes roamed the semi-desert regions.[17] The inability to control these relatively small and unaggressive animals may have contributed to the antelope's eventual negative symbolism in Egyptian mythology. As a result, magical and protective objects depict them among the creatures under the control of Horus, conveying the power over all potential evil to the object's user (figures 13, 33).

The multifaceted character seen in many other animals extends to antelopes as well. Despite their largely negative symbolism, their natural grace was observed by the Egyptians, and their image was adopted by minor queens and princesses for adornment and symbolic protection in place of the *uraeus*. A mummified and carefully wrapped gazelle found in a Twenty-second Dynasty royal cache suggests their role as pets. Like cats and monkeys, common images of gazelles under people's chairs may symbolize regeneration.

The goddess Satet, venerated in the form of an antelope in the city of Elephantine and believed to guard the southern border of Egypt, was depicted as a woman with an antelope-horned crown. Satet's name means "She Who Shoots/Pours Out," and her epithet "Mistress of the Water of Life" closely linked her with water. Pyramid Texts describe her as purifying the deceased king. First signs of the inundation were observed annually at Elephantine, the location of Satet's temple. Also associated

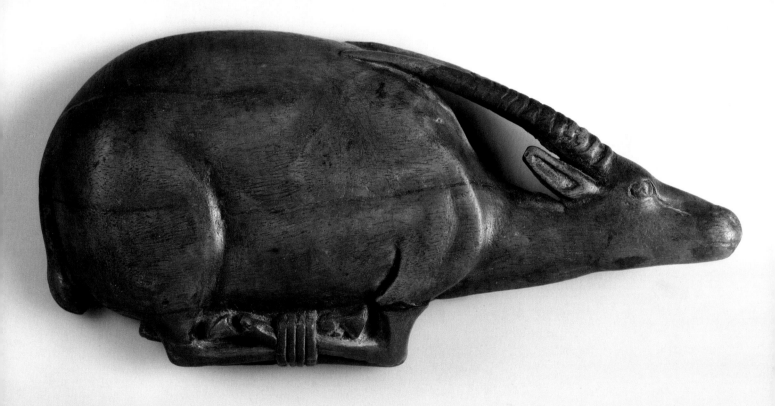

with gazelles was Satet's daughter, the huntress Anuket, whose cult dates back to the Old Kingdom. With her main temple at Elephantine, next to the first Nile cataract, Anuket's festival commenced the annual inundation.

Monkey, Baboon

Mummies of monkeys appear in almost every animal necropolis of the Ptolemaic Period, but it is unclear whether monkeys were ever native to Egypt. If they were, they must have moved south, along with elephants, lions, and other savanna animals, at the end of the Predynastic Period. Monkeys enjoyed great popularity among the Egyptian elite. Records of Hatshepsut's expedition to the south[18] and the tale of the Shipwrecked Sailor[19] describe their importation into pharaonic Egypt from Nubia and Punt. Tomb scenes and stelae dating back to the Fourth Dynasty depict monkeys under people's chairs, suggesting their role as pets. Such images may represent sexuality, as texts indicate monkeys' significance for rebirth. As such, monkeys were at times buried alongside humans. Although scenes of monkeys and baboons performing agricultural tasks have been interpreted as evidence of their service to humans, this theory remains questionable due to the rarity and presumed cost of these animals in ancient Egypt. Satirical depictions on inscribed potsherds and stone flakes, known as ostraca, and on papyri, particularly from the New Kingdom, include monkeys performing such human tasks as playing musical instruments. In mythology, the green monkey represents aspects of sun and moon deities, and accompanies the sun god in Netherworld books. Strangely, no cult of monkeys existed.

Like monkeys, baboons were not native to Egypt during much of the pharaonic period. Excavations yielded baboon burials at Hierakonpolis already in Naqada III, and Early Dynastic votive figurines of *cynocephalus* baboons from Abydos (figure 34). The Egyptians observed baboons getting up on their hind legs and raising their arms every morning to warm their bodies as the sun came up after a cold night. Because the gesture closely resembled that of adoration in Egyptian hieroglyphs, 𓀢, baboons appeared to greet and worship the rising sun each morning, reinforcing their link with the sun and moon.

In the Late, Ptolemaic, and Roman Periods, baboons were equated with Osiris, mummified and carefully buried in catacombs. From the time of Ptolemy I, burials of sacred baboons

33. Bound Oryx Dish
Antelopes' and gazelles' preferred habitat, the dangerous desert edge, accounts for their negative role in Egyptian belief. Images of bound antelopes refer to sacrifices meant to ritually control the marginal areas of the universe.

From Egypt
New Kingdom, Dynasty 18, probably from the reign of Amunhotep III, circa 1390–1352 B.C.E.
Wood
4 3/16 × 8 3/4 in. (10.6 × 22.3 cm)
Charles Edwin Wilbour Fund, 49.54

34

34. Baboon Appliqué
Baboons were deemed important from the
late Predynastic Period onward. Images
of baboons were used as votive offerings
throughout Egyptian history.

Possibly from Saqqara, Egypt
Ptolemaic Period, 305–30 B.C.E.
Linen
5 9/16 × 2 3/16 in. (14.2 × 5.6 cm)
Charles Edwin Wilbour Fund, 37.272E

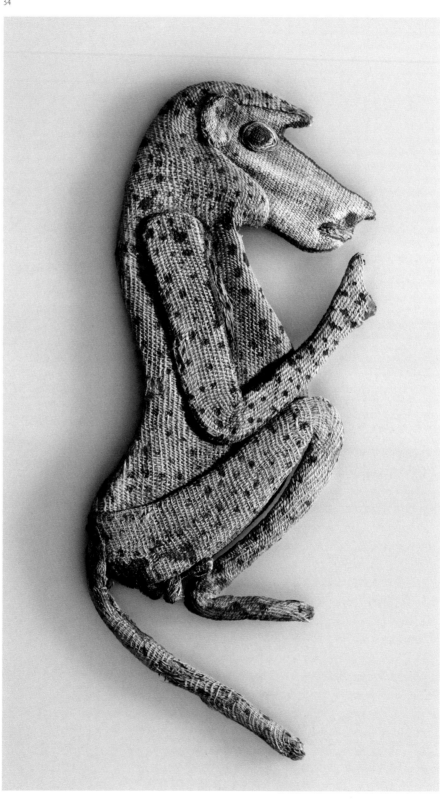

35

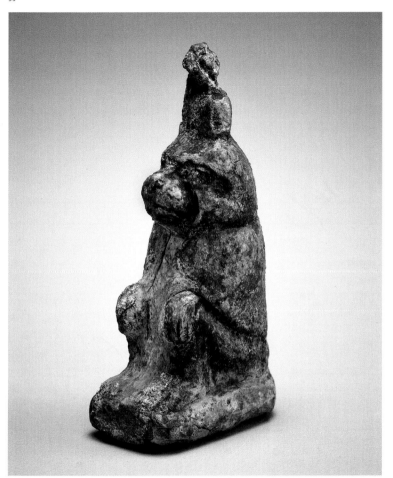

35. *Cynocephalus* Baboon
Baboons were sacred to Thoth, the patron
of writing and knowledge. Scribes used small
figurines of seated baboons as protective
amulets from the earliest times and on into the
Roman era.

From Egypt
Late Period, Dynasty 26 or later, 664–332 B.C.E.
Bronze
2 1/2 × 1 3/8 × 13/16 in. (6.3 × 3.5 × 2 cm)
Charles Edwin Wilbour Fund, 08.480.41

included personal names of each baboon, genealogies, and
dates of birth and death, as well as references to the new god
traveling with the sun god in his boat. "Osiris-baboon" (*wsir-pa-
aan*) was venerated alongside "Osiris-ibis" (*wsir-pa-hb*), another
form of Thoth. Thoth, the purveyor of writing, knowledge, and
recordkeeping, was frequently portrayed as a *cynocephalus*
baboon. The god Hapy, one of the four sons of Horus connected
with mummification, was typically depicted with a baboon
head. The squatting baboon god Hedj-wer ("The Great White
One") represented the king himself for the royal ancestors who
symbolically confirmed the newly appointed king. This deity
occurs in the Early Dynastic Period and the Old Kingdom, but
comes to represent Thoth and the moon god Khonsu thereafter
(figure 35). Thoth records the results of Osiris's judgment of the
dead, and baboons appear in the vicinity of scales, weighing the
deceased's heart in the Book of the Dead, Spell 125.

36. Ichneumon

From *Description de l'Égypte, ou, Recueil des observations et des recherches qui ont été faites en Égypte pendant l'expédition de l'armée française* (Paris: Imprimerie de C.L.F. Panckoucke, 1821–30), book 32: *Histoire naturelle*, vol. 2, pl. 6, no. 1. Brooklyn Museum Libraries—Special Collections; Wilbour Library of Egyptology

37. King and Ichneumon

In this image, the king originally held an offering for the oversized ichneumon. The animal's ability to fight snakes closely linked it with such solar deities as Atum and Horus.

From Egypt
Late Period, Dynasty 26 to Dynasty 31, 664–332 B.C.E.
Bronze
2 9/16 × 4 1/8 × 4 3/4 in. (6.5 × 10.5 × 12 cm)
Charles Edwin Wilbour Fund, 76.105.2

36

Baboons' aggressive nature places them as guardians of the Netherworld Lake of Fire, where the sun regenerates daily. The Book of the Dead, Spell 126, describes them as those "who judge between the needy and the rich, who gladden the gods with the scorching breath of their mouths, who give divine offerings to the gods and mortuary offerings to the blessed spirits, who live on truth and sip of truth, who lie not and whose abomination is evil." Their temperament is reflected in the hieroglyph "to be furious," representing a baboon with a raised tail, 🐒. The largely negative divinities like Seth and Apep at times assume baboon forms.

Ichneumon, Shrew

A large type of mongoose common in Africa, the ichneumon (*Herpestes ichneumon*; figure 36) is represented in Egyptian art from the Old Kingdom onward. Venerated for its ability to kill snakes, the ichneumon was related to Horus and Atum, among others, and worshipped throughout the country (figure 37); in fighting the divine serpent Apep, the sun god is said to have taken the form of an ichneumon with a sun disk surmounting its head. The normally feline goddess Mafdet, venerated for her power over snakes and scorpions, at times assumed the form of a mongoose; Mafdet protected the deceased from snake bites in the

37

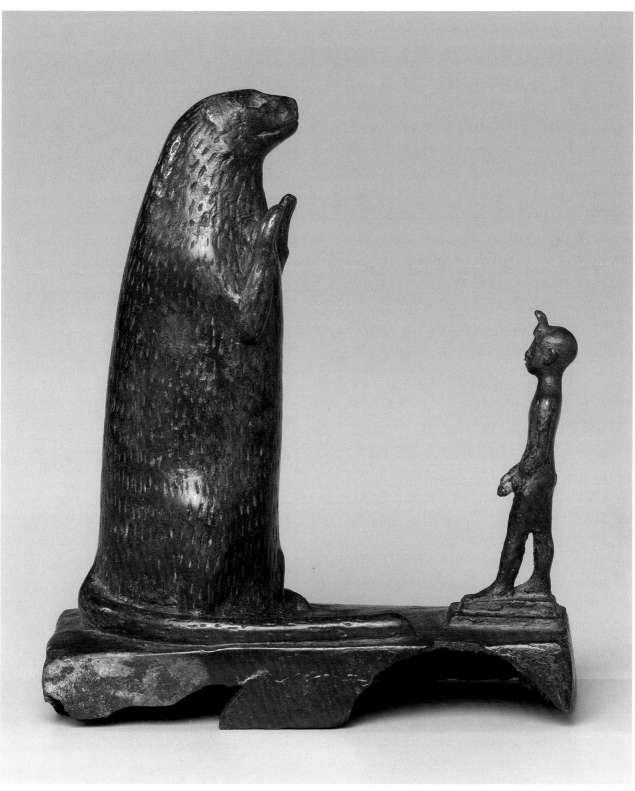

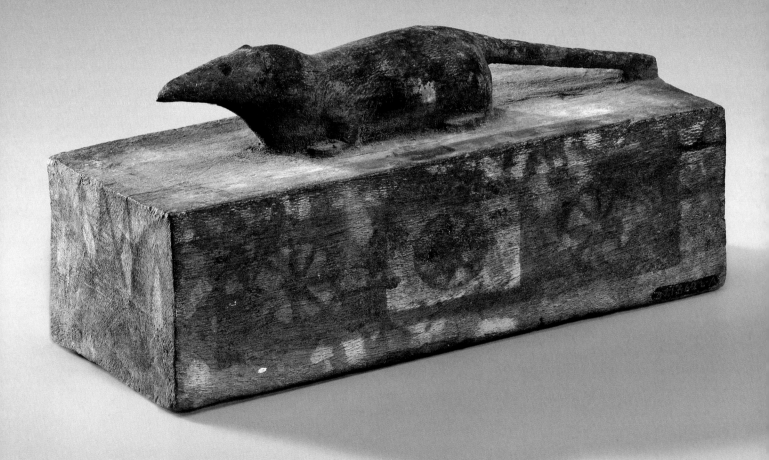

39

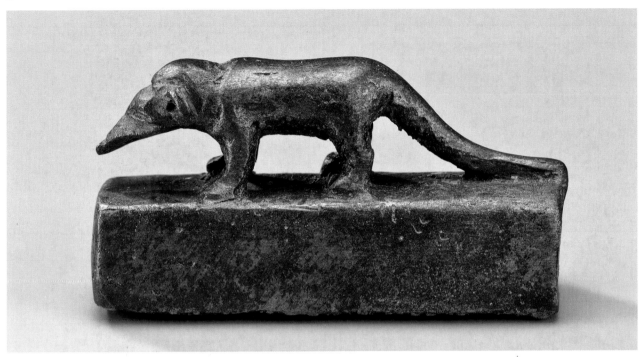

Book of the Dead, Spell 149, by beheading venomous snakes in the seventh mound of the Netherworld.

The shrew, a mouse-size nocturnal mammal, substituted for ichneumons in Egyptian myth (figures 38, 39). Believed to have vision in both light and darkness, the god Horus Khenty-irty of Letopolis was represented by the wide-eyed type of ichneumon and the shrew, respectively. Shrews appear as the focus of worship particularly in the Late Period.

Duck, Goose

Indigenous and migratory birds were plentiful in the Nile valley. Waterfowl that appeared in Egypt during the annual migration brought together the elements of water and sky. Several religious texts imply that stars turned into fish in the waters of Nun, and flew up to the sky as birds. Tomb scenes depicted ducks being netted, consumed at banquets, and offered to the deceased. Appropriately, ducks are an example of mummified food offerings. Geese, on the other hand, were closely associated with important gods like Geb and Amun, who was referred to by the epithet "Great Gander." (Compare this with the lowly sparrow, ⟲, adopted as the hieroglyph for words like "small" and "bad," the latter most likely because they ate the grain planted in the fields.)

38. **Shrew Coffin with Mummy**
Reportedly from Saqqara, Egypt
Late Period or later, Dynasty 26 or later, 664–332 B.C.E.
Wood, paint, animal remains, linen
3 1/4 × 6 3/4 × 2 5/8 in. (8.3 × 17.1 × 6.7 cm)
Charles Edwin Wilbour Fund, 37.1362Ea-b

39. **Shrew Coffin**
The god Khenty-irty, whose name means "Prominent of Eyes," was believed to have vision both in the light of day and in darkness. The shrew could represent the nocturnal aspect of this deity.

From Lower Egypt
Late Period to Ptolemaic Period, Dynasty 26 or later, 664–30 B.C.E.
Bronze
1 5/16 × 2 1/2 × 11/16 in. (3.3 × 6.3 × 1.8 cm)
Charles Edwin Wilbour Fund, 37.410Ea-b

40

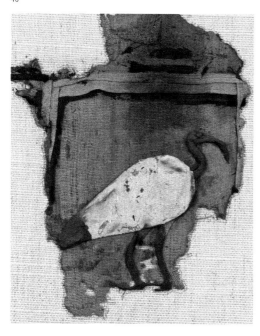

41

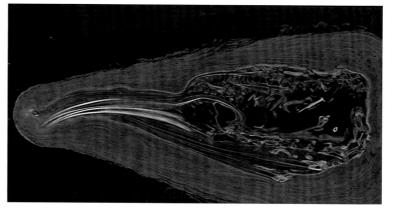

40. Ibis Appliqué
One myth describes the sun god emerging from
a sacred ibis egg in Hermopolis Magna during
creation.

From Abydos, Egypt
Early Roman Period, 30 B.C.E.–early 1st century C.E.
Linen, limestone paste
6 ¹¹/₁₆ × 5 ¹¹/₁₆ in. (17 × 14.4 cm)
Gift of the Egypt Exploration Fund, 14.657

41. Ibis Mummy (CT scan)
Through the research for this book, the tools
of modern technology, such as X-rays and CT
scans, provide new ways of understanding animal
mummies as physical objects. This CT scan, for
example, reveals the actual ibis body within the
mummy wrappings, its beak evoking the shape of
the crescent moon. For an exterior image of this
mummy, see figure 72. The essay by Lisa Bruno, later
in this volume, explores the use of medical imaging
in more detail.

Ibis

There were several species of ibis in Egypt. The most commonly
known "sacred ibis" (*Threskiornis aethiopicus*), with a white body,
black neck, legs, and wingtips, and a dark bill, disappeared from
Egypt by the middle of the nineteenth century C.E. (figure 40).
This is the species mummified in huge numbers in the Late,
Ptolemaic, and Roman Periods.

Although ibises generally feed on crustaceans, fish, and
small mammals, the Egyptians saw them as destroyers of snakes.
This identified the bird with the sun god and his constant battle
with the serpent Apep. The archive of the priest named Hor
explicitly refers to ibises, bred and embalmed in the Saqqara
temple, as "The Ibis, The God and the Soul of Thoth." Thoth's
importance to writing and knowledge is reflected in his association
with the moon, because lunar phases were recorded for calendric
purposes from the beginning of writing. Similarly, the ibis's beak
evoked the shapes of both the reed pen and the long curve of
the crescent moon (figure 41). The Book of the Dead frequently
depicts the ibis-headed god recording the "Weighing of the Heart"
scene, and Pyramid Text 359 describes Thoth ferrying gods to the
Netherworld on his wing. The ibis's connection to Thoth closely
linked it to other patrons of knowledge and creativity, like Imhotep,
Ptah, and Osiris.[20]

The so-called "glossy ibis" (*Plegadis falcinellus*), named
for the bronze hue of its feathers, was generally depicted in black.
Both sacred and glossy ibises are represented in tomb reliefs
dating back to the Old Kingdom. The "hermit" or "crested ibis"
(*Geronticus eremita;* spelled as *akh* in ancient Egyptian), with a
ruff of feathers on the back of its neck, is not very common in river
scenes because it is not a waterside bird. The hieroglyph of this

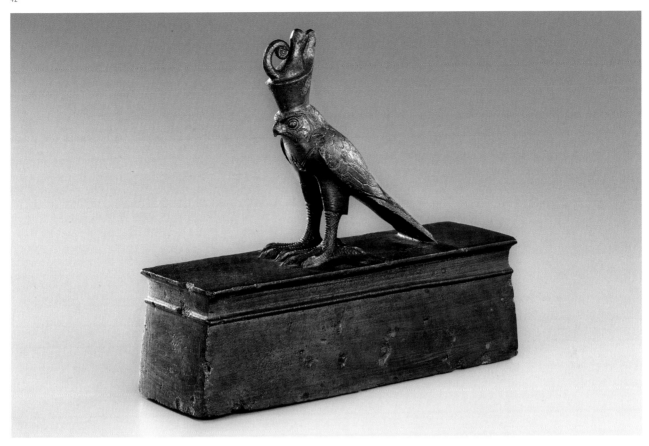

bird, 𓅓, represents a variety of words, meaning "to shine," "be effective," and "blessed dead."

Falcon

Scientific analysis of animal mummies, such as X-rays and CT scans, suggests that Egyptians did not distinguish between most species of raptors. Several different species of birds of prey were mummified and interred as the *ba* of Horus (a god represented as a hawk or a hawk-headed human) in the Late, Ptolemaic, and Roman Periods (figure 42).

Falcons are rarely represented in early Predynastic art, but one of the most prominent Predynastic cities, Hierakonpolis, became the cult center of the god Horus. In myth, Horus was the son of Osiris, who inherited Egypt's throne as king of the gods. Representations of falcons stretching their wings around the pharaoh show their role as the symbol and protector of the pharaoh. In life, the pharaoh was identified with the falcon (see figure 18), and after death his *ba* flew up in the form of a falcon. The *ba* of a non-royal human was also depicted as a human-headed falcon.

The keen sight and ability to soar higher than other species made this bird into a prominent solar symbol and closely linked it to the sky. The wings of the sun god in the form of a falcon represented the sky, while its eyes were the sun and

42. Falcon Coffin
The falcon god Horus became the first legitimate heir to Egypt's throne after he defeated his uncle Seth and avenged the death of his father, Osiris.

Possibly from Saqqara, Egypt
Late Period, Dynasty 26 to Dynasty 31, 664–332 B.C.E.
Bronze, linen, animal remains
7 3/16 × 6 5/16 × 2 1/8 in. (18.3 × 16.1 × 5.4 cm),
Charles Edwin Wilbour Fund, 37.416Ea–b

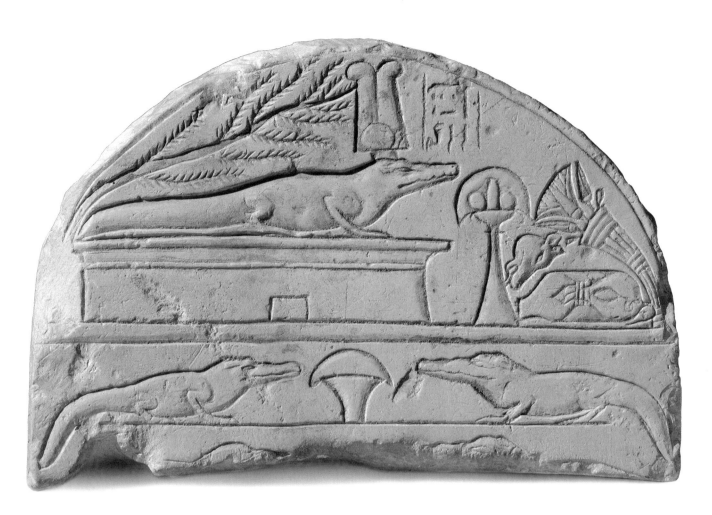

43

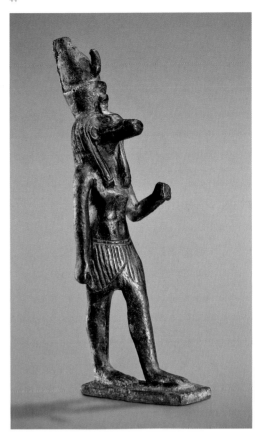

moon. The falcon worshipped at Philae had the epithet "Living Soul of Re," while the Archive of Hor gives falcons such epithets as "*Ba* of Osiris, Horus, Isis, Ptah, Apis, Pre, Shu, Tefnut, Geb, Nephthys." Horus's mother, Isis, is also represented as a female falcon or a woman with falcon wings. She and Nephthys are referred to as great kites (*Elanus*). Also sacred to the gods Sokar, Sopdu, Montu, and Hathor, the falcon perched on a staff, 𓅆, became the hieroglyph representing the notion of divinity.

Crocodile

To the Egyptian mind, the amphibious and nocturnal nature of the crocodile linked it to the primeval state of being, described in Egyptian mythology as a dark and watery expanse. The menace of this creature is attested from the Old Kingdom. The Book of the Dead, Spell 31, is titled "Spell for Repulsing a Crocodile...," and spells in the Harris Papyrus[21] (a New Kingdom document recording hymns, magical spells, and invocations) are intended to keep crocodiles away. Images of men spearing crocodiles appear in representations of constellations in New Kingdom tombs. As an aggressive inhabitant of marshy regions of the Bahr Youssuf branch of the Nile, leading up to the Fayum, the crocodile was venerated as offspring of the annual inundation and the god of primeval watery Nun.

Already in the Early Dynastic Period, the crocodile god Sobek became an important symbol of the Nile's fertility as well as of danger and destruction. His earliest attested cult was located near the modern lake Birket Qarun in the Fayum, the "Lake of Sobek" in ancient Egyptian. This large, powerful animal represented royal power, and the deceased king equated himself with Sobek in Pyramid Text 317. Depicted either as a crocodile or a crocodile-headed human (figure 43), Sobek became widely popular in the Middle Kingdom, figuring in such royal names as Sobekhotep ("Sobek Is Satisfied") of the Thirteenth Dynasty. Unlike most deities in the Egyptian pantheon, no myth providing Sobek with a specific role, family, or emotion is attested. Only his associations with the sun god, the Nile, and Osiris provide prominent characteristics for this god (figure 44).

Although they were worshipped in many localities, temples of crocodile gods were generally situated in marshy areas, their natural habitat, and included pools where actual crocodiles lived. At the main temple of Shedet, later called Crocodilopolis, sacred crocodiles were mummified and displayed in temple shrines or carried in processions.

43. Crocodile Stela
The double-plumed crown and sun disk on the head of the crocodile seated on the shrine identify him as the god Sobek or Sobek-Re, with his earthly manifestations shown on the lower register.

Possibly from Dahamsha, Egypt
New Kingdom, Dynasty 19 to Dynasty 20, circa 1292–1075 B.C.E.
Limestone
6 1/2 × 9 11/16 × 2 5/8 in. (16.5 × 24.6 × 6.7 cm)
Charles Edwin Wilbour Fund, 67.174

44. Sobek
The god Sobek was most commonly depicted with a crocodile head and human body. However, the gods Geb, Hathor, Horus, Khnum, Osiris, Re, and Seth also assumed crocodile form at times.

From Egypt
Late Period to Ptolemaic Period, Dynasty 26 or later, 664–30 B.C.E.
Bronze
4 1/2 × 11/16 × 1 5/8 in. (11.4 × 1.7 × 4.1 cm)
Charles Edwin Wilbour Fund, 08.480.37

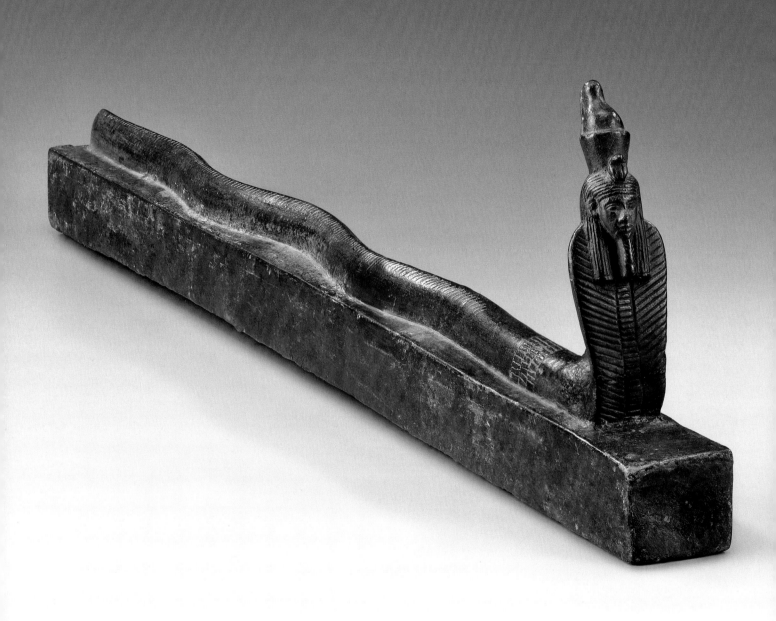

Snake, Lizard

Like many cultures, Egyptians saw serpents as creatures of the earth that embody primeval, chthonic qualities, involved in the process of creation. Because many snakes inhabit marshes, they were closely linked to water and the primeval ocean of Nun. The god Atum was said to swim in Nun as a snake before creation (figure 45). According to a creation myth from the city of Hermopolis, four female deities with snake heads were among a group that initiated creation. Many deities take the form of snakes; the Middle Kingdom tale of the Shipwrecked Sailor describes an unidentified divine serpent who helps the main character. A religious text, known as the Book of the Heavenly Cow, suggests that *ba*'s of all gods may live as snakes. Attested in the Eighteenth Dynasty, the *ouroboros* snake, whose body encircled the universe, represented renewal and rebirth; the regeneration of the sun god was believed to occur nightly inside its body. Another primeval creature, the snake god Nehebkau, guarded Re, the dead king, and gates of the Netherworld. When invoked in magical spells, Nehebkau protected people from poisonous bites.

Egyptians were well aware of both the snake's usefulness in controlling vermin and the dangers posed by its poison. Texts like the Brooklyn Snakebite Papyrus[22] (a collection of medical and magical remedies for victims of snakebites based on snake type or symptoms) include remedies and magical spells to cure the bitten. Snake deities were worshipped in hopes of preventing potential attacks by their earthly representatives. The serpent goddesses Renenutet and Meretseger prevented, and cured, snakebites, turning snakes' destructive power into protection. Attested from the Old Kingdom, the name Renenutet means "One Who Nurses," leading to her association with agricultural fertility. Meretseger, "The One Who Loves Silence," personified the mountain above the Valley of the Kings, protecting the Netherworld entrance and deceased rulers (see figure 7). She was also worshipped in a domestic setting in the nearby workmen's village.

Usually represented as a rearing cobra, Wadjet was worshipped from the Predynastic Period. Wadjet was also identified as the Eye of Re, depicted as a feline-headed woman with a sun disk. As a symbol for Lower Egypt, her name means "Green One" or "She of Papyrus." Together with the vulture goddess Nekhbet, who represented Upper Egypt, she signified the

45. Snake Coffin
A human-headed, crowned cobra represents the creator god, Atum, who was believed to swim in the chaotic waters of Nun before creation.

From Egypt
Late Period to Ptolemaic Period, Dynasty 26 or later, 664–30 B.C.E.
Bronze
5 11/16 × 1 9/16 × 22 1/16 in. (14.4 × 3.9 × 56 cm)
Charles Edwin Wilbour Fund, 36.624

46

47

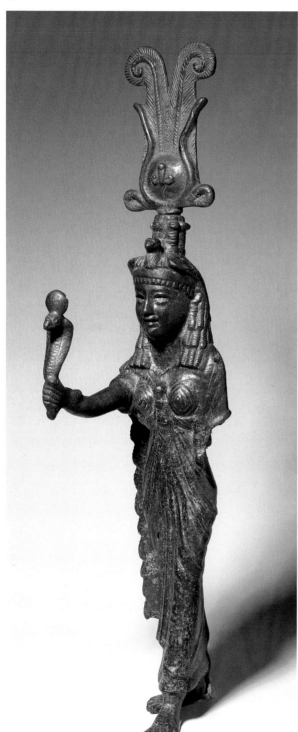

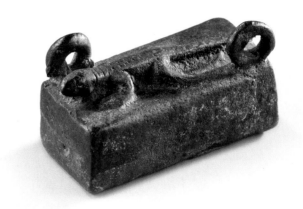

46. Isis
The great magician goddess Isis holds a cobra representing Wadjet, who guards its owner by spitting fire at all enemies. Wadjet's epithet, "Great of Magic," connects serpents with supernatural practices.

From Egypt
Roman Period, probably 1st century c.e.
Bronze
14 ⁷/₁₆ × 2 ¹¹/₁₆ × 2 ¹³/₁₆ in. (36.6 × 6.9 × 7.2 cm)
Charles Edwin Wilbour Fund, 05.395

47. Lizard Coffin
Because of the ability of some species to regrow severed limbs and tails, lizards likely symbolized multitude and regeneration.

From Egypt
Late Period to Ptolemaic Period, Dynasty 26 or later, 664–30 b.c.e.
Bronze
1 ⁷/₁₆ × 1 × 2 ¹/₁₆ in. (3.6 × 2.5 × 5.2 cm)
Charles Edwin Wilbour Fund, 08.480.60

duality of the Egyptian worldview. Wadjet became the *uraeus*, the coiled cobra on the brow of the king, protecting him by spitting fire against his enemies (figure 46).

The serpent Apep, the principal enemy of universal order, and of Re in his journey through the Netherworld, incarnated the dangerous qualities of snakes. As a creature of the earth and darkness, Apep symbolized chaos and evil.

Commonly mummified in the Late, Ptolemaic, and Roman Periods, lizards did not play much of a role in earlier culture (figure 47). The hieroglyph 🏷️ represents the term "numerous," implying the abundance of these creatures in ancient Egypt. Lizards were typically included among the malevolent, marginal creatures controlled by Horus and depicted on magical stelae, known as *cippi* (see figure 13).

Fish

A late New Kingdom fish cemetery at Mendes is one of the first examples of the phenomenon of mass animal burials. Fish were a great source of food for much of Egypt's population (figure 48). Tomb scenes depict nets and traps gathering fish, while hooks and harpoons are attested from the Neolithic age onward. The Book of the Dead, Spell 153, prevents the deceased from being caught in a trawling net. Elite estates frequently included fishponds for embellishment and as a food source. Fish appear on the menus of royal tomb workers of the Valley of the Kings and of low-ranking temple officials. But due to negative mythological associations, fish were taboo for royalty and high-ranking priests. Fish's watery

48. Schilbe Fish of Hatmehit
The Delta goddess, Hatmehit, whose name means "Chief of the Fishes," was venerated in the form of a schilbe fish or a woman with a fish emblem.

From Egypt
Ptolemaic Period to early Roman Period, Dynasty 26 or later, 664–30 B.C.E.
Bronze
1 5/16 × 2 11/16 in. (3.3 × 6.8 cm)
Charles Edwin Wilbour Fund, 05.573

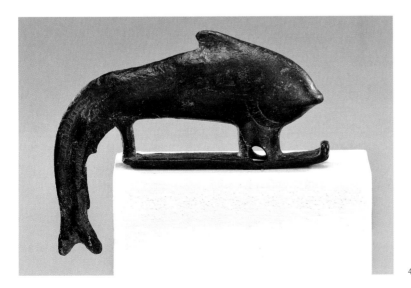

48

49

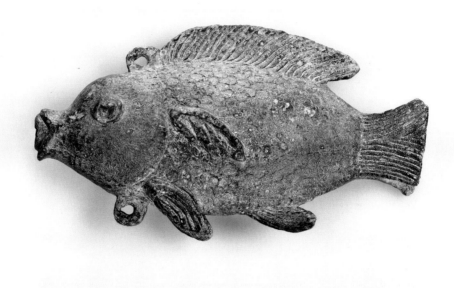

50

habitat naturally associated them with the primeval ocean of Nun, a chaotic force that should be controlled. In his rendering of one Egyptian myth, Plutarch explained that as Seth killed and dismembered his brother, Osiris, and threw his body in the Nile, three species of Nile fish (Nile carp [or *Lepidotus*], *Oxyrhynchus*, and *Phagrus*) fed on Osiris's phallus. The Kushite king Piye refused to meet most Lower Egyptian princes who came to submit: "They could not enter the palace because they were uncircumcised and were eaters of fish, which is an abomination to the palace."[23] Nevertheless, the *Oxyrhynchus* fish became sacred in a Fayum town by the same name, where it was believed to have originated from the wounds of the murdered god. The goddess Neith, venerated at Esna, took the shape of the Nile perch (*Lates*), and swam in Nun. Because of this, the inhabitants of Esna (later called Latopolis) did not eat the Nile perch.

The tilapia is distinctive for carrying fertilized eggs in its mouth until the young hatch to be released, protected and fully developed (figures 49, 50). This feature was associated with the creator god, Atum, and fertility and rebirth, as the young fish appeared to come into existence instantly from its mother's mouth. The bright fins of the tilapia and dark blue fins of the Abdju fish were believed to lead the boat of Re through the Netherworld, and warn him if his adversaries drew near. The sun god himself could swim the primordial waters at night in the form of a fish.

Scarab

Images of scarabs were placed in tombs as early as the fourth millennium B.C.E, and used as official seals and amulets for the living and the dead (figure 51). Egyptians observed young scarab beetles (*Scarabaeus sacer*) emerge from a ball of dung. (A mother scarab lays its eggs in the warm dung for incubation and pushes it around wherever it goes, protecting and nourishing the young. When ready, the eggs hatch from the dung.)

Represented as a scarab from the Old Kingdom, the young sun god Khepri emerged from the darkness of the Netherworld each morning, symbolizing cyclical resurrection. The Egyptian word for scarab also means "to come into being" or "appear." A scarab pushing a spherical object evoked the image of the beetle propelling the sun disk through heaven.

·

The enormous significance of animals in the ancient Egyptians' view of the world is clearly evident from the

49. Tilapia Lamp
The Egyptians honored the tilapia fish for much of pharaonic history because it protectively carries its eggs in its mouth until they hatch.

From Egypt
Late Ptolemaic Period to Roman Period, 100 B.C.E.–200 C.E.
Bronze
3 1/2 × 1 3/4 × 6 1/4 in. (8.9 × 4.4 × 15.9 cm)
Gift of the Ernest Erickson Foundation, Inc., 86.226.12

50. Tilapia
From *Description de l'Égypte: Histoire naturelle*, vol. 2, pl. 18, no. 2.

51. **Heart Scarab of Sheshenq III**
A heart scarab, like this one, typically records
a spell requesting that the heart, the seat of
an individual's consciousness, not bear witness
against the deceased during Osiris's judgment.

Probably from Tanis, Egypt
Third Intermediate Period, Dynasty 22, reign
of Sheshenq III, circa 835/30–783/78 B.C.E.
Stone
3 1/8 × 1 15/16 × 3/4 in. (7.9 × 4.9 × 1.9 cm)
Charles Edwin Wilbour Fund, 61.10

51

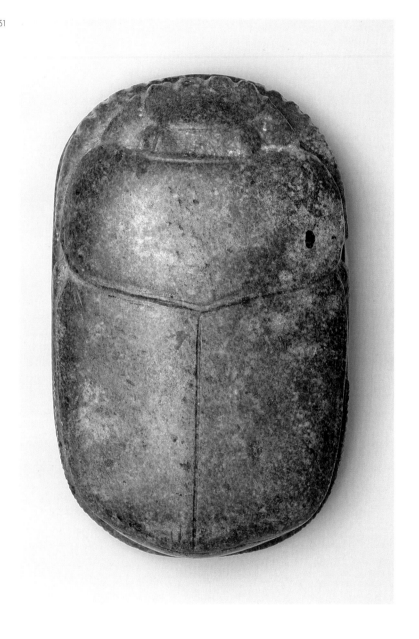

beginnings of their civilization. From Predynastic times, animals were domesticated, kept as pets, and used as food. Closely observing the fauna surrounding them, Egyptians saw animals' power, ferocity, danger, or tenderness as evidence of the divinity of beasts. The complex, multifaceted nature of many animals represented a kind of divine diversity.

From the rise of Egyptian culture, certain sacred animals received their own temple cults. Images of other creatures denoted specific gods or the forces of nature. Figurines of these animals were offered to the gods by worshippers, expressing gratitude and adoration, and conveying messages to the gods. Animals and animal images also took on the supernatural function of oracles, delivering divine messages back to humanity.

These rich pharaonic traditions involving the creatures of the world formed the foundation for the vast development of animal cults and animal mummification in the Late, Ptolemaic, and Roman Periods. The nature and purpose of those later cults is the subject of the next essay, by Edward Bleiberg.

Notes

1 Inscription of Amenhotep III, dated to year 30, tomb of Kheruef; see Epigraphic Survey in cooperation with the Department of Antiquities of Egypt, *The Tomb of Kheruef: Theban Tomb 192* (Chicago: University of Chicago Press, 1980), p. 43; and Wolfgang Helck, *Urkunden der 18. Dynastie: Historische Inschriften Amenophis' III*, vol. 4 (Berlin: Akademie Verlag, 1957), p. 1867, lines 15–16.

2 Some myths describe the sun's cycle, rising at dawn and setting in the evening, as the sky goddess Nut's swallowing the sun every evening and giving birth to him every morning.

3 John Taylor, *Death and the Afterlife in Ancient Egypt* (Chicago: University of Chicago Press, 2001), p. 246. Renée Friedman, "Hierakonpolis," in Diana Craig Patch et al., *Dawn of Egyptian Art* (New York: The Metropolitan Museum of Art; New Haven, Conn.: distributed by Yale University Press, 2012), pp. 53 and 87, describes the remains of at least fifty-eight animals buried whole and unbutchered in Tomb 16's mortuary compound at Hk6. Among these, an elephant was ritually interred in large amounts of linen; see Renée

Friedman, "Elephants at Hierakonpolis," in S. Hendrickx et al., *Egypt at Its Origins: Studies in Memory of Barbara Adams; Proceedings of the International Conference "Origin of the State, Predynastic and Early Dynastic Egypt," Krakow, 28th August–1st September 2002* (Leuven, Belgium; Dudley, Mass.: Peeters Publishers, 2004), pp. 131–68; and Joseph Majer, "Elephant Hunting at Hierakonpolis," *Nekhen News* 21 (2009), PDF at *www.hierakonpolis-online.org*, p. 89.

4 Miriam Lichtheim, *Ancient Egyptian Literature: A Book of Readings*, 3 vols. (Berkeley: University of California Press, 1973–80), vol. 2 (1976), p. 90.

5 While animal burials in human cemeteries appear to be connected with mortuary beliefs, Predynastic temples function differently by including animals sacrificed for ritual purposes; see Diane Victoria Flores, "Funerary Sacrifice of Animals in the Egyptian Predynastic Period," in Hendrickx, *Egypt at Its Origins*, pp. 731–52.

6 Taylor, *Death and the Afterlife in Ancient Egypt*, p. 246.

7 Translation based on *The Ancient Egyptian Pyramid Texts*, trans. and with an introduction and notes by James P. Allen, ed. Peter Der Manuelian (Atlanta, Ga.: Society of Biblical Literature, 2005), p. 57. The numbering of the Pyramid Texts here and below is based on Kurt Sethe, *Die Altaegyptischen Pyramidentexte nach den Papierabdrücken und Photographien des Berliner Museums* (Leipzig: J.C. Hinrichs'sche Buchhandlung, 1908–22).

8 Aidan Dodson, "Bull Cults," in Salima Ikram, ed., *Divine Creatures: Animal Mummies in Ancient Egypt* (Cairo and New York: American University in Cairo Press, 2005), pp. 72–74.

9 Herodotus, Book 3, line 28; see *Herodotus: The Histories*, trans. Robin Waterfield (Oxford and New York: Oxford University Press, 1998), p. 181.

10 Paul T. Nicholson, "The Sacred Animal Necropolis at North Saqqara: The Cults and Their Catacombs," in Ikram, ed., *Divine Creatures*, pp. 45–46.

11 Ibid., p. 48. Dodson, "Bull Cults," pp. 72, 89.

12 Dodson, "Bull Cults," pp. 92–95.

13 Unfortunately, these catacombs have not yet been located; William J. Murnane and Charles C. van Siclen III, *The Boundary Stelae of Akhenaten* (London and New York: Kegan Paul International; New York: distributed by Routledge, Chapman & Hall, 1993), pp. 41, 169.

14 Dodson, "Bull Cults," pp. 95–96. Robert Mond and Oliver H. Myers, *The Bucheum*, 3 vols. (London: Egypt Exploration Society, 1934), vol. 2, p. 27.

15 For instance, the Merhu bull ("The Anointed One") became identified with an Old Kingdom princess; also attested are the Bata bull of Cynopolis, the Kemwer bull of Athribis, and the Hesbu bull in the 11th Upper Egyptian Nome, among others.

16 From the Myth of the Solar Eye recorded in the Philae temple.

17 A good overview is presented in Åsa Strandberg, *The Gazelle in Ancient Egyptian Art: Image and Meaning* (Uppsala: Uppsala University Press, 2009).

18 Hatshepsut's expedition is recorded on the walls of her mortuary temple at Deir el-Bahri.

19 Lichtheim, *Ancient Egyptian Literature*, vol. 1 (1973), pp. 211–15.

20 According to some myths, the sun god magically appeared from a sacred ibis egg in Hermopolis Magna; Sue Davis and H.S. Smith, *The Sacred Animal Necropolis at North Saqqara: The Falcon Complex and Catacomb; The Archaeological Report* (London: Egypt Exploration Society, 2005), p. 55.

21 The Harris Magical Papyrus, British Museum EA 10042; see Christian Leitz, *Magical and Medical Papyri of the New Kingdom* (London: British Museum Press, 1999), pp. 31–51; especially Part II (VI, 10–IX, 14) of the papyrus.

22 Papyrus Brooklyn Museum 47.218.48/85; see Serge Sauneron, *Un traité égyptien d'ophiologie: papyrus du Brooklyn Museum no 47.218.48 et .85* (Cairo: Institut Français d'Archéologie Orientale, 1989).

23 Lichtheim, *Ancient Egyptian Literature*, vol. 3 (1980), p. 80.

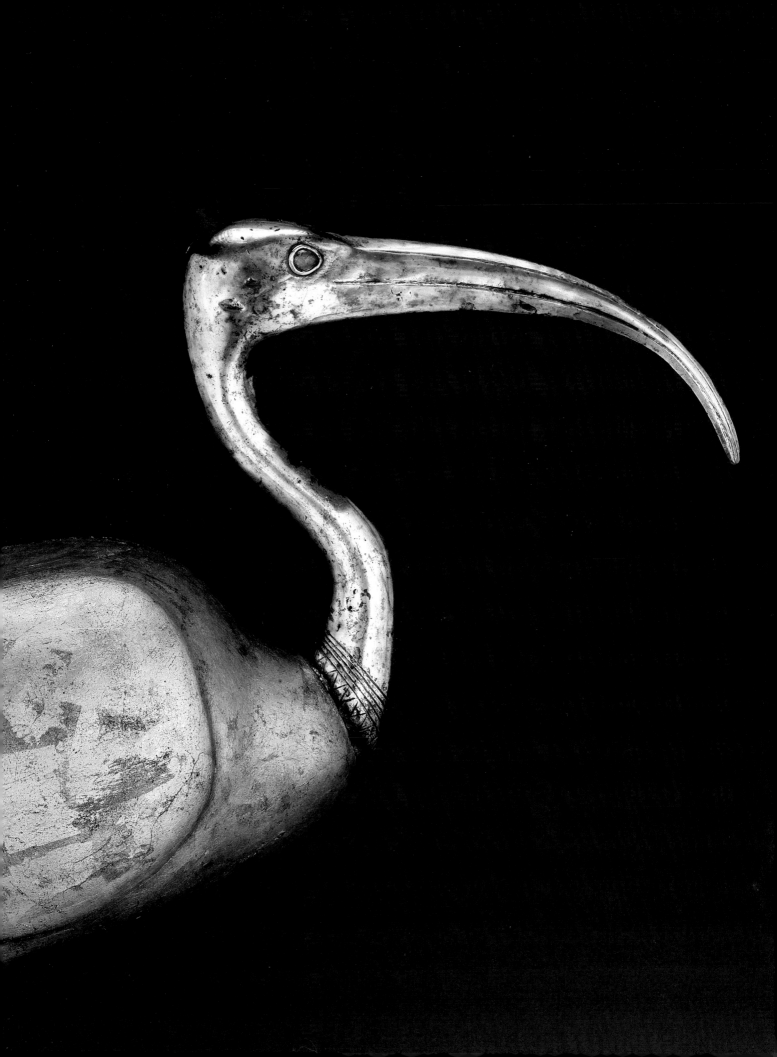

Animal Mummies:
The Souls of the
Gods

EDWARD BLEIBERG

52

The Problem with Animal Mummies

Animal mummies constitute the largest class of objects the ancient Egyptians created. The ibis cemetery in Saqqara alone yielded more than four million individual mummies, while millions more were excavated in Abydos (figure 52). The Saqqara dog cemetery contained seven million mummies, with countless others found throughout Egypt (figure 53). And there are thirty-one known animal mummy cemeteries in Egypt, with perhaps more waiting to be discovered. But as is so often the case with practices they would have found ordinary, the Egyptians apparently never wrote an explanation of the role that animal mummies played in their religion, culture, or society—creating a problem for anyone seeking to understand this widespread phenomenon. Although mummified beasts are the most numerous of Egyptian artifacts, they are among the least well understood of all the objects found in Egyptian collections.

This essay begins to address the problem with animal mummies by briefly reviewing Hebrew, Greek, Roman, and early Christian attitudes toward Egypt's animal cults, suggesting

53

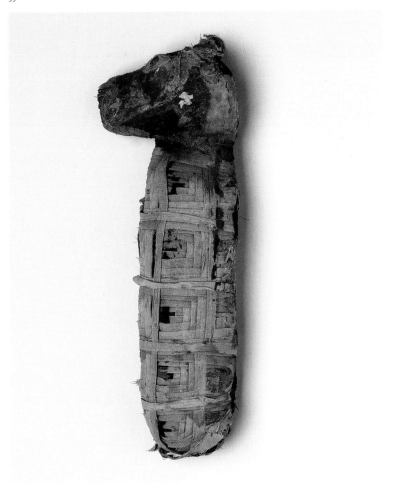

52. **Ibis Mummy**
The ibis was one of the animals associated with Thoth, god of writing and the moon. It was among the most numerous of animals mummified, because of the growth of the cult of Thoth during the first millennium B.C.E.

From the ibis cemetery at Abydos, Egypt
Early Roman Period, 30 B.C.E.–100 C.E.
Animal remains, linen
2 15/16 × 14 3/16 × 4 5/16 in. (7.5 × 36 × 11 cm)
Gift of the Egypt Exploration Fund, 14.652

53. **Dog Mummy**
Dogs, jackals, and canines in general were the soul of the god Wepwawet, god of the necropolis. He led the deceased to Osiris, god of the next world. Some scholars believe that the presence of actual jackals in the cemeteries located at the desert edge led to their association with the god of the necropolis.

From Egypt
Carbon-14 dated to 510–230 B.C.E.
Late Period to Ptolemaic Period, Dynasty 27 or later (525–30 B.C.E.)
Animal remains, linen
3 1/4 × 17 × 5 1/2 in. (8.3 × 43.2 × 14 cm)
Charles Edwin Wilbour Fund, 37.1984E

why we moderns, too, have difficulty understanding this peculiarly ancient Egyptian cultural practice. It then proposes an explanation of just why the Egyptians made votive animal mummies—and found a role for the animals' souls in important rituals. Finally, it explores the social and economic aspects of animal mummy-making, by looking at documents preserved from the ibis sanctuary in Saqqara.

Modern People and Animals

Modern Americans, consciously or not, divide animals into three categories: food sources, workers, and pets. Most Americans living in cities have little contact with the animals that eventually will serve as their food, from ranching, farming, or hunting. And perhaps even fewer interact with work animals, aside from guard or seeing-eye dogs. Most Americans who know an animal also know its name. Because the animal is their pet, they have developed an emotional bond with it and would be horrified by the idea that it could ever become food, or even do any work.

The historian Katherine Grier has written that pets in America are a relatively new phenomenon.[1] The relationship between Americans and their pets is possible only when

54

prosperity allows us to feed an animal who makes no economic contribution to the family's well-being (see figure 6). When examining the Egyptian view of animals, we must remember that our almost exclusively emotional relationship with animals today is a recent development and virtually unique in history. The Egyptians were rarely sentimental about animals, which played a very important role in their worldview.

Speaking of Animals

To understand the Egyptian attitude toward animals, we can examine the words that they used when speaking of them. The presence (or absence) of an Egyptian equivalent to an English word helps us see how the Egyptians organized the world around them into meaningful concepts and categories, which may be different from our own.

As in English, the Egyptians had words for specific types or species of animals, such as cats or dogs. And they named many animal types based on the sound the animal made; the Egyptian word for cat sounds like *me-yu,* very close to the English "meow," and means "the one who meows." Other animal names based on sound include *yu-yu* ("dog"), *a-a* ("donkey"), and *ru* ("lion"), a sound not so far from the English *roar.* The Egyptians also had words (and thus categories) for cattle, birds, fish, and snakes.

Yet despite these individual species names—and even though animals dominated Egyptian symbolism, writing (figure 54), religion (figure 55), and art—for millennia the Egyptians actually had no word meaning "animal" as a general category.[2]

54. Hieroglyphic Inscription
Egyptian writing incorporates 176 signs based on whole mammals, birds, amphibians, reptiles, fishes, insects, and various parts of these animals. For more on the use of the baboon, sparrow, ibis, falcon, and lizard in hieroglyphs, see the essay by Yekaterina Barbash.

From Lisht, Egypt
Middle Kingdom, Dynasty 12, Reign of
Senwosret II, circa 1844–1835 B.C.E.
Limestone
11 1/4 × 16 1/8 in. (28.5 × 41 cm)
Museum Collection Fund, 14.667

55. Mating Hippopotami
Animal symbols such as mating hippopotami first appear in the Predynastic Period and continue in use throughout Egyptian history. Mating hippopotami represented fertility in general, leading to the notion that the female hippopotamus goddess Taweret protects pregnant women.

From Egypt
Late Period to Ptolemaic Period, Dynasty 26 or later, 664–30 B.C.E.
Limestone
5 1/2 × 3 9/16 × 10 3/8 in. (14 × 9 × 26.3 cm)
Charles Edwin Wilbour Fund, 36.262

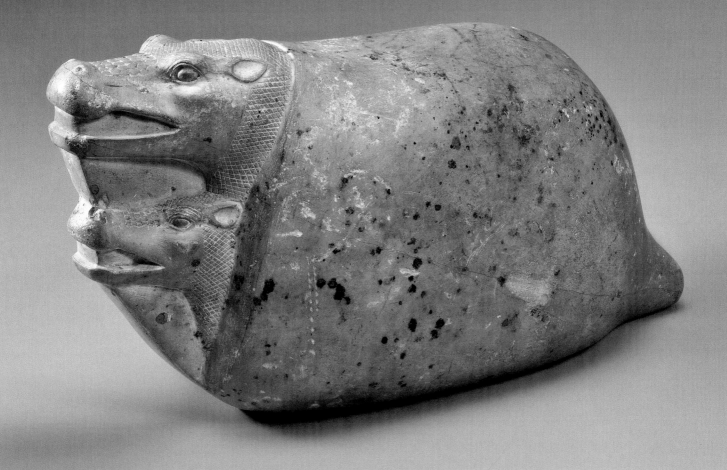

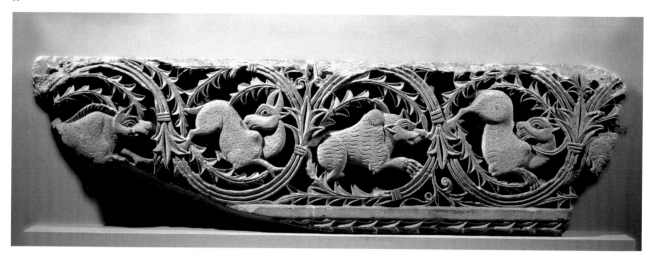

56. *Frieze of Animals in Plant Scroll*
In Late Antiquity, when many Egyptians had
converted to Christianity, representations of
animals in art remained popular. Unlike their pagan
ancestors, however, Egyptian Christians regarded
animals as without souls.

From Hierakonpolis Magna, Egypt
Roman and Byzantine Periods, 4th century C.E.
Limestone, paint
14 3/8 × 50 3/16 × 4 5/16 in (36.5 × 127.5 × 11.7 cm)
Charles Edwin Wilbour Fund, 41.1266

It was not until their language began to accommodate Christian
views of the universe, in the first century C.E., that it developed
a word for animals in general. (That word was the Greek import
therion, which refers to wild animals; figure 56.) Indeed, the
ancient Egyptians lacked such a word for so long in part because
they did not consider the animal world in general to be an entirely
separate category unto itself. Rather, they regarded animals as
living creatures—just as humans were living creatures—fashioned
by the gods. Moreover, they held a view that was unique among
the peoples of the ancient Mediterranean world: they did not
regard animals as inferior to humans.

Not only were they not inferior, but also some animals,
the Egyptians believed, either were or contained a *ba,* a part of
the soul that is active in this world and the spiritual world. They
believed that animals had—or actually were—souls, whether alive
or dead. Animals could also become gods, through death and
mummification, just as humans could become divine through
the same sequence. In fact, one of the words used for an animal
mummy—*netjer*—was the equivalent of "god." Or, more specifically,
a deceased animal could "become Osiris" and achieve immortality,
also the hope for humans after death. In this respect, too,
Egyptians' beliefs differed markedly from those of their immediate
Mediterranean neighbors, the Hebrews, the Greeks, and the
Romans, who all regarded animals not only as subject to human
will but also as beings without a soul. The view that animals were
soul-less was passed from Judaism and the Greek and Roman world
to Christianity and, ultimately, to modern Western cultures.

·

Egypt's Mediterranean neighbors took an intense
interest in this ancient culture. Hebrews, Greeks, Romans, and
early Christians all wrote extensively about animal worship
and, to a lesser degree, about animal mummies. Whether they
portrayed Egyptian culture in a negative light, as did Jewish
literature, or in a more positive light, as did the Greeks, none

of Egypt's neighbors took a sympathetic view of animal cults and mummy-making. The scholars of religion K.A.D. Smelik and E.A. Hemelrijk have argued that the worship of animals was one element of a general stereotype about Egyptians held by their neighbors.[3] While Jews regarded animal worship as an abomination, Greeks and Romans, with some exceptions, took a satirical view of it and saw it as either foolish or despicable. Early Christians saw it as sinful.

Jewish Views of Animal Worship

The Torah comments at length on Egyptian culture. In general, the Hebrew text takes a negative view of Egyptian religion. The multiple gods and extensive use of images in their worship stood in direct contradiction to Jewish belief. It is no wonder, then, that the Torah condemns animal worship and mummification as abominations.

Interestingly, two passages in the Torah that discuss "the abomination of the Egyptians" make it plain that the Hebrew writer did not distinguish between particular Egyptian sacred animals—that is, single, individual beasts—and the whole species of rams and bulls in general.

Exodus 7 to 11 narrates the ten plagues that the Torah says God sent against the Egyptians when the pharaoh would not respond to Moses's pleas to let the Hebrews leave Egypt. In Exodus 8:25, the pharaoh falsely claims that he will relent if God will end the fourth plague, flies. He suggests that Moses and Aaron should make a sacrifice to their God so that he will end the plague. Yet Moses resists this solution. In Exodus 8:26, Moses calls the animal sacrifice he would make "the abomination of the Egyptians." Furthermore, if such a sacrifice were made within Egypt, the Egyptians would stone him. The implication here is that the standard Hebrew sacrifice of a ram to God would incite the Egyptians because a ram is one of the animals regularly worshipped in Egypt and then mummified after its death (figure 57). In verse 28, the pharaoh therefore suggests that Moses make the sacrifice in the wilderness outside Egypt. Moses agrees, but ultimately there are six additional plagues before the pharaoh finally lets the Hebrews leave.

Moses's claim that the ram he must sacrifice is "the abomination of the Egyptians"—that is, the ram which the Egyptians believe is divine—shows a common misunderstanding among non-Egyptians of the Egyptians' relationship to animals. Not all rams

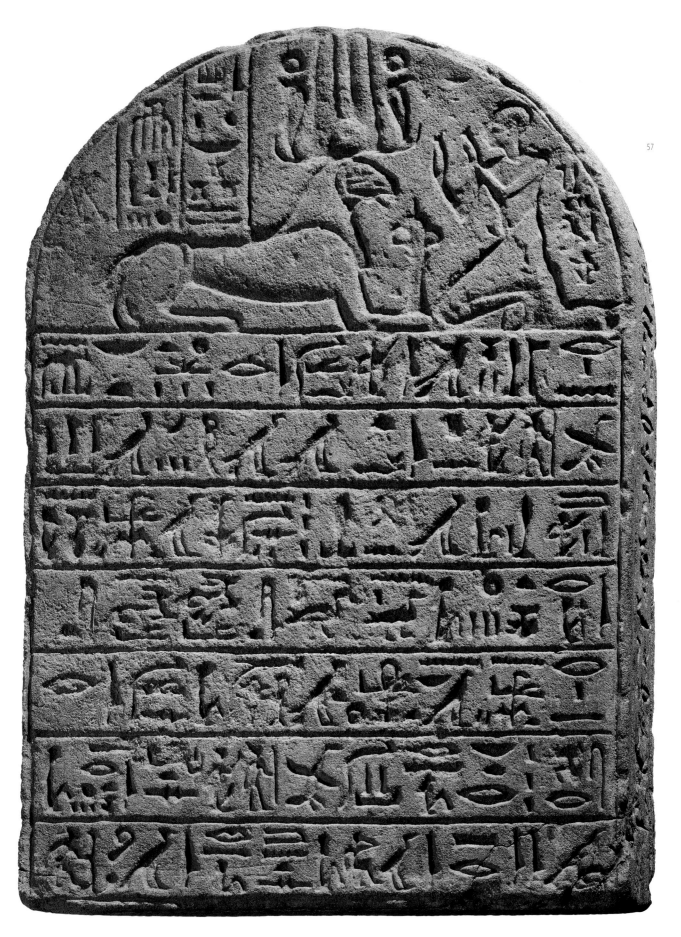

57

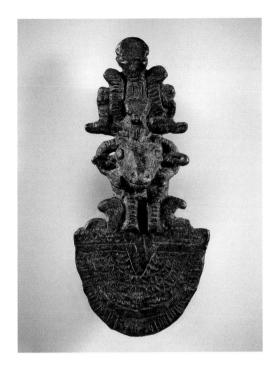

58

were divine, and the Egyptians themselves were able to slaughter, cook, and eat many of the beasts from the various species that contained certain divine animals. Only particular, singular bulls, rams, or crocodiles, among members of other species, had the special markings that made them the incarnation of a god. Regardless of this distinction, however, the real problem for Moses and subsequent Jewish commentators on Egyptian practices is that attributing divinity to *any* animal was to them an "abomination."

This aspect of Moses's meaning is clear in the Aramaic translation of the Hebrew Bible called Targum Yerushalmi. This same passage, translated into Aramaic, has Moses say, "It will not be right to do so, because we shall take lambs, which are the idols of the Egyptians, and offer them before the Lord our God. Behold, if we offer the idols of the Egyptians before them, they would stone us with stones as an act of justice." Even though the Aramaic refers to lambs rather than adult rams, the equation here is clear: the "abomination of the Egyptians" in the original Hebrew text means the lambs that are idols, the false gods of the Egyptians (figure 58).

Similarly, the story of Joseph's meeting with his brothers, recounted in Genesis 43:32, reveals another Hebrew interpretation of the "abomination of the Egyptians." After their initial meeting, Joseph, who appears to his brothers as an Egyptian high official, arranges a meal for them separate from his own meal. The original Hebrew text states: "And they set [the meal] for him by himself, and for them by themselves, and for the Egyptians, that did eat with him, by themselves; because the Egyptians might not eat bread with the Hebrews; for that is an abomination unto the Egyptians." The later Aramaic translation

60

of this passage, known as Targum Onkelos, renders the verse with this interpretation: "For the Egyptians cannot eat bread with the Hebrews, because the cattle that the Egyptians worship, the Hebrews eat." Here, the word "abomination" in the Hebrew is translated as "the cattle that the Egyptians worship" in the Aramaic, just as, in our earlier Aramaic example, "abomination" meant the attributing of divinity to lambs. Again, this translation of Genesis conflates the individual divine animal with all the animals in the species—a widespread misunderstanding among virtually all non-Egyptians.

Greek Views of Animal Cults
Unlike the Hebrews, Greeks of the fifth century B.C.E. had less direct contact with Egyptians. Their attitudes toward the Egyptians were much less uniform than the overall negative attitude displayed in the Hebrew Bible (figure 59). While Aeschylus, like the other writers of tragedy, described the Egyptians as barbarians, the historian Herodotus took a somewhat more positive view of the Egyptians in general.

Aeschylus exhibits some direct knowledge of Egyptian habits in his play *The Suppliants*. In the play, the Danaids flee a forced marriage to their Egyptian cousins. The Egyptians are described as crocodiles, beer drinkers, and papyrus eaters. Random details of Egyptian life, apparently known to Aeschylus, are used to ridicule the Egyptians as treacherous barbarians.

Herodotus visited Egypt and so had much more knowledge of its inhabitants than did the tragedian, who lived slightly earlier than he did and never left Athens. Herodotus takes a much more positive view of Egypt than was current in Athens in his time. He describes Egypt in superlatives, saying, for example, that they are the most religious of all peoples. This idea leads him to mistakenly say in *The Histories* (Book 2, Chapter 65) that the Egyptians consider all animals to be sacred. He makes other incorrect observations, such as asserting that anyone who killed an ibis or hawk was executed. In Chapters 66–67 he describes

59. Serapis
This remarkable double statue of the Egyptian-Greek god Serapis (a combination of the Egyptian Amun and the Greek Zeus), found on a Greek island, demonstrates the general approval that Egyptian culture enjoyed in contemporaneous societies. Yet foreigners still had great difficulty understanding its practices of animal worship and mummification.

Possibly from Kos, Greece
Roman Period, 30 B.C.E.–395 C.E.
Marble
25 × 14 1/2 × 14 1/2 in. (63.5 × 36.8 × 36.8 cm)
Gift of Robert B. Woodward, 13.1070

60. Crocodile Coffin
The Greek historian Herodotus devoted two chapters of his book on Egypt to crocodile worship, a practice he found quite exotic. The Egyptians offered baby crocodiles, in small, wooden coffins like this one, to the god Sobek in order to expedite requests for help.

From Egypt
Late Period, Dynasty 26 or later, 664–332 B.C.E.
Wood
2 15/16 × 8 7/16 × 2 9/16 in. (7.5 × 21.5 × 6.5 cm)
Charles Edwin Wilbour Fund, 37.1367E

62

61. Alexander the Great
When Alexander the Great conquered Egypt, he acknowledged the Egyptian gods and all local forms of worship.

From Egypt
Late Ptolemaic to early Roman Period, 100 B.C.E.–100 C.E.
Marble
3 1/2 × 2 × 1 1/2 in. (8.9 × 5.1 × 3.8 cm)
Charles Edwin Wilbour Fund, 54.162

62. Ptolemy II
Ptolemaic kings continued Alexander's policy of promoting Egyptian religion, including the regulation of animal mummy-making.

From Benha il-Assel, Egypt
Ptolemaic Period, reign of Ptolemy II, 285–246 B.C.E.
Limestone
17 1/2 × 13 3/4 × 7 1/2 in. (44.5 × 34.9 × 19.1 cm)
Charles Edwin Wilbour Fund, 37.37E

crocodiles and their worship, an extremely exotic custom to him (figure 60). Herodotus also describes imaginary animals, such as the phoenix or winged snakes, as if they were real. In all of these remarks about Egyptians and animals, he is interested in the most fantastic details and explanations. He thus avoids describing Egyptian theology, as he readily admits himself. For him, animal worship is just one more of the curiosities of Egypt.

Of course after Alexander the Great (figure 61) conquered Egypt in 332 B.C.E. and the Ptolemies came to the throne following his death, Greek-speaking Egyptian kings became major sponsors of the animal cults. The Canopus Decree of Ptolemy III Euergetes reports that the king and his queen performed many important good deeds for the temples of Egypt, such as honoring the Apis and Mnevis bulls and other sacred animals. The Ptolemies took their position as the new pharaohs quite seriously and continued to support traditional Egyptian religion as long as they reigned (figure 62).

63. Ptolemaic Queen (Cleopatra VII?)
Cleopatra VII was the last Ptolemaic ruler of
Egypt, defeated by the Roman general Octavian,
who would later change his name to Augustus.
The Roman historian Cassius Dio derided
Egyptian animal worship, in part to belittle the
Egyptian queen and her ally, Marc Antony.

From Egypt
Late Ptolemaic Period, 50–30 B.C.E..
Limestone
5 1/2 × 4 3/4 × 4 1/2 in. (14 × 12 × 11.5 cm)
Charles Edwin Wilbour Fund, 71.12

Roman Views

The Roman view of Egyptian animal cults stemmed from political
circumstances, when the Romans conquered Cleopatra VII
(figures 63, 64), the last Ptolemy, and her partner Marc Antony.
The Roman historian Cassius Dio, in Book 50, Chapter 25, of his
history, has the future emperor Augustus comment derisively on
the Egyptians as people "who worship reptiles and beasts as gods,
who embalm their own bodies to give them the semblance of
immortality."[4] Even though, earlier in his career, the emperor had
expressed an interest in supporting the temple of Isis in Rome,
he later turned against Egypt as his political enemy. Officially,
Romans never approved of Egyptian worship of animals.

63

64

64. Ptolemaic Prince
This Egyptian prince wearing a Roman hairstyle likely represents Caesarion, the putative son that Cleopatra VII bore the Roman general Julius Caesar. Cleopatra hoped to seal an alliance with Rome through this birth. But Caesar never recognized the prince's legitimacy.

From Egypt
Late Ptolemaic Period, 50–30 B.C.E.
Greywacke
12 1/2 × 4 1/2 × 3 1/4 in. (31.8 × 11.4 × 8.3 cm)
Charles Edwin Wilbour Fund, 54.117

65. Thoth Baboon Mummy Shrine
Baboons were offered to the god Thoth, though much more rarely than were ibises, and received much more elaborate burials. (In this baboon shrine at Tuna el-Gebel, modern lighting has been installed.)

Animal cemetery at Tuna el-Gebel, Egypt
Ptolemaic Period, 305–30 B.C.E.
(Photo: © Jim Henderson/Crooktree.com)

Christian Views

The early Christians held beliefs similar to other foreigners in their view of Egyptian animal worship. Clement of Alexandria (150–215 C.E.), a Christian bishop who would have known well what his Egyptian neighbors did, ridicules the fact that once the curtain is drawn back in an Egyptian shrine, the god inside is "a cat, a crocodile, or a native snake or a similar animal"[5] (figure 65). In the *Paedagogus* (Book 3, Chapter 2), Clement describes animal worship as contemptible, evil, and sinful. Here he found himself in rare agreement with his Jewish neighbors in Alexandria.

66

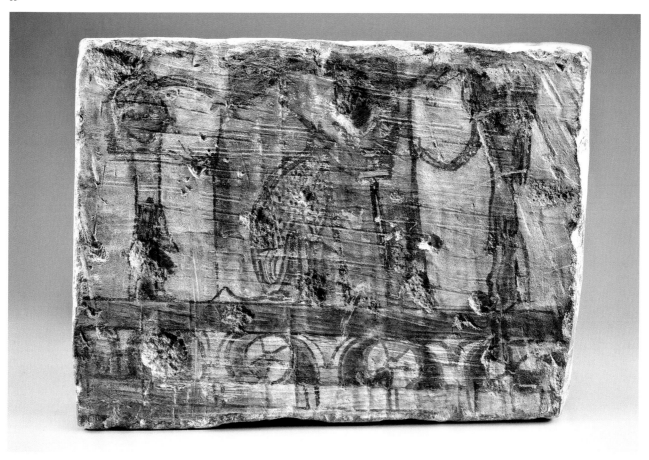

Votive Animal Mummies

With their uniqueness in the Mediterranean context in mind, let us now look at the animal cults themselves more closely. As a practical matter, the Egyptians in fact made four different types of animal mummies.

 In rare cases, and always at the highest reaches of society, pets could be mummified. The best-known examples are a dog belonging to king Amenhotep II (reigned 1426–1400 B.C.E.) and a cat belonging to the royal prince Thutmose, son of Amenhotep III (reigned 1390–1353 B.C.E.), which is similar to the example shown in figure 66.

 More frequently, meat intended to be consumed in the next world could be mummified and placed in the tomb. These food mummies included whole ducks (in duck-shaped coffins) and preserved bull forelegs.

 In addition, particular animals that were regarded as incarnations of gods were also mummified after death. The most famous animal cult is that of the Apis bull. Worshipping and mummifying the Apis bull began as early as the First Dynasty, about 3000 B.C.E. (see figure 115).

 The most common type of animal mummies, however, were beasts killed, mummified, and buried in the extensive animal cemeteries associated with human cemeteries at Saqqara, Abydos,

66. Sarcophagus and Cat Mummy
This rare scene, on the side of sarcophagus, shows the deceased cat crouching in the center before an offering table. A partially damaged figure stands on the other side of the offering table dressed in a traditional leopard skin, taking the role of a *sem*-priest making offerings. (A priest like this would normally be seen in this setting in human tombs.) Another cat stands upright behind the deceased. The closest parallel to this scene is found on the cat coffin made for a pet of the royal prince Thutmose, son of king Amunhotep III. (For another view, see figure 112.)

From Egypt
Ptolemaic Period to early Roman Period,
305 B.C.E.–1st century C.E.
Limestone, animal remains, linen
5 ¾ × 20 ¾ × 8 ½ in. (14.6 × 52.7 × 21.6 cm)
Charles Edwin Wilbour Fund, 37.1841Ea-b

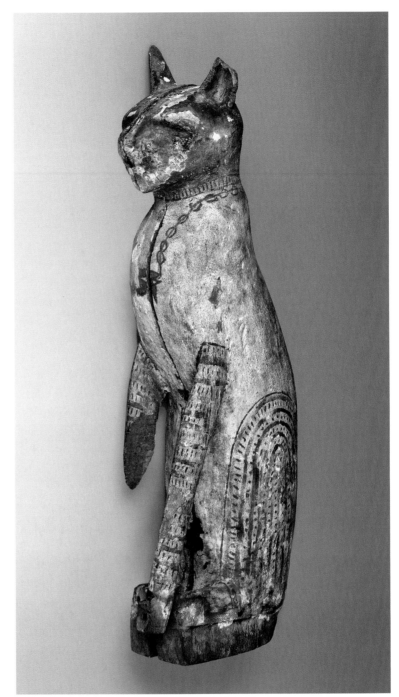

67

67. Cat Coffin with Mummy
Cat mummies were often placed in
wood cases having the form of a cat.
Combinations of black rings and lines used
to represent fur are characteristic of the
Istabl Antar animal mummy cemetery.

Possibly from Istabl Antar, Egypt
Late Period to Ptolemaic Period, Dynasty 26
or later, 664–30 B.C.E.
Wood, paint, animal remains, linen
23 5/8 × 5 1/4 × 6 5/16 in. (60 × 13.3 × 16 cm)
Charles Edwin Wilbour Fund, 37.1947E

Tuna el-Gebel, and other major archaeological sites. These votive
animal mummies seem to be limited to the first millennium B.C.E.
(a time frame indicated by carbon-14 tests recently conducted by
the Conservation Laboratory of the Brooklyn Museum). Called
"votive" because in modern Egyptology they were originally
understood as offerings to the gods, they form the main subject of
this essay. Ibises, hawks, dogs, cats, crocodiles, shrews, fish, and
snakes (figures 67, 68) all could become votive mummies because
each had an association with a particular god or goddess in the
Egyptian pantheon.

68

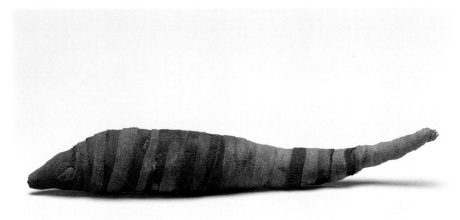

68. Shrew Mummy

Shrews have a poisonous bite, enabling them to hunt and kill snakes. They are also nocturnal, active during the time, according to Egyptian belief, when the sun is threatened by the evil snake Apep. Shrew mummies were therefore buried with falcon mummies, a sacred animal of the sun god Horus, to protect him from Apep at night.

Excavated by the Egypt Exploration Society at the ibis cemetery, Abydos, Egypt
Roman Period, 30 B.C.E.–100 C.E.
Animal remains, linen
6 5/16 × 23 5/8 × 5 1/4 in. (16 × 60 × 13.3 cm)
Gift of the Egypt Exploration Society, 14.653

The Purpose of Votive Animal Mummies

Some scholars have argued that votive animal mummies relate to a royal New Year's festival celebrated annually (figure 69).[6] Others have argued that they derived from pilgrimage festivals. And in another theory, votive mummies were held to be sacrifices to the gods. Here, however, a different view will be advocated.

The early theories that votive mummies were sacrifices to gods have their limits. Those theories implicitly compared animal mummies to Catholic votive offerings (which typically include candles, flowers, statues, vestments, or monetary donations) made either to fulfill a vow made to God for deliverance or in gratitude for some favor that God granted. But animal mummies in Egyptian religion were a different sort of gift with a different purpose. Moreover, an animal mummy was just one element of a complex ritual performed by an Egyptian who was trying to solve a problem that required help from a god. Though the existing evidence is only suggestive and not conclusive, it is possible to reconstruct parts of this ritual's purpose and performance, as well as its financial demands on those seeking aid, and offer a somewhat different explanation for the proliferation of animal mummies.

The Egyptian scribe Hor, living in the second century B.C.E., suggests the purpose underlying the practice of mummifying animals: "The benefit [of mummification] which is performed for the Ibis, the soul of Thoth, the greatest one, is made for the Hawk also, the soul of Ptah, the soul of Apis, the soul of Pre, the soul of Shu, the soul of Tefnut, the soul of Geb, the soul of Osiris, the soul

69. Royal Ka

The purpose of votive animal mummies is widely debated. One proposal holds that they were part of the annual royal New Year's ritual that, hypothetically, required all soldiers to offer animal mummies to the gods. This explanation is one way to account for the vast number of animal mummies preserved from ancient times.

From Abydos, Egypt
Late Period, Dynasty 30, 381–343 B.C.E. or reign of Ptolemy VI, 186–145 B.C.E.
Limestone, paint
9 3/4 × 13 15/16 × 1 3/16 in. (24.7 × 35.4 × 3 cm)
Charles Edwin Wilbour Fund, 67.69.2

of Isis, the soul of Nephthys, the great gods of Egypt, the Ibis and the Hawk."[7] What Hor is stating here is that animal mummies are the souls of the gods: he describes the ibis as the soul of Thoth and the hawk as the soul of many different gods. That is to say, some animals were, or contained, a *ba*—a part of the soul that is an active agent in this world and the spiritual world.

Therefore, the purpose of votive animal mummies proposed in this essay is that *the animals' souls acted as messengers between people on earth and the gods*. Animals could facilitate interactions between people and the gods because the animal, once it was mummified, was the *ba* of the god with which it was associated, a statement often made in the texts known from the ibis sanctuary at Saqqara. Significantly, the Egyptians represented the *ba*, a part of every individual's spiritual side, in the shape of a human-headed bird (figure 70).

69

70

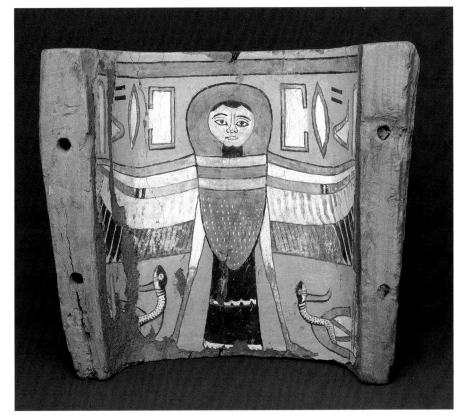

70. Image of a *Ba*-Bird
The human *ba* is an active agent for the individual person in the next world, using tools, consuming food and drink, and speaking.

From Egypt
Third Intermediate Period, Dynasty 22 to Dynasty 24, 945–712 B.C.E.
Wood, paint
11 × 12 ⅝ × 5 ⅝ in. (28 × 32.1 × 14.3 cm)
Charles Edwin Wilbour Fund, 75.27

The *Ba* of the God

With humans, the *ba* had slightly different meanings for each rank of person: for a king, it was the manifestation of royal power; for an ordinary human, the *ba* could refer to personality. In life, the *ba* could speak with the individual and disagree on important issues; a text dating to the Twelfth Dynasty (1937–1759 B.C.E.) details a debate that a man has with his *ba* about the meaning of life on earth. (The outcome of the debate is unclear.)

For humans after death, the *ba* could consume food and drink offerings, continue to speak, and, most important, it could move around through space on earth and in the spiritual world. For a human *ba,* these movements were controlled by priests through spells that directed the *ba* toward gathering food to maintain the combined spiritual entity in the next world, called the *akh*.

For animals, too, the *ba* retained mobility and powers of communication. Mummified animals, the *ba* of the god, could activate a message to that god. A request made with a human voice could direct the animal *ba* toward the god to which the animal was linked and communicate a request for divine intervention.

Though animal mummies themselves consist of only the mummified creature plus linen wrappings and perhaps a container, a certain amount of written evidence suggests what the Egyptians said to gods in the oral communications that accompanied animal mummies to their ceremonial burials. Animal mummies then carried these messages into the presence of the god, requesting its intervention in a human problem. The known texts make clear the kinds of divine intervention sought by participating in this ritual. The vast numbers of mummies preserved in animal cemeteries suggest the enormous popularity of this custom.

Letters to the Gods

Lending support to the idea that animal mummies acted as divine messengers, a small number of letters to gods that accompanied some animal mummies still exist. The majority of these letters have no definite provenance; however, some can be traced to a general location on the basis of their contents. A smaller number of letters are known to come from the animal sanctuaries and cemeteries of Saqqara and Hermopolis (figure 71). Thus, although the connection between these letters and animal mummies is only suggestive and not conclusive, it is reinforced by their occurrence at the same sites.

At some point in the first millennium B.C.E., the Egyptians began to use animal mummies, probably in addition to the mummies of their ancestors, to communicate with the gods.[8] In a moment, we will look at some of the letters to the gods, written during this era, that can be associated with animal cult sanctuaries or cemeteries. The texts include complaints, requests, and vows.

Complaints are the most common feature of letters addressed to the gods, according to the Egyptologist A.G. Migahid, and were accompanied by an animal mummy.[9] The writers complain about a variety of subjects, most often a crime committed against him or her. The most common crime is a theft by someone the writer knows. But the complaint can also address sickness, a deplorable state of affairs at work, an injustice within a family, perjury in court, a threat from a god, or libel against the writer.

After a complaint in a letter, a request very often follows—the second feature of letters to the gods. Requests are in general polite in tone and represent the writer's desires, demands, or wishes for the redress of the grievance. The request can take the form of a command, a wish, an exhortation, or a plea. There are several formulaic types of requests. In one type, the writer can ask

71

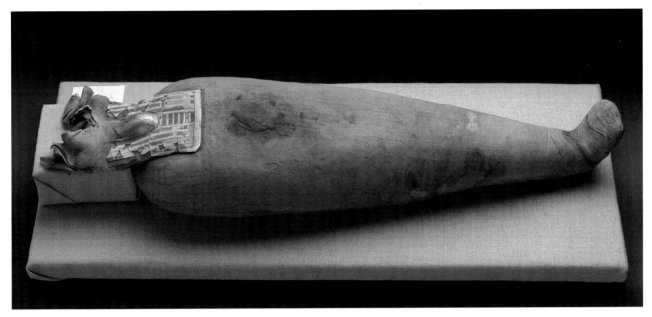

71. Ibis Mummy
Many preserved letters to the gods are
addressed to Thoth, whose *ba* is often the ibis.

From Egypt
Late Period to Ptolemaic Period, Dynasty 26 or
later, 664–30 B.C.E.
Animal remains, linen, cartonnage, paint
6 11/16 × 22 1/4 × 3 9/16 in. (17 × 56.5 × 9 cm)
Charles Edwin Wilbour Fund, 37.1986E

that "justice be procured" or that "the decision be determined";
these two phrases both seem to be used when the complaint also
involves the judicial system. Another type of formula asks for
protection or salvation; protection seems to be a general term,
while the formula asking for salvation usually names the evildoer
whom the writer fears. Still another type of formula requests a
curse on the evildoer.

The third of Migahid's elements of letters to the gods is
the vow. A vow acts like a personal performance bond with a
particular god and thus appears to be more businesslike than
a complaint or request. The letter writer promises to make a
financial donation to the god in return for the solution to his or
her problem. The desired solution is normally the god's mercy
in a crisis or rendering assistance of some other kind. The vow
is formulated so that a particular sum in either money or goods
will be paid to the god's temple or an action will be performed
in return for the god's assistance.

The Egyptologist Kata Endreffy has stressed the
businesslike, transactional nature of the vow.[10] The letter writer
specifies a particular amount that he or she will pay the god for
the fulfillment of a request or a particular action that the writer
will take. Sometimes, the writer includes a promise to withhold
any rewards for the god if the deity does not render the requested
help (figure 72).

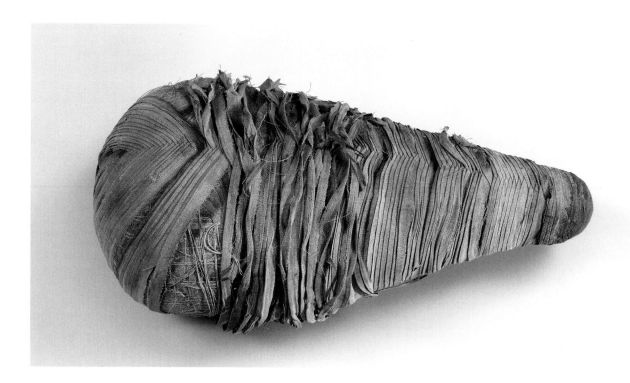

72. Ibis Mummy
Ibis mummies could accompany petitions or vows made to the god Thoth. The mummy could be offered either when a person made the vow or after Thoth performed the requested task. (For a CT scan of this mummy, see figure 41.)

From Saqqara, Egypt
Late Period to Ptolemaic Period, Dynasty 26 or later, 664–30 B.C.E.
Animal remains, linen
5 ¹³/₁₆ × 15 ¹¹/₁₆ × 7 ¹/₂ in. (14.7 × 39.9 × 19.1 cm)
Charles Edwin Wilbour Fund, 37.2042.7E

Who Petitioned the God?

The limited number of letters preserved and published reveals a surprising variety of individuals who used letter writing and animal mummies to solve a problem. Though priests of the temples would be expected in this group, the sources also include men without titles, two children, and an individual who describes himself as an old man. Such writers, if the sample is truly representative, were all drawn from the middle ranks of society. The vast number of animal mummies that did not include written texts may have been used by people of even lower rank who lacked the knowledge to write letters or funds to pay a scribe to create them. Thus, letter writing seems to represent a means of problem solving more for ordinary Egyptians than for nobles or royalty.

Here are some of the stories that can be told about those individuals who used the ritual of written petition to attempt to solve a problem, along with the offering of an animal mummy (figure 73). (Further on in this essay, more light will be shed on this practice by considering the financial price of participation.)

A text from the ibis cemetery in Hermopolis (and now preserved at the Oriental Institute of the University of Chicago) addresses the problems of a priest.[11] The letter dates to 502 B.C.E. in the Twenty-seventh Dynasty, the period of Persian rule, and reveals the difficulties at his place of work faced by Yuf-aa, son of Hor-nefer-heby. This letter and the animal mummy that would have accompanied it are his attempt to solve his problems with the help of the ibis god, Thoth. It is a good example of a complaint coupled with a request. Yuf-aa tells the god that he worked in

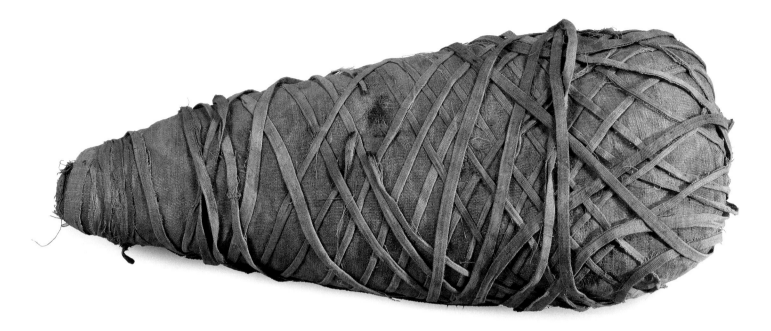

73. Ibis Mummy (without Skeleton)
A wide range of ancient Egyptians offered
ibis mummies as a way to solve problems. The
extant evidence indicates that a simple mummy
could be offered by lower-ranking people.
Perhaps this incomplete mummy, lacking a
skeleton, represented a cheaper offering. Or
perhaps it reflected a corrupt practice.

From Saqqara, Egypt
Late Period to Ptolemaic Period, Dynasty 26
or later, 664–30 B.C.E.
Animal remains, linen
6 1/16 × 16 1/2 × 7 7/16 in. (15.4 × 41.9 × 18.9 cm)
Charles Edwin Wilbour Fund, 37.2042.18E

Thoth's service for nine years. But now he has been forced to leave
the god's service because of a co-worker named Pa-sher-tai-het,
son of Mentuhotep. In at least one instance in the three previous
years, Pa-sher-tai-het physically attacked Yuf-aa and his servants
and stole his possessions. Pa-sher-tai-het also managed to divert
Yuf-aa's income for his own use. In addition, Yuf-aa asserts that
Pa-sher-tai-het has been stealing from the god's resources. To solve
this problem, Yuf-aa asks for the god's protection.

This common formula, requesting protection, does not
immediately suggest what result Yuf-aa specifically expects
from his request. Presumably, the wrongs that he enumerates in
his letter will be righted through the god's action. The long time
period described here, lasting at least three years of trouble with
Pa-sher-tai-het, might also indicate that this was not the only
means of redress that Yuf-aa attempted. In fact, the relationship
between the kind of problem brought to the god, on the one hand,
and the kind of problem brought to civil courts, on the other,
is not clear. Possibly, Yuf-aa had tried to resolve his problem
through non-supernatural means, in court, before appealing to
the god. Alternatively, a request to the god could be viewed as an
additional step toward success with a civil court case. None of the
texts clarify this point.

A second letter (now at the Egyptian Museum in Cairo)
from a low-level priest, the servant Wennefer, son of Tjay-aan, was
written on linen and discovered during excavations at the sacred
animal necropolis at Saqqara. Here, Wennefer addresses the god
of the sanctuary, Osorapis, asking justice against Irpy, daughter

74. Seated Baboon
The god Thoth could take the form of a
seated baboon or an ibis. Both ibis and
baboon mummies are known from his temple.
This wooden image of a baboon likely came
from a shrine of Thoth.

From Egypt
New Kingdom, Dynasty 18 to Dynasty 20,
circa 1539–1075 B.C.E., or Late Period, Dynasty
26 to Dynasty 31, 664–332 B.C.E.
Wood
8 7/8 × 4 15/16 in. (22.5 × 12.5 cm)
Charles Edwin Wilbour Fund, 61.127

of Padiwesir. Irpy has "taken my woman and appealed against
me."[12] The reference to an appeal seems to indicate a legal action
that Irpy took against Wennefer. Wennefer thus asks the god for
justice and harsh punishment for Irpy.

This circumstance suggests that Wennefer is working to
solve his problem both through the judicial system and through the
supernatural by appealing to the god. From his perspective, these
would be two effective and mutually reinforcing paths to justice.

Both letters from priests to gods use the term "voice" to
describe their communication with the god. This emphasis on
the fact that writing is merely an aid to remembering an oral
declaration is suggestive of how the animal mummy ritual
functioned. The letter was more a record of an oral declaration
and request, an addition to the most important part of the ritual,
which was spoken. The act of voicing the complaint, request, and/
or vow—out loud—must have accompanied the vast number of
animal mummies that contain no written material.

•

A letter to the god Thoth from a man named Djehuty-nakht,
son of Gemuhep (now preserved in the British Museum), illustrates
the kind of vow a man of middling means could make in return for
a request for healing.[13] This text also comes from the ibis cemetery
in Hermopolis and might have been prepared with an ibis mummy.
In the letter, Djehuty-nakht requests that Thoth prevent the death of
his father, Gemuhep, during a current illness. Djehuty-nakht vows
that if his father recovers, he will contribute a sum in silver both to
the temple and for additional ibis mummies for the god.

Again, this letter suggests that, in this case, seeking
supernatural solutions to a problem was simultaneous with
natural solutions. This letter was written in the late Ptolemaic
Period, during the first century B.C.E., and would have been
contemporary with a well-developed medical-care system.
Just as the priest Wennefer sought justice by both natural and
supernatural means, here Djehuty-nakht likely sought healing for
his father through both medicine and a vow promising payment.

•

Another letter (also in the British Museum) represents
the interests of two children who describe themselves as minors
when their problems occurred.[14] Pasherdjehuty and his sister
Naneferhor claim that their father, Horankh, son of Horpakemet,
threw them out of the house when their mother died. They make
their request to a number of gods, including Thoth, Horus, and

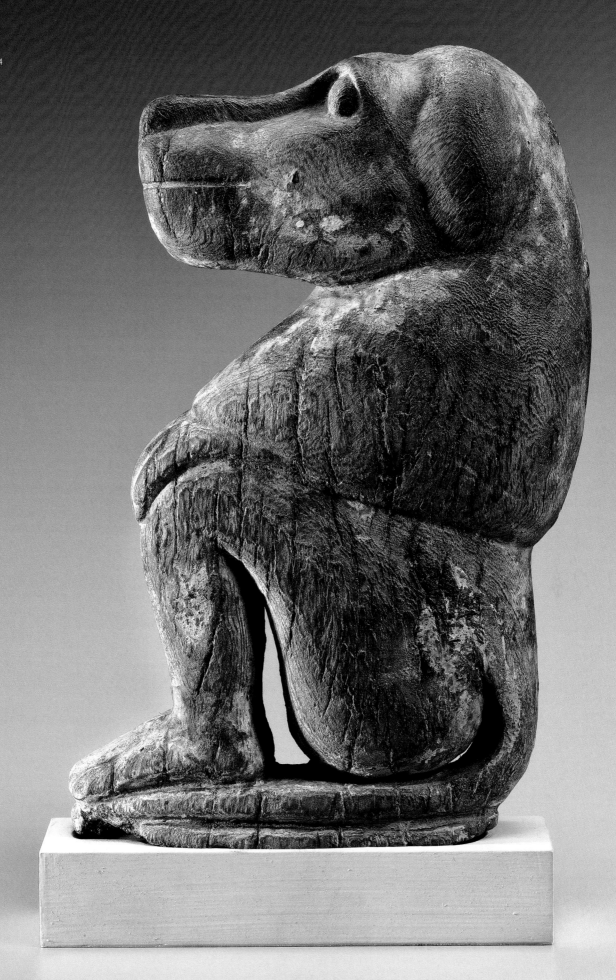

other, unspecified deities (figure 74). The references to this group of gods suggest an animal necropolis as the provenance of the letter. The children's complaint against their father is extremely detailed. They recount that he refused them shelter, food, clothing, and cleansing oil, forcing them to rely on strangers for survival. Their father even encouraged men who had attacked the children on the street. They therefore ask the gods for justice according to the law. This justice seems to be sought in a court in the next world, when their father is judged before Osiris. A reference to a previous judgment in the father's favor made by an oracle suggests that this appeal is not the first attempt the children made at redress of their problems. But the mechanics of how children would make this appeal are not clear from the text. Perhaps, as was the case in fulfilling their other needs, the children relied on strangers.

•

In a letter (now in a private collection) probably from Hermopolis, Nesnaqenbeutaay, son of Hor, asks Thoth of Hermopolis and other, accompanying gods to save him from an evil spirit.[15] This letter was written on linen and dates to the end of the Twenty-sixth or the beginning of the Twenty-seventh Dynasty. Twice in the letter the writer refers to himself as old. He admits that he has done wrong against a god but is no more specific than that. He throws himself on Thoth's mercy. In this case, the letter most likely was the primary attempt at a solution. Since his problem concerned only the supernatural, it required a supernatural solution.

•

The people who added a written record of their communications with the gods must have had the means either to write the letter themselves or to hire a scribe to write it for them. If they wrote it themselves, perhaps they worked at a relatively high level in the priesthood or in the bureaucracy, though it is unlikely that any of them were either noble or royal, since they never use a title in their communications. Djehuty-nakht, son of Gemuhep, who made a vow to Thoth to pay him three silver pieces during the course of a year if his father recovered, must, however, have been a man of substantial means to pay this high sum. As will be shown below, not only such payments but also additional bronze or wooden elements placed on the animal mummy appear to have been rather costly.

75

The Archive of Hor: A Glimpse of an Animal Sanctuary

Letters to the gods reveal the kinds of problems solved through animal mummies, and the kinds of people who sought aid this way. Details about the setting where letter writing and the ritual burial of animal mummies took place are preserved in a remarkable set of documents discovered in the animal sanctuary in North Saqqara in 1965 and 1972.[16] Together, these documents are called the Archive of Hor. The documents reveal much of what occurred in the day-to-day activities of the sanctuary in addition to ritual—identifying the people who worked at the sanctuary, and giving us surprising information about how corruption at a religious institution was addressed. They also reveal some of the financial costs of participating in the animal mummy ritual. The documents provide a vivid sense of the everyday business affairs surrounding Egyptian religion.

These documents were written by a scribe named Hor of Sebennytos (who was quoted earlier). He lived in Memphis and worked at the House of Thoth, the largest institutional

division of the temples in North Saqqara during the reign of Ptolemy VI Philometor (reigned 180–145 B.C.E.) (figure 75). Sixty texts—on broken potsherds—that Hor of Sebennytos wrote were discovered in excavations conducted by the Egypt Exploration Society at a chapel near the ibis burials in Saqqara. Though these texts on pottery were actually the rough drafts for unpreserved documents on papyrus, and thus technically not an archive, they still reveal much about the workings of an animal sanctuary.

Hor of Sebennytos himself joined the service of Thoth after receiving a message from the god in a dream. Hor had been a priest (Greek *pastophoros,* Egyptian *wenu*) of Isis. But Thoth insisted in the dream that Hor switch his allegiance to Thoth's ibis temple. In return, Thoth would guarantee Hor's support in this life and a burial in Memphis for the next. Hor's activities reflect the general rise of Thoth in this period. Thoth was the god of both scribes and the moon; the ibis makes the perfect symbol for these activities, with his beak that resembles both the scribe's pen and the crescent moon.

The details of the ibis cult found in the archive are probably generally applicable to the cult of the hawk, which adjoined it in Saqqara. In broad outline, the practices of the ibis cult probably also applied to the cults of dogs, cats, crocodiles, and other animals mummified for the purpose of communicating with the gods.

Hor worked in Saqqara at a complex that contained a large number of buildings, in addition to the underground galleries nearby holding millions of ibis mummies (figure 76). The presence of the hawk galleries and the adjoining sanctuary points to the importance of the connection between Thoth the moon god and Horus the sun god. Thoth and Horus represented the night and the day; together, the two of them controlled all that occurred during the diurnal cycle. The association of these gods became so close later, in the Roman Period (30 B.C.E.–395 C.E.), that they were conceived of as a combination god named Horus-Thoth.

The scribe Hor worked in the group of buildings known as the House of Thoth, which was located in an area of North Saqqara that the Egyptians called *Pi-waab-nebes,* meaning the Embalming Place of Her Lord. The name alludes to the goddess Isis, whose lord is Osiris, the lord of the dead. In addition to the House of Thoth, areas called the Compound of Thoth and the Compound of Horus were located here. (The Archive of Hor was discovered in the Compound of Thoth.) Adjacent to *Pi-waab-nebes* were the five great Houses of Rest, or animal mummy

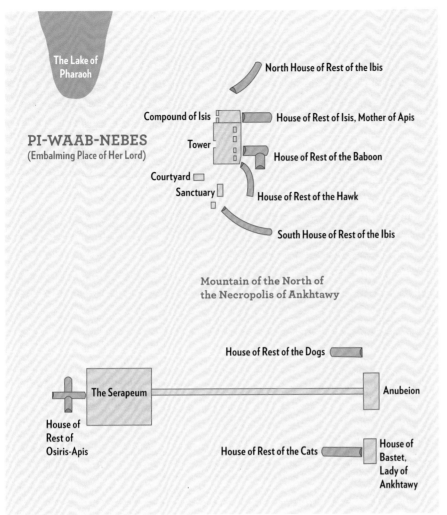

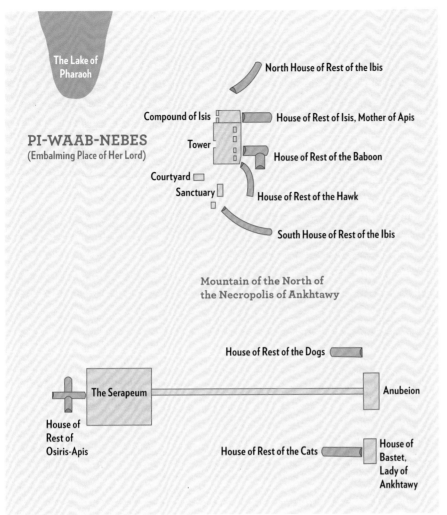

The Lake of Pharaoh

North House of Rest of the Ibis

Compound of Isis

PI-WAAB-NEBES
(Embalming Place of Her Lord)

Tower

House of Rest of Isis, Mother of Apis

House of Rest of the Baboon

Courtyard

Sanctuary

House of Rest of the Hawk

South House of Rest of the Ibis

Mountain of the North of
the Necropolis of Ankhtawy

House of Rest of the Dogs

The Serapeum

Anubeion

House of
Rest of
Osiris-Apis

House of Rest of the Cats

House of
Bastet,
Lady of
Ankhtawy

cemeteries: two were dedicated to the ibis, with the rest of the underground galleries, used to bury bulls, called the House of Rest of Isis the Mother of Apis; the House of Rest of the Baboon, associated with the baboon- or ibis-headed Thoth; and the House of Rest of the Hawk, associated with the hawk-headed Horus. Farther south, but in easy walking distance, were the Serapeum (the name given to this structure by Auguste Mariette, when he first excavated it in the mid-nineteenth century, because he thought it was a temple of Serapis; in fact, it was the location where the Apis bull was buried); the House of Rest of the Dogs, associated with the jackal-headed god Anubis; and the House of Rest of the Cats, associated with the feline goddess Bastet. Thus, in North Saqqara there was an animal cemetery for each of the major types of animals that the Egyptians mummified and buried, except for the crocodile. Because the majority of the Brooklyn Museum animal mummies were acquired in the early nineteenth century, when Saqqara was the major source of such mummies, it is highly likely that most of those in the Brooklyn collection came from this vast complex in North Saqqara.

 Within the House of Thoth, where Hor of Sebennytos worked, were a number of buildings whose names are mentioned in the archive. These names are a clue to the daily functioning

76. Map of the Sacred Animal Necropolis at Saqqara, Egypt
The necropolis contained both temples (each called a "Compound of" a god) and underground galleries (each called a "House of Rest" of a god) where the animal mummies were buried. This map shows the locations of the Compounds and the Houses of Rest in Saqqara as determined by excavations of the Egypt Exploration Society and the work of John Ray.

(Information based on J.D. Ray, *The Archive of Hor* [London: Egypt Exploration Society, 1976], fig. 4, p. 153)

77. Ibis Egg Mummy

Ibis eggs were incubated at ibis temples in Egypt. This would have been one source of the many ibises needed to complete the requests made to Thoth.

From Abydos, Egypt
Roman Period, 30 b.c.e.–100 c.e.
Linen, animal remains
1 15/16 × 2 1/4 × 2 3/4 in. (5 × 5.7 × 7 cm)
Gift of the Egypt Exploration Society, 14.654

78. Ibis Coffin

The workers at the sacred animal necropolis ate in the presence of a statue of Thoth as an ibis. The silver legs and beak were probably added to this ancient coffin in modern times. For an X-radiograph of this coffin, see figure 114.

Possibly from Tuna el-Gebel, Egypt
Ptolemaic Period, 305–30 b.c.e., with later additions
Wood, silver, gold, rock crystal
15 1/16 × 7 15/16 × 21 15/16 in. (38.2 × 20.2 × 55.8 cm)
Charles Edwin Wilbour Fund, 49.48

77

of the cult. The first is a building called the Birth Chapel. The Egyptologist John Ray hypothesizes that this building was used to incubate ibis eggs (figure 77). Though others have suggested that ibises from the wild were captured to supply the cult, the large number of eggshells found during the excavations of this area suggest that eggs were collected in the wild and incubated in the temple. The very large number of ibises needed for the cult perhaps indicates both collection of eggs from the wild and also hunting of young ibises to obtain enough individual birds. Hor mentions, in the text describing the dream that brought him to Thoth's service, that there were at one time sixty thousand living ibises present in the temple. Considering the millions of ibis mummies remaining today in the underground galleries, all of them collected over a period of seven hundred years, Hor's number might not be an exaggeration.

Another building in the House of Thoth complex was called the Table. This area appears to be the mess hall for the staff. It is here that "the food rations of Pharaoh" were brought. One text remarks that "the men who perform labor shall eat rations upon the table before the Ibis."[17] Ray suggests that a statue of an ibis stood in this mess hall, which would explain the passage (figure 78). If so, this practice might represent the Egyptian custom called reversion of offerings: officially, the food that the pharaoh sent was conceived as a gift for the ibis god; once the god consumed the spirit of the food, the actual bread was eaten by the human staff.

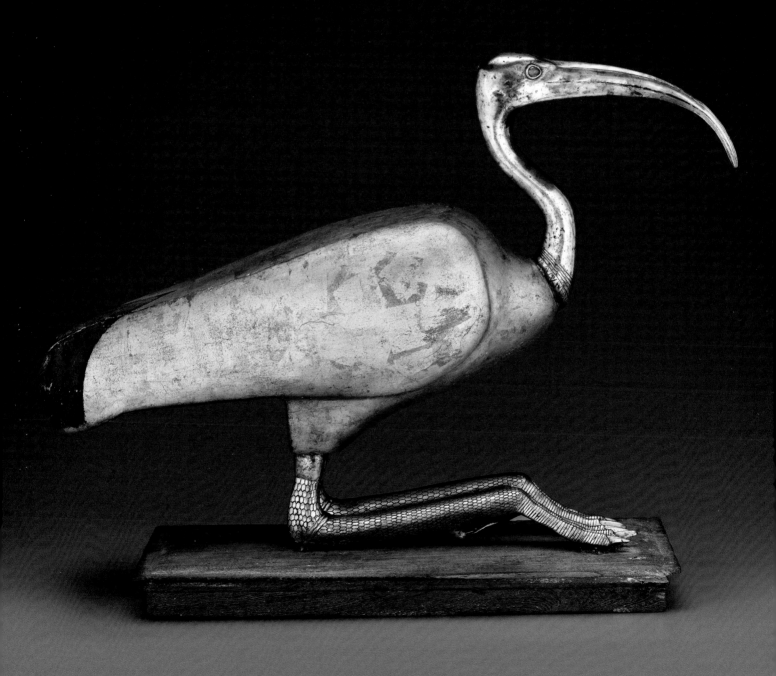

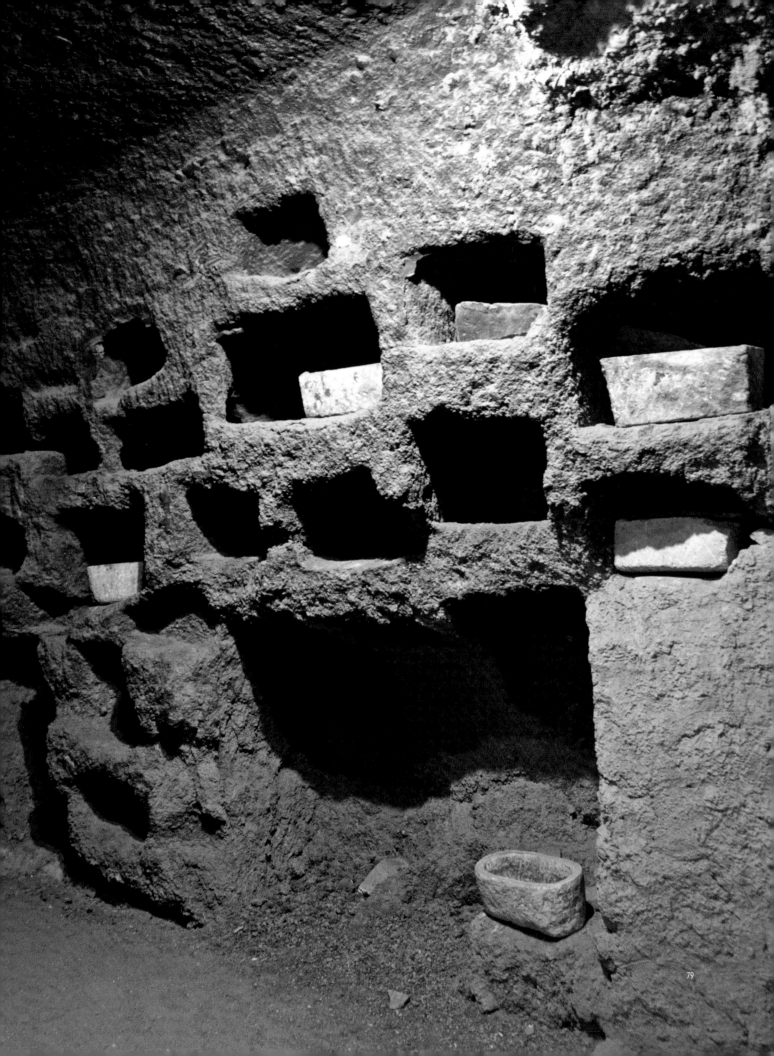

The birds, too, had to eat, and this occurred in an area called, unsurprisingly, the Feeding Place of the Ibises. Farmers assigned to plots of land owned by the god brought clover here to feed the birds. The Archive of Hor provides further information on how the mummified ibises and hawks were then moved to the underground Houses of Rest, the actual burial spot.

During the course of a year, ibis mummies that had been used ritually were placed in a holding area called the House of Waiting, until their eventual burial. This area seems to be the side galleries in the animal cemetery, different from the main corridors of burial.

The archive also describes a mass burial of all the animal mummies in North Saqqara, performed once a year. The whole population of the area assembled in a procession, which included priests qualified to conduct the proper ceremonies along the way. The procession led to the underground galleries of each of the animals, where the mummies were finally stacked (figure 79). To account for the current number of mummies found in the ibis galleries, at least five thousand animal mummies must have been deposited every year that the cemetery was in operation. (These calculations reflect the carbon-14 date studies conducted by the Brooklyn Museum's Conservation Laboratory, which locate the earliest votive animal mummies in the Third Intermediate Period, beginning about 750 B.C.E.)

Administering the Cult

The Archive of Hor also allows identification of the various officials who had authority over the activities there. The head of the Compound of the Ibis, a division of the House of Thoth, was a priestly official called the *lesonis* in Greek, or the *mer-shen* in Egyptian. He appears to have headed the administration and made many of the decisions. Another high official was called the controller; he represented royal interests in the cult of the ibis and must have monitored the supply of food that the pharaoh sent to the cult. It was important that the food be used to support the workers here, rather than sold for some official's personal benefit. Sometimes, there was more than one controller at the same time, suggesting a heightened degree of royal interest in the cult. After the dream that led him to the cult of Thoth, Hor approached a priest called the Prophet of Khons, whose title referred to another form of the moon god. This prophet seemed to be in charge of personnel, for he was the one who brought Hor into Thoth's service.

79. Animal mummy burials in place; animal cemetery at Tuna el-Gebel, Egypt
The limestone animal mummies' coffins were placed on shelves carved into the bedrock in the House of Rest.

Ptolemaic Period, 305–30 B.C.E.
(Photo: © Jim Henderson/Crooktree.com)

80. Jar for Ibis Coffin

This jar contained an ibis mummy when it was
discovered. Ptolemy VI issued orders that only one
ibis could be buried in each jar.

From Abydos, Egypt
Early Roman Period, 30 B.C.E.–100 C.E.
Terracotta
a: ¹¹/₁₆ × 6 ⁷/₁₆ × 17 ¹⁵/₁₆ in. (1.7 × 16.3 × 45.5 cm)
b: 6 ³/₄ × 3 ³/₈ × 9 in. (17.2 × 8.6 × 22 cm)
Gift of the Egypt Exploration Society, 14.656a–b

Another group of priests, from the nearby Temple of Ptah,
in Memphis, also had some control over the House of Thoth, and
was responsible for conducting an investigation of the cult. (More
on this in a moment.)

The actual work of the temple from day to day was likely
performed by the ordinary priests, called *wabu* ("purified ones").
They served in rotation for limited periods of time. This service
was probably the middle-class equivalent of the practice that
Egyptologists call the *corvée*, forced labor rendered by farmers
to the state, usually in construction, on a regular basis during
the year. The *wabu* priests seemed eligible to be named to the
Council of Twenty-five, a group that advised the permanent
administrators. Hor sometimes calls these twenty-five priests
the "great men."

While priests such as *wabu* served the religious needs of
the cult, there were others who served more practical purposes
essential to running the temple. The "doorkeepers" guarded
the living birds and ensured that no harm came to them. The
"servants of the ibises" were perhaps responsible for feeding
them. These servants were supervised by "inspectors." It is these
inspectors who became the object of investigation in the year
174 B.C.E. and whose misdeeds led to the reforms of 172 B.C.E.

80

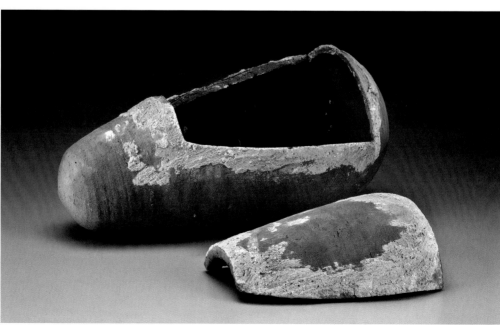

Corruption and Reform in the Ibis Cult

Hor of Sebennytos recounts in one document that up until the year 207/206 B.C.E., the House of the Ibis was well run.[18] The following thirty-three years, however, were less fortunate for the cult. In 174 B.C.E., the elders of the priests of the nearby Temple of Ptah met with a representative of the pharaoh and made some untranslatable charges about the running of the House of Thoth. The phrase used suggests that certain irregularities had crept into the practices at the temple. They included fraudulent sales or packaging of animal mummies in the vessels or jars sometimes used as coffins, irregular delivery of animal mummies to the House of Rest, and inaccuracies in the listing of the servants who had charge of the mummies. The accusations were serious enough that the priests sent a message to Alexandria to determine the exact nature of the law that had been violated. The mention of Alexandria suggests that royal officials had to be consulted before the priests of Ptah could carry out the punishments they believed the servants of the ibis and the hawk deserved. Following this consultation, the elders of the priests of Ptah met with the servants of the House of the Ibis and the servants of the House of the Hawk. As a result of the proceedings, six of the servants were imprisoned.

Following the punishment of the six servants, the elders of the priests of Ptah gathered the inspectors—the men who supervised the servants—and issued new regulations for fulfilling the mission of the House of Thoth and the House of Horus. They thus made provisions to ensure that food for the ibises and food for the workers went to those for whom it was intended. First, they required the inspectors to appoint three reliable priests, who would become responsible for food delivered to the ibises, and also for recording the income in food that the temple received from the fields that the god owned and which was used to feed the employees. The temple's income from those who made votive offerings would also now be monitored by accurately counting the number of animal mummies in the House of Waiting, each representing a fee received.

The new regulations express special concern that each vessel in the House of Waiting contain "one god in one vessel," meaning one animal mummy per jar (figure 80). CT scans of animal mummies show that multiple animals were sometimes wrapped together. In the case of small animals such as snakes and shrews, enough animals could be wrapped together that it is not quite possible to disentangle the skeletons and count them

81. Ibis Mummy (CT scan)
Two birds were wrapped together in one mummy in this example. Presumably, the temple collected two fees but produced only one mummy. A royal decree in the reign of Ptolemy VI (186–145 B.C.E.) required that each animal be prepared separately, aiming to end this practice.

From Egypt
Carbon-14 dated to 760–400 B.C.E.
Third Intermediate Period to Late Period, Dynasty 25 to Dynasty 28, 760–399 B.C.E.
Animal remains (1 adult, 1 juvenile?), linen
7 × 29 1/2 × 5 1/2 in. (17.8 × 74.9 × 14 cm).
Charles Edwin Wilbour Fund, 37.1990E

81

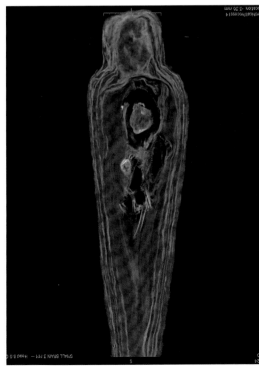

(see figure 119). In addition, one ibis mummy in the Brooklyn Museum seems to contain both an adult and a juvenile bird (figure 81). Thus it appears that this regulation regarded multiple animals in one container as a problem that was now to be solved.

All of the vessels were now to be gathered on just one occasion per year, when all the mummies would be buried at once. At that time, there would be a procession of all the people of the area to bury both the ibises and the hawks. The names of the three reliable priests responsible for the god's income would be noted in writing, and the document with their names was to be placed in a sealed chest. The information about who had held responsibility for the burial of the ibises and the hawks was then passed to the priests of the Serapeum, the overall authority for the area.

Clearly, the reforms were largely a matter of establishing, and enforcing, stricter bookkeeping procedures. The measures were intended to prevent abuses by fixing responsibility for determining the precise income derived from food entering the temple and from the mummies themselves for each year. The names of the priests noted in the sealed chest firmly established their accountability for those figures. And the practice of gathering all the mummy offerings for one year in the House of Waiting provided a better chance to calculate an accurate annual total of the number of offerings, with their related fees.

Determining Prices

The archive contains two other references to financial reforms. The first gives instructions for paying the sums assessed for bandaging the animal mummies; the second regards paying salaries to the workers. Much is unclear in these important lines of the texts. What is clear, though, is that the sums paid for bandaging were now to be fixed prices, uniformly charged; and the salaries were now to be paid at one specific time and place, also in a fixed amount. The transactional value of these newly fixed prices and salaries, however, is difficult to discover, in part because the sums are measured both in "portion of the god" and in "silver." (John Ray has suggested that the "portion of the god" represents in-kind commodities.[19])

We are on somewhat firmer ground in addressing an additional cost—for the coffins occasionally used, which are sometimes adorned with fixtures. Though there is no evidence for the cost of the mummies themselves, the value of the bronze fittings and coffins can be determined simply by weighing them.

82

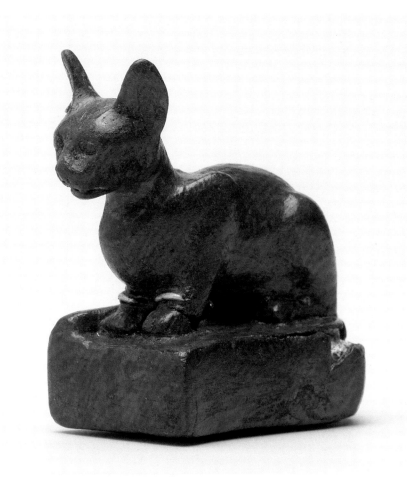

82. Cat-Form Three-*Deben* Weight
Analyzing historical units of weight and measure can help us to understand the market value that individual objects had in the ancient world. One ancient *deben* equaled approximately 90 grams.

From Saqqara, Egypt
Late Period to Ptolemaic Period, Dynasty 26 or later, 664–30 b.c.e.
Bronze
2 1/16 × 2 3/16 × 1 in. (5.2 × 5.5 × 2.5 cm)
Charles Edwin Wilbour Fund, 37.424E

83. Bronze Ibis Head
Sculpted bronze ibis heads were added to some ibis mummies, sometimes wrapped inside the linen bandages. They range in weight from as little as 1.5 *deben* (135 grams) to as much as 12 *deben* (1.08 kilograms). The price of these fixtures was based on the weight of the bronze used in them.

From Egypt
Late Period to Ptolemaic Period, Dynasty 26 or later, 664–30 b.c.e.
Bronze
3 5/8 × 4 1/4 in. (9.2 × 10.8 cm)
Gift of Evangeline Wilbour Blashfield, Theodora Wilbour, and Victor Wilbour honoring the wishes of their mother, Charlotte Beebe Wilbour, as a memorial to their father, Charles Edwin Wilbour, 16.580.156

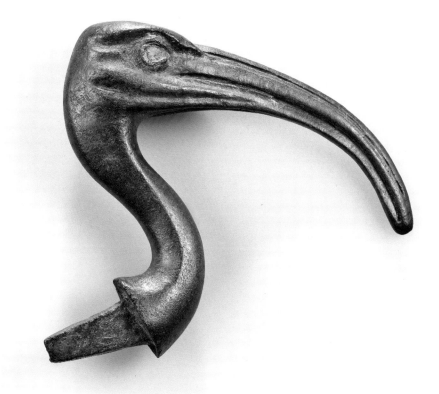

83

84. Ibis Leg and Foot
Sculpted bronze legs and feet could be added to ibis-shaped mummy coffins. Their weight in *deben* was used to calculate their price.

From Egypt
Late Period to Ptolemaic Period, Dynasty 26 or later, 664–30 B.C.E.
Bronze
2 7/8 × 2 1/8 × 9 5/8 in. (7.3 × 5.4 × 24.5 cm)
Charles Edwin Wilbour Fund, 37.385Eb

85. Ibis Coffin
Some coffins could be quite expensive, as measured by the weight of the bronze used in them. This one weighs 13.5 *deben* (1.22 kilograms).

From Saqqara, Egypt
Late Period to Ptolemaic Period, Dynasty 26 or later, 664–30 B.C.E.
Bronze
6 × 6 9/16 × 3 1/8 in. (15.3 × 16.7 × 8 cm)
Charles Edwin Wilbour Fund, 37.417E

This straightforward procedure at least establishes relative values, or what we would now call a price point.

Bronze fittings, such as sculpted heads attached to ibis mummies, and bronze coffins for a wide variety of animal mummies survive in good enough states of preservation that their weights can be tested against a known ancient measure of weight called the *deben* (figure 82). An Egyptian *deben* of bronze weighs 90 grams. The bronze heads, feet, and coffins in the Brooklyn Museum suggest the variety of price points available for these fittings for animal mummies: the four bronze ibis heads in the Brooklyn collection vary from one and a half *deben* to twelve *deben* in weight (figure 83); the bronze ibis foot in Brooklyn weighs four *deben* (figure 84). Therefore, assuming that two feet were needed, the bronze fittings of a head plus two feet could vary between 10 and 20 *deben*, a rather large amount for the average Egyptian.

Bronze coffins for animal mummies were also available in a wide variety of sizes, and thus prices. One snake and lizard coffin in the Brooklyn Museum weighs only half a *deben*. One bronze ibis coffin in Brooklyn weighs 13.5 *deben*, indicating a very large sum (figure 85).

In order to make sense of these numbers, we need to know how they related to salaries. Alan Bowman states that part-time agricultural laborers could earn 18 *drachma* per month during the first and second centuries C.E.[20] The *drachma* was introduced into Egypt by the Ptolemaic kings and was used during the period simultaneously with the older Egyptian measure of weight,

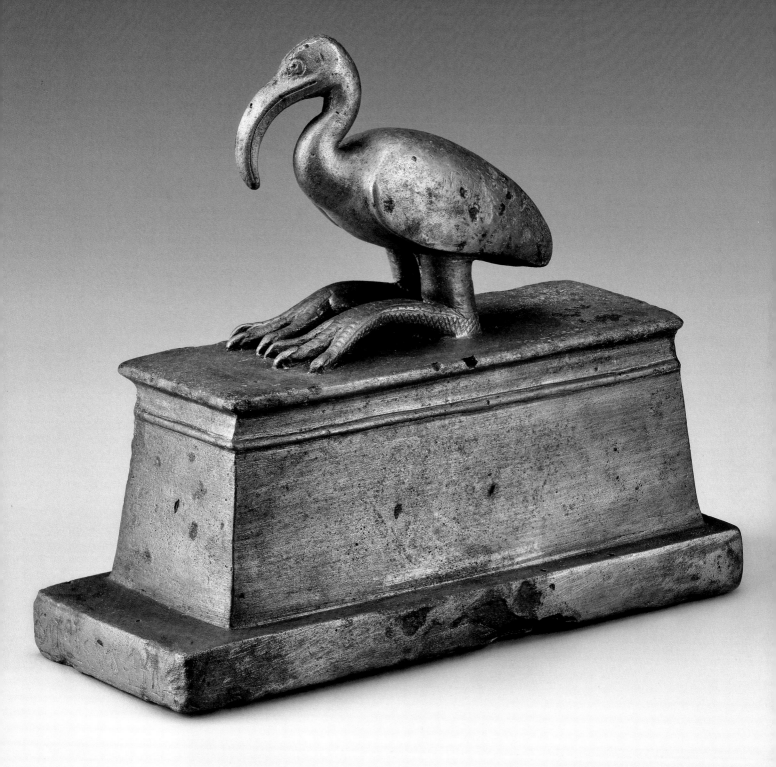

86. Ibis-Headed Thoth
The god Thoth was often portrayed as an ibis-headed human.

Temple of Ramesses II, Abydos, Egypt
New Kingdom, Dynasty 19, reign of Ramesses II, 1279–1213 B.C.E.
(Photo: © BasPhoto; used under license from Shutterstock.com, 56882323)

86

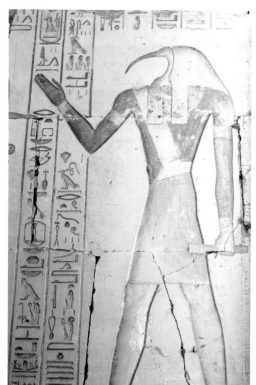

the *deben*. According to Miriam Lichtheim's calculations, each bronze *deben* was equal to 20 bronze *drachma*.[21] Using these admittedly conjectural figures from different time periods (which, unfortunately, are the only data available for these calculations), it is still obvious that the bronze fittings were very expensive: the smallest bronze coffin in the Brooklyn collection represents 40 bronze *drachma,* or more than two months' salary for a part-time agricultural laborer; the heavy bronze ibis coffin mentioned above would have cost 270 *drachma*, or fifteen months' salary for a part-time agricultural laborer.

All of these figures suggest that most Egyptians would have used animal mummies as messengers without such expensive extras. These bronze objects represent the tastes of the upper-middle-class priests and bureaucrats who could afford a slightly more luxurious version of an animal mummy to send their messages to the gods.

Conclusion

The mundane details of how an animal sanctuary operated financially from day to day, and what it charged its customers, may seem somewhat far removed from the spiritual role ascribed to the animals themselves as divine messengers. And yet, as the Archive of Hor reminds us, any large-scale organized religion will have its practical and administrative side, providing services to its believers and facilitating transactions in the performance of sacred rituals.

Animal worship and manufacturing animal mummies were both uniquely Egyptian cultural practices. No strict difference was recognized between a god with animal form and a god with human form; indeed, the hybrid representations of animal-headed humans, or human-headed animals, are among the most familiar images in Egyptian art (figure 86). As this might suggest, the Egyptians simply regarded all the living creatures made by the gods as retaining the potential for divinity within them. Religion did not foreclose the possibility that animals had a spiritual side and allowed that they could have a soul, just like a human. As we have seen, the animal's *ba* operated much like a human's *ba* and could perform supernatural work if guided by the human voice. Thus, animals associated with a particular god could be used, in a mummified form, to approach the god with a complaint, request, or vow that solved a problem in the here and now. The human world, the animal world, and the realm of the gods were not

entirely separate, and existed in a state of dynamic interaction, tied together in part by these messengers.

Yet no matter how much their foreign contemporaries admired other aspects of Egyptian culture—its antiquity, its wisdom, or its feats of engineering—none of them could find meaning in the idea that animals possessed, or were, the soul of a god. Greeks and Romans sacrificed animals to the gods and ate the sacrifices. For the Hebrews, animals were subject to human control from the beginning of creation. Jewish animal sacrifice during the time of the Temple of Jerusalem demonstrated the belief that clean animals were food sources for both people and God. Early Christians inherited this belief, and it was confirmed by early Christian writers even when both Christians and Jews abandoned animal sacrifice in the first century. As a result, these views have been firmly established in Western culture for over two thousand years. Our ancestors have passed along their distaste for the Egyptian idea of ensouled beasts to their modern descendants, and we still find it difficult to understand. Only now, as we use the tools of archaeology and cultural history to investigate this unique aspect of the Egyptian worldview, in its own right, do we begin to appreciate how animal mummies could be thought of as the souls of the gods.

Notes

1 Katherine C. Grier, *Pets in America: A History* (New York: Harcourt, Brace, 2007), p. 6.

2 Erik Hornung, "Die Bedeutung des Tieresimalten Ägypten," *Studium Generale* 20.2 (1967), p. 69.

3 In K.A.D. Smelik and E.A. Hemelrijk, "'Who Knows Not What Monsters Demented Egypt Worships?' Opinions on Egyptian Animal Worship in Antiquity as Part of the Ancient Conception of Egypt," in Wolfgang Haase, ed., *Principat: Religion* (Berlin: Walter de Gruyter, 1984), pp. 1997 and following.

4 Ibid., p. 1928.

5 Ibid., p. 1993.

6 Dieter Kessler, *Die heiligen Tiere und der König* (Wiesbaden: Harrassowitz, 1989). For connections between votive animal mummies and earlier Egyptian customs, see the Appendix to the present volume.

7 From the Archive of Hor, active 170-145 B.C.E. See *The Archive of Hor*, trans. John Ray (London: Egypt Exploration Society, 1976), Text 25, p. 92.

8 For further explanation of this earlier custom, see the Appendix to this volume.

9 Abd-el-Gawad Migahid, *Demotische Briefe an Götter von der Spät- bis Römerzeit: Ein Beitrag zur Kenntnis des religiösen Brauchtums im alten Ägypten* (Würzburg: Inaugural-Dissertation, 1986), pp. 13–19.

10 Kata Endreffy, "Business with Gods: The Role of Bargaining in Demotic Letters to the Gods and Graeco-Roman Judicial Prayers," in Andras Hudescz and Mate Petrik, eds., *Commerce and Economy in Ancient Egypt* (Oxford: Archaeopress, 2010), pp. 49–54.

11 P. Oriental Institute 19422; discussed in Migahid, *Demotische Briefe an Götter von der Spät- bis Römerzeit*, pp. 38–44.

12 Following John Ray, "An Inscribed Linen Plea from the Sacred Animal Necropolis, North Saqqara," *Journal of Egyptian Archaeology* 91 (2005), p. 175.

13 British Museum Papyrus 10857; discussed in Migahid, *Demotische Briefe an Götter von der Spät- bis Römerzeit*, pp. 122–29.

14 British Museum Papyrus 10845; discussed in Migahid, ibid., pp. 115–21.

15 From Michaelides Collection; discussed in Migahid, ibid., pp. 137–39.

16 This and the following, Ray, *The Archive of Hor*, pp. 117–24.

17 Ibid., p. 139.

18 Ibid., p. 143.

19 Ibid., p. 146.

20 Alan Bowman, *Egypt After the Pharaohs* (London: British Museum, 1986), p. 238.

21 Miriam Lichtheim, *Demotic Ostraca from Medinet Habu* (Chicago: Oriental Institute, 1957), p. 2.

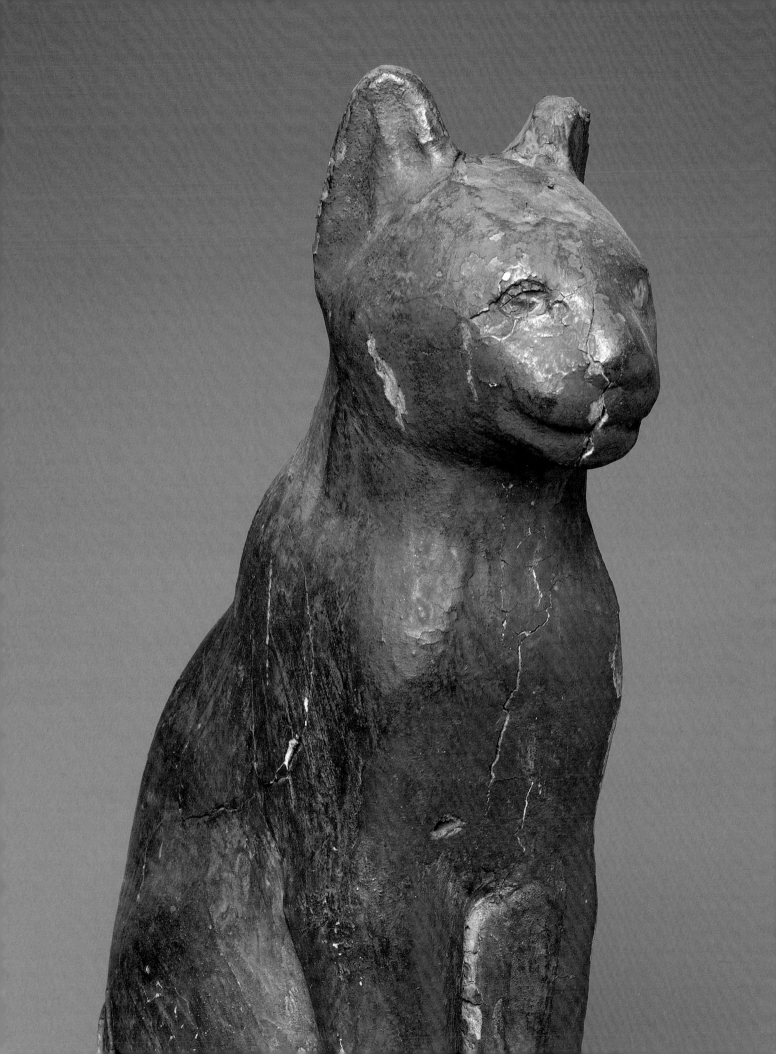

The Scientific Examination of Animal Mummies

LISA BRUNO

87

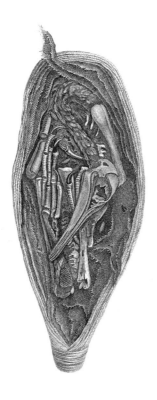

87. Ibis Mummy
As with nineteenth-century anatomical drawings for the medical field, this ibis mummy is depicted cut in half to reveal the interior. The result is not unlike what modern CT scanning achieves today.

From *Description de l'Égypte, ou, Recueil des observations et des recherches qui ont été faites en Égypte pendant l'expédition de l'armée française* (Paris: Imprimerie de C.L.F. Panckoucke, 1821–30), book 28: *Antiquités (Thèbes, Hypogées)*, A. vol. 2, pl. 53. Brooklyn Museum Libraries—Special Collections; Wilbour Library of Egyptology

ncient Egyptian mummies have always fascinated us. Among the most unusual types of mummies produced by the ancient Egyptians are, arguably, animal mummies. Millions of animals were mummified, for reasons that are not fully understood. Today, since there are no comparable traditions for this kind of practice on such a mass scale, it can be difficult to grasp why this practice developed and what it might mean. And yet, as every viewer of forensic-science television dramas knows, the remains themselves have their own hidden story to tell. Like an investigator or detective, one may begin to understand these mummies by looking at them closely, meticulously recording whatever data is evident. This scientific approach of systematically examining, describing, and identifying what is physically present does not often answer questions of motivation, but it does give a solid base on which to build ideas and theories.

Early Studies

Scientific methods of analysis have been used to examine and document Egyptian mummies almost since these objects were introduced to the Western world. The expeditions undertaken by Napoleon Bonaparte produced some of the first documentation of animal mummies (figure 87). Archaeologists in the late nineteenth and early twentieth centuries, such as Sir William Matthew Flinders Petrie (1853–1942), continued emphasizing the scientific method by clearly recording their observations in written archaeological reports. These reports built upon the ancient historical accounts of the process of mummification as recorded by such observers as the Greek historian Herodotus in the fifth century B.C.E. However, these ancient and early modern written observations, and the assumptions underlying them, were based on previous knowledge and experience rather than pure materials analysis. That is, since the techniques of analysis that we have today, which can identify a substance to an elemental or molecular level, did not yet exist, the early descriptions of the materials thought to have been used in ancient mummification practices were based instead on historical assumptions and anthropological records that may or may not have reflected the actual material used.

A primary example of the kind of early misconceptions that arose involves the supposed use of bitumen. Also known as

asphalt, bitumen is a black, viscous, petroleum-based substance, which through visual observation has long been associated with mummification processes; basically, since the black substance seen on unwrapped mummies simply looked like bitumen, that is what it was thought to be. To add to the misconception, the word *mummy* may be derived from the Persian word *moom,* which means asphalt or bitumen. The etymology of a word is something to consider when reading historical texts or descriptions of mummies, though it can be misleading. Consequently, in the early descriptions of mummies, nearly every black resinous material observed was characterized as bitumen, without the benefit of our current methods of analysis.

However, as early as 1908, Alfred Lucas, a chemist at the Cairo Museum, began investigating, and in 1914 he published a study proving that the embalming materials on Egyptian mummies did not include bitumen.[1] Although he was without the modern instruments now available for materials analysis, he did follow sound scientific principles, determining that the solubility of the dark brown substances on the royal mummies in the Cairo Museum was not the same solubility as bitumen; this allowed him to conclude that bitumen was unlikely to have been used.

What might have been utilized instead? Recent studies employing modern analytical techniques have also not found actual bitumen as an embalming material on mummies. Analyses performed on animal mummies from the Brooklyn Museum's collection have shown that the darkened resinous materials are most often waxes or coniferous resins, also sometimes referred to as pitch.[2] Indeed, a comparison can be made between the etymology of the words *bitumen* and *pitch* that may be of interest. Although in modern usage the word *bitumen* refers to dark, petroleum-based products, it is thought to have derived from the Sanskrit words *jatu,* meaning resin from a tree, and *jatu-krit,* meaning producing resin from a coniferous tree. The word *pitch* is a general term that can refer to both petroleum products and coniferous tree resins. Language can be deceiving, especially in historical accounts, but it can also be revealing. Since the derivation of the word *bitumen* has origins in plant-based material, it appears that at some point ancient historians may have been referring to the plant resin for mummification processes, but that this reference may simply have been lost in translation over the course of many hundreds of years, and through many languages and cultures.

As the bitumen misconception suggests, unless one knows exactly what substance has been used in the making of a mummy, it is best just to describe the material evidence as accurately as possible, without conjecture or supposition. The limits of the description will be a factor of the observational and scientific tools, such as microscopes and various spectrometers for materials analysis, that are available. Modern conservators and scientists will sometimes use what seems to be vague language to describe an object or material. Conservators, for example, would describe the brown substance seen on mummies as translucent, shiny, or dark. They may call it "resinous" or "bitumen-like" but would hesitate to call it a resin or bitumen per se unless this was confirmed by scientific characterization of the material. A vague-sounding description is often the most accurate level that can be achieved.

In addition to materials analysis, other scientific approaches emerged in early studies. State-of-the-art imaging tools have been used practically since their invention to study ancient Egyptian mummies. The German physicist Wilhelm Conrad Röntgen discovered X-rays in 1895, and in 1896 another German scientist, Carl Georg Walter Koenig, published a paper on the use of X-radiography to study artifacts; a cat mummy was included in the study. Also in 1896, the British doctor Charles Thurston Holland radiographed a bird mummy on site in an Egyptian tomb. Concurrently, the Austrian Egyptologist Alexander Dedekind used X-radiographs to distinguish between real mummies (those that contain an actual body) and so-called fake mummies (which contain nothing or only parts of mummified remains).[3]

In preparing for the exhibition *Soulful Creatures,* the Conservation Laboratory at the Brooklyn Museum examined and analyzed these unusual yet fascinating objects. Using observational tools such as stereomicroscopes, as well as different strengths of electromagnetic radiation, such as ultraviolet light, X-radiography, and computed tomography (CT), allowed us to see the physical construction of these objects in different ways. Analytic techniques, such as X-ray diffraction (XRD) and gas chromatography (GC), were employed on samples of the embalming resins and other materials in hopes of better identifying these substances, and more accurately characterizing the black resinous materials found on the animal mummies. And radiocarbon or carbon-14 dating (known as C14) was done on

several samples of the linen wrappings, to compare the physical age of the linen with the supposed age of the mummies. (The initial dating of the mummies was based on previous historical assumptions. Since the geometry of the wrapping patterns found on many animal mummies is similar to the decoration found painted on the walls of datable architectural structures, the thought was that they must be of the same time period.)

As a general rule, it is important to remember that in the study of these objects, one needs the combined resources of scientific observation, historical knowledge, and a secure art-historical and archaeological grounding. No single discipline can by itself encapsulate all there is to know or understand about these puzzling objects.

Analyzing the Mummies' Wrappings

At the outset of any investigation, the gathering of initial observations is basic. You start at the surface and proceed through the layers. Ultimately, a conservator wants to produce examination reports that describe the materials and construction of an object, as well as its current condition and state of preservation. We started our analysis of the Brooklyn Museum's animal mummies by recording the materials in the outer wrappings.

The fabric wrapping of mummies has traditionally been described as linen—a textile made from flax. The fiber from which linen is made comes from the inner bark of the flax plant and is known as a bast fiber. Bast fibers are easily distinguishable from other plant fibers, such as cotton, with polarized light microscopy. We used this technique to identify the fabric. This optical technique uses light waves vibrating in only one direction to view small material samples, including textile fibers, under magnification. Light rays can be polarized by directing them through specific filters in the microscope. The bending or splitting of light rays when they pass through a substance is called birefringence; different structures will bend the light in different ways, and this, along with certain physical structures in a plant fiber, can be diagnostic. For example, it is easy to distinguish cotton fiber, which appears twisted and transparent under magnification using polarized light, from linen, which is straight and exhibits small bumps, or dislocations, often seen as X-shaped marks or cross-markings running along the length of

the fiber. The X-shaped marks are structural elements present since the fiber was part of the plant. All bast fibers have these X-shaped marks, making more careful observation necessary to distinguish between different bast fibers, which include hemp and jute in addition to linen. Here is where the historical observation and archaeological data assist in the scientific observation. Early records and texts from 4000 B.C.E. tell of the existence of a linen textile industry. Although Egyptian cotton may be prized today, in ancient Egypt it was linen that was the textile of choice—which polarized light microscopy, a very basic scientific tool, confirms.

The processing of a plant into a textile fiber yarn involves cleaning, straightening the fibers, and spinning into a yarn. The process can be laborious and includes the removal of the woody skin of the stem, revealing the inner fiber. The final step in the processing, known as spinning, requires a spindle or spindle whorl. The spindle is a spiked tool, often weighted, to help tease out, stretch, and twist a mass of plant fibers into a yarn or thread for weaving into a textile. These plant fibers produce a yarn that is either twisted in the counterclockwise direction to produce a Z-twist single yarn or in the clockwise direction to produce an S-twist single ply. These single yarns can by twisted together to form yarns of several plies. Historically, and in the animal mummies included in our study, ancient Egyptian yarn has been found to be single ply with an S-twist.

In addition to noting the type of fiber, when recording the textiles employed on the mummies, the weave of the textile and shape and size of the strips forming the wrappings were recorded when possible. (Sometimes, these features are obscured by pigment, resinous deposits, or damages.) Most of the linen found on the animal mummies seems to be what is termed an unbalanced plain weave. In plain weave (also, interestingly, known as linen weave) the warp (the fiber running the vertical length of the fabric) simply passes over and under the weft (the horizontal fiber), filling in the spaces between the vertical fibers and thus creating the body of the fabric. The term *unbalanced* means that the warp and weft threads are not the same thickness, or the thread count is not the same in both warp and weft. With Brooklyn's animal mummies, sometimes the thread count was twice as much or more in one direction over the other. For example, in most of the un-dyed linens used in its wrappings, the cat mummy (figure 88) has 72 warp threads per inch, compared to only 36 weft threads per inch. In addition, we found that more than one type of linen fabric has been

88

used in the wrapping; strips of a slightly darker, dyed linen contain 60 to 62 warp threads per inch, versus only 26 weft threads per inch. It is an indication that many different pieces of fabric were often used to wrap one mummy, suggesting that linen from other sources, such as garments, may have been recycled or reused.

The sizes of the strips wrapping the mummies vary, depending on style, but often, in all but the most plainly wrapped mummies, the raw or cut edges have been slightly folded down to make a neat and clean line. The fold is small, possibly to reduce the amount of fabric lost and/or create less bulk for an intricate wrapping.

Most of the wrappings are un-dyed, exhibiting the natural hue of the flax fiber. Some are colored a deep brown. The brown fabric seems to have been primarily a decorative accent. The textiles are for the most part in surprisingly good condition given their age, remaining supple and pliable. The sections of linen that show the most breakdown of the cellulose, the structural component of plant fibers, are those most intimately in contact with the materials of the mummification process, and those fabric wrappings that were intentionally dyed brown. Although we were unable to determine the exact material used to dye the fabric brown, it likely involved an iron compound. Iron is known to cause a breakdown of cellulose. Indeed, when examined with a portable X-ray fluorescence tool, the brown fabric on the hawk mummy

88. Cat Mummy
A before-treatment image of a cat mummy showing different strips of linen and their weave structure. Photographs like this one—incorporating a scale, a color card, the object's accession number, the date of the photograph, and the treatment status (in this case, BT signifies "before treatment")—are standard practice in documenting conservation work on museum objects.

From Egypt
Ptolemaic Period to Roman Period, 305 B.C.E.–395 C.E.
Animal remains, linen, painted
2 1/2 × 14 1/2 × 3 1/2 in. (6.4 × 36.8 × 8.9 cm)
Charles Edwin Wilbour Fund, 05.307

89

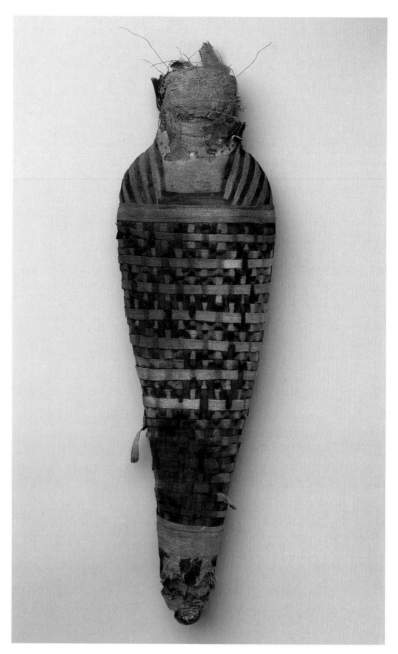

89. Hawk Mummy
An intricately wrapped mummified hawk showing deteriorating brown-dyed strips of cloth. Note where the brown strip has completely deteriorated, but left a darkened mark on the underlying un-dyed linen.

From the ibis cemetery at Abydos, Egypt; excavated by the Egypt Exploration Fund
Roman Period, 30 B.C.E.–395 C.E.
Animal remains, linen
4 ¹³⁄₁₆ × 16 ⁵⁄₁₆ × 2 ⁵⁄₈ in. (12.2 × 41.4 × 6.7 cm)
Gift of the Egypt Exploration Fund, 13.1092

was found to contain iron (figure 89). This finding alone may not be definitive, however. In this kind of analysis, high-energy X-rays or gamma rays hit particular elements or materials, and the energy bounces back in ways that are specific to that material; the reflected energy can then be captured and read to determine what elements are present. The advantage of this materials analysis technique is that a physical sample does not have to be taken, and it is therefore non-destructive to the object. The disadvantage, however, is that the detector reads not only the surface elements but also a small range below, depending on the density of the object. Therefore, iron detected in a surface analysis of brown fabric might be attributed to something below the linen. Again, here is where multiple perspectives are needed to interpret the

data. Analyses of textiles from other collections indicate that iron, in the form of iron oxide clays, has been found to be a dyestuff to produce brown for ancient Egyptian textiles, while plant-based dyes have been found to produce blue, red, and possibly yellow colors. This analysis of objects in other collections, as well as the knowledge of how iron-based colorants affect cellulose, help to conclude, with the materials analysis of the hawk mummy, that iron is a likely colorant for the brown textiles.

The hawk mummy pictured opposite was acquired from the Egypt Exploration Society in 1913, and it has a known excavation site, the ibis cemetery in Abydos, Egypt. Because of the relative unimportance ascribed to these animal mummies in the history of archaeology until very recently, most of them were collected without the benefit of recorded archaeological data from controlled excavation sites. This results in the loss of contextual information that might have been useful in interpreting these mummies. To compensate for some of that loss, the sharing of accurate, systematic records of wrapping patterns between collections may someday help in the identification of sites of manufacture, or at least provide a more comprehensive account of the types of wrappings employed across ancient Egypt.

Seeing Inside the Mummies

After looking at the animal mummies and recording what is visible on the outside, the scientific investigation continues with the use of X-radiography, a non-destructive method of seeing inside an object without actually having to peel away its outer layers. Despite the early use of X-rays as a tool to examine mummies, they were often also unwrapped to see what was inside. Unfortunately, much information was lost, because the outer components were not thoroughly described or photographically documented before being removed and discarded for the supposed greater treasure lying inside.

Like visible light, X-rays are electromagnetic radiation. They move in space in a wave pattern that is outside the range seen by the human eye and even shorter than the wavelengths of UV light. The shorter the wavelength, the higher the intensity of the radiation and the more powerful the wave. These waves can pass through most materials and are blocked only by denser matter, such as metal and bone. Historically, the image produced

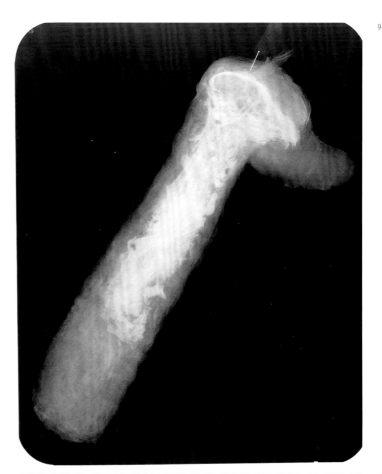

90. Dog Mummy (X-radiograph, 1939)
The X-ray of the dog mummy shows a
compressed skeleton with the tail tucked
between the hind legs. The individual bones
are difficult to distinguish. The pin, being
denser than the bones, appears whiter on the
radiograph.

From Egypt
Ptolemaic Period to Roman Period,
305 B.C.E.–395 C.E.
Animal remains, linen, painted
3 1/4 × 18 × 7 in. (8.3 × 45.7 × 17.8 cm)
Charles Edwin Wilbour Fund, 05.308

91. Snake Coffin with Mummy
(X-radiograph of mummy)
(see figure 108)
In this direct-capture digital X-radiograph
(using a RayzorXPro Imager from Vidisco),
the image was controlled so as to show the
dense materials in the bundle and remove
most of the linen by overexposure.

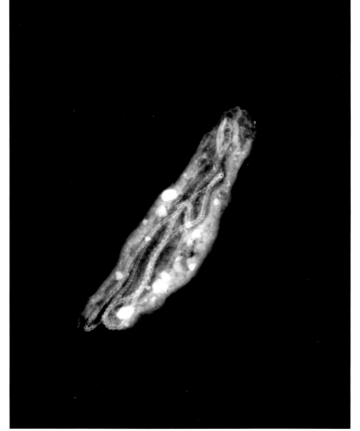

by the X-rays was recorded on film. The X-rays selectively pass through the less dense parts of the animal mummy and hit the film placed below the subject mummy. The film is black where the rays have passed through nothing but air; white, where the rays have been entirely blocked by some very dense material and have not hit the film at all; and shades of gray, depending on the in-between density of the material they are passing through. The densities of all the layers the X-rays pass through are superimposed and recorded on the same film, providing a two-dimensional image of a three-dimensional object.

X-rays were taken of animal mummies early on at the Brooklyn Museum. One dog mummy was X-rayed in 1939 (figure 90). The X-ray shows the dense and compact skeleton of the dog within the upper two-thirds of the wrapped mummy form. The individual articulations of the bones are difficult to distinguish due to the compacting of a three-dimensional object into this two-dimensional image, while the densities of the bones make it difficult to distinguish individual parts. The small metal pin is a restoration done in the past to keep the fragile ears of the mummy wrappings, which were formed from small triangles of cut linen, in place. Also note how much of the mummy's dog shape is formed from bunches of linen. The animal is enclosed within only a small portion of the actual sculptural form created by the wrapping.

As technology changes, X-radiographs are now being recorded digitally. The Brooklyn Museum has an X-radiograph system that saves the data generated by the X-ray directly as a digital file. The advantage is that the image is instantaneous and can easily be manipulated. The radiation intensities can be adjusted for the materials present to provide clearer, more articulated images. For example, the digital X-ray taken of a snake mummy was manipulated to show the internal bones and dense, small, granular shapes within the mummy bundle while reading through, and not recording, the lower-density linen of the bundle (figure 91).

Historically, X-radiographs have been viewed in negative images, meaning the dense solid parts are lighter than parts with less solid material. With digital X-radiographs, however, these images can be reversed to read like a positive, which might assist in the interpretation of the data. Digital X-radiographs of the mummy of a young crocodile, in the collection, show the difference. The traditional X-radiograph presents a negative image: the light form of the mummy on a dark background (figure 92). The mummy's bones are more articulated, because they are denser than the skin

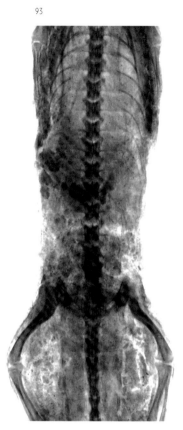

92. Crocodile Mummy
(negative X-radiograph)
Direct-capture digital X-radiograph (using a
RayzorXPro Imager from Vidisco) showing
the body of a young crocodile mummy as a
negative image. The linens are not visible
because of the intensity of the radiation.

From the crocodile cemetery at Kahun;
excavated by the British School of
Archaeology
Roman Period, 1st century C.E.
Animal remains, linen, white tape
2 × 29 1/2 × 4 3/8 in. (5.1 × 74.9 × 11.1 cm)
Museum Collection Fund, 14.668

93. Crocodile Mummy
(positive X-radiograph)
(see figure 92)
This second direct-capture digital
X-radiograph shows the body of the same
young crocodile mummy as a positive image.

and interior components. When converted to a positive image, the digital radiograph shows a different articulation that may be easier for some viewers to read (figure 93).

The disadvantage of traditional X-radiographs, whether film-based or digital, is that they compact three-dimensional objects onto one image plane. As a result, a more dense material will inevitably obscure a less dense material. X-ray computed tomography (CT or CAT scanning) solves this problem by isolating X-ray images in discrete slices through an object. The X-ray tube spins around the object being examined, selectively gathering information from all angles. The beauty of the technique is that the slices can be in the axial plane or cross section of the object; the coronal plane (also known as the frontal plane), providing slices through the object from front to back; and the sagittal plane, providing slices through the object from left to right. These slices can be viewed individually, or as a series to produce a moving internal image, or manipulated to show a three-dimensional image of one specific interior plane. For example, with an ibis mummy, all of the digital information pertaining to the wrapping, and the ibis's skin and feathers, has been digitally

94 95

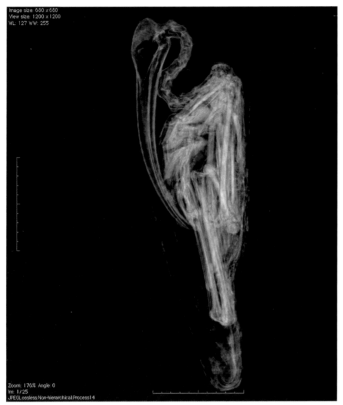 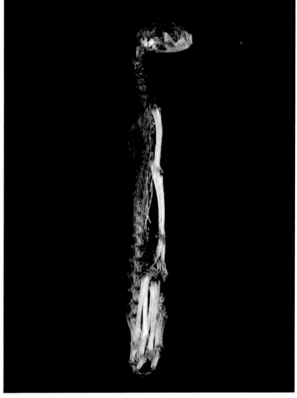

stripped away to show the bone structure alone within the mummy bundle, allowing us to clearly isolate the components (figure 94). Another excellent example of this technique concerns a cat mummy (figure 95). Unlike traditional X-radiographs, this technique allows researchers to separate out areas of the X-ray for individual viewing. What can clearly be seen for both the ibis and the cat is a careful placement of the body parts. The ibis's head and neck have been carefully turned back on itself and tucked along the spine. The cat's tail is carefully tucked between its hind legs, and its front paws align with the belly.

Examining a mummy originally thought to be a bundle of snakes (figure 96) illustrates the differences in clarity between traditional film X-radiographs, digital X-radiographs, and CT scans. The film X-ray was taken in 1989 (figure 97): it shows an amorphous mass of web-like radiopaque material within the mummy bundle; teeth might be visible. The digital X-ray was taken in 2009 (figure 98): because of the ability to better control the X-ray exposure, the amorphous mass begins to take shape as hollow straight elements, which can be indicative of bones. CT scans take us further, isolating and articulating sections (figure

94. Ibis Mummy (CT scan)
The CT scan isolates the bones alone in this profile image of a beautifully positioned ibis mummy.

From the ibis cemetery, Abydos, Egypt, excavated by the Egypt Exploration Fund
Late Period to Ptolemaic Period, Dynasty 28 or later, 404–200 B.C.E.
Animal remains, linen
5 5/16 × 15 9/16 × 5 1/2 in. (13.5 × 39.5 × 14 cm)
Gift of the Egypt Exploration Fund, 14.651
(Scan by Anthony J. Fischetti, DVM, MS, The Animal Medical Center, New York)

95. Cat Mummy (CT scan)
CT scan showing only the bones in profile of this dense and tightly wrapped cat mummy. For another image of this mummy, see figure 8.

96. **Shrew Mummy Bundle**

This plainly wrapped mummy bundle contains shrews (but was once thought to contain snakes). Note the contrast with the more elaborately wrapped hawk mummy in figure 89.

From Egypt
Late Period to Ptolemaic Period, Dynasty 26 or later, 664–30 B.C.E.
Animal remains, linen
4 3/4 × 1 1/16 × 8 1/4 in. (12.1 × 2.7 × 21 cm)
Brooklyn Museum Collection, x1179.2

97. **Shrew Mummy Bundle**
(X-radiograph, 1989)
(see figure 95)

In this decades-old X-ray, dense areas in the mummy bundle are shown without much clarification. Some teeth may be seen in the lower right-hand corner.

96

97

99): the seeming bundle of snakes turns instead into a rather impressive bundle of some type of shrew, numbering at least twenty individuals.

Another advantage of CT scans over traditional X-rays is the ability to better articulate soft tissue or less dense materials. CT can articulate differences in density of approximately 1%, allowing for clearer images of materials that have similar densities. An excellent example of this very principle can be found with an ibis mummy (figure 100). The mummy was excavated from the ibis cemetery in Abydos by an expedition funded through the Egypt Exploration Society; it was acquired with a group of objects by the Brooklyn Museum in 1914, as part of an exchange for funding of the excavation. The mummy is

98

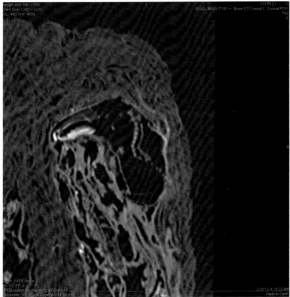

99

98. Shrew Mummy Bundle (X-radiograph, 2009)
(see figure 96)
With the same mummy, a direct-capture digital
X-radiograph (using a RayzorXPro Imager from
Vidisco) shows slightly greater clarity in the dense
mass within the bundle.

99. Shrew Mummy Bundle (CT scan)
(see figure 96)
One small portion of the bundle was isolated and
manipulated until the profile image of a single
shrew emerged.

(Coronal CT scan by Anthony J. Fischetti, DVM,
MS, The Animal Medical Center, New York)

an anthropoid form with an attached carved wooden and resin-
covered ibis head and elaborate triple-*atef* headdress. The linen
wrappings are thin and intricate, formed into a herringbone
pattern of alternating dark brown and natural linen. It is one
of the most spectacularly wrapped animal mummies in the
Museum's collection. Because of the exterior appearance and the
elaborate wrapping, when the X-radiograph did not show a whole
animal, there was surprise (figure 101). From the X-ray, all that
could clearly be distinguished were a few random unidentified
bones and some dense material, possibly stones. We decided to
do a CT scan, to gain further insight.

Many animal mummies do not contain whole animals. Those
have been traditionally known as "fake" or "false" mummies. It has

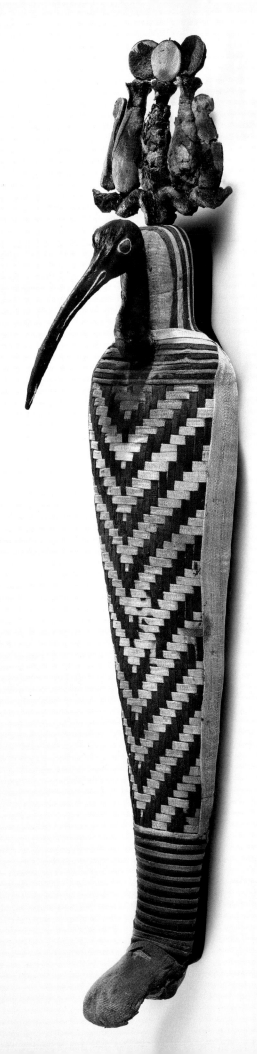

100

100. Ibis Mummy
The elaborate wrapping here takes the form of a human mummy, into which is inserted the carved wooden head of the ibis. Note the raised and articulated foot at the bottom. For other views, see figures 101, 102.

From the ibis cemetery at Abydos; excavated by the Egypt Exploration Fund
Early Roman Period, 30 B.C.E.–early 1st century C.E.
Animal remains, resin, linen
4 ¹³⁄₁₆ × 29 ⁵⁄₁₆ in. (12.3 × 74.5 cm)
Gift of the Egypt Exploration Fund, 14.655

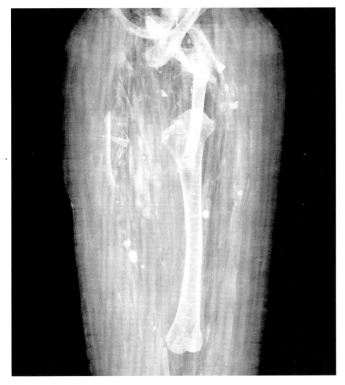

101. Ibis Mummy (X-radiograph)
(see figure 100)
The X-ray (using a RayzorXPro Imager from Vidisco) shows a detail of the upper portion of the same ibis mummy bundle, just below the attached wooden head. A few random bones are visible on the inside.

102. Ibis Mummy (CT scan)
(see figure 100)
The CT scan shows a cross section or transverse view of the same ibis mummy. The entire mummy bundle is stuffed with feathers, as evidenced by the hollow spheres of the quills as seen in cross section.

been supposed that these incomplete examples were the result of lack of resources to meet demand, or possibly of outright fraud. A CT scan of the ibis mummy provided a clearer understanding of what was going on internally. Since the CT scan can isolate planes within the structure, and better articulate images produced by materials of similar densities, it now became possible to see the structure of feathers within the entire bundle (figure 102). (The X-rays are simply too powerful to differentiate the density of feather from linen, making the feathers nearly invisible with traditional X-ray technology.) Although the mummy still does not contain a whole animal, it does contain an abundance of feathers, and clearly it was meticulously and elaborately wrapped. Since the ibis mummy was so carefully wrapped and decorated, it is hard to imagine that it was anything close to being faked, fraudulent, or a low-budget item. Though our analysis of the ibis mummy may not explain what was going on in the minds of the Egyptians who made it, it certainly does contribute new evidence toward better understanding the issue of fake or false mummies. Some of them might just be more special than originally thought: maybe some of these "fake" or "false" mummies contain parts of a very special individual animal, much like reliquaries for saints and other religious figures.

103

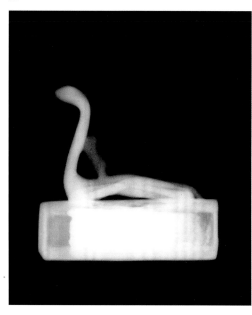

103. Snake Coffin (X-radiograph)
X-radiograph of a sealed bronze coffin showing a
dense material inside. (Made using a RayzorXPro
Imager from Vidisco)

From Egypt
Late Period, Dynasty 26 to Dynasty 31, 664–332
B.C.E., or later
Bronze
2 15/16 × 3 1/8 × 1 7/16 in. (7.5 × 7.9 × 3.6 cm)
Gift of Evangeline Wilbour Blashfield, Theodora
Wilbour, and Victor Wilbour honoring the wishes of
their mother, Charlotte Beebe Wilbour, as a memorial
to their father, Charles Edwin Wilbour, 16.600

CT scans are not the answer to all problems, though, in imaging animal mummies. Several of the mummies in the collection remain sealed within coffins. When the coffins are made of wood, or another less radiopaque material, like cartonnage, CT scans can be used to penetrate the coffin to image what is inside. However, when the coffins are made from metal, the outer coffin is usually too dense to permit penetration. The X-rays from a CT scanner will bend and scatter upon hitting a very dense metal object, creating a pattern that obscures anything that may lie within. Here is where traditional X-rays actually do work better, but are still only useful to a point. One example is a copper-alloy coffin of a snake. The X-rays do reveal a radiopaque interior form held within this hollow rectangular coffin decorated with two snakes on the top (figure 103). Alas, beyond confirming that there is something inside that is more radiopaque than the metal used to make the coffin, the X-rays can tell us little with certainty. The outer coffin contains copper, attested by the presence of green corrosion, and is likely copper mixed with tin, lead, and other trace elements—a mixture called bronze. Without conducting materials analysis to determine precisely what elements are present, conservators and metallurgists would simply call this a copper alloy. There are other alloys of copper that include other types of metals. The material inside this coffin is whiter in X-ray, and therefore denser, than the surrounding copper alloy. One guess would be that it is pure lead, one of the densest elements existing. There has been some evidence of lead used as a core material around which to cast the other metal alloys,[4] but with the readily available methods of scientific analysis and instrumentation, we cannot know.

Issues of Date and Material

In addition to the issues of fake or false mummies and their meaning, the perplexing question of the age of these objects has vexed scholars for some time. Traditionally, they have been dated to the Ptolemaic and Roman Periods, 332 B.C.E.–first century C.E. This dating was based purely on an aesthetic interpretation of their wrapping styles. The elaborate herringbone patterns found on the animal mummies have also been found on Roman Period human mummies and architectural elements. Now, with radiocarbon dating, a more accurate method is available for

104

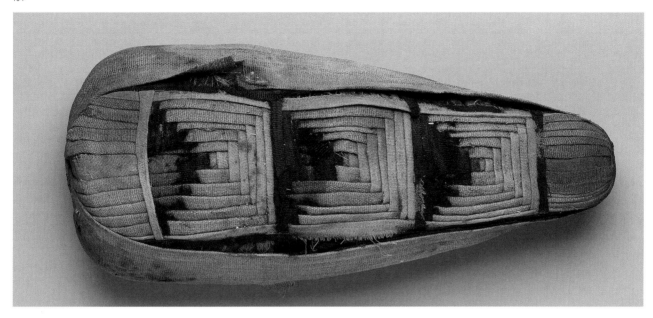

dating objects. The principle behind radiocarbon dating is a complex one involving measuring the half-life of radioactive carbon (C14). Any organic material, such as linen, contains carbon. Some radioactive carbon will be present, and this can be measured using C14 analysis. Up until very recently, the sample size needed to get an adequate measurement of this small amount of decaying radioactive carbon made it too destructive for the examination of art objects or portable cultural material. Now, however, with the development of Accelerated Mass Spectrometry (AMS), the detection of this decaying carbon can be amplified, reducing sample sizes to around 5 mg or less.

Another mummy of an ibis is an example of an elaborate wrapping that, based on style alone, was originally catalogued with the dates 30 B.C.E.–395 C.E., putting it solidly in the Roman Period (figure 104). The bundle was X-radiographed and a whole ibis was found to be contained within. In order to gain more information on the possible date or age, the linen from this mummy was sampled. Pieces of the fabric were removed and sent to the National Science Foundation AMS Laboratory at the University of Arizona, Tucson, for radiocarbon analysis. The results of the analysis indicate a date of 400–110 B.C.E., placing it much earlier than the Roman Period. Does this change the date of the object? The important thing to keep in mind about radiocarbon dating is that it does not give the age of the object specifically: instead, it gives the end date of when the organic

104. Ibis Mummy
A triangular mummy bundle containing a whole ibis.

From Egypt
Late Period to Ptolemaic Period, Dynasty 28 or later, 404–110 B.C.E.
Animal remains, linen, paint
4 3/4 × 10 5/8 × 2 15/16 in. (12.1 × 27 × 7.5 cm)
Brooklyn Museum Collection, x1179.4

105

105. Hawk Mummy (X-radiograph)
The X-radiograph appears to show a single wing contained within the mummy bundle. The outer form of this mummy (figure 89) is that traditionally used for birds of prey. It is unknown whether this wing is from a hawk.

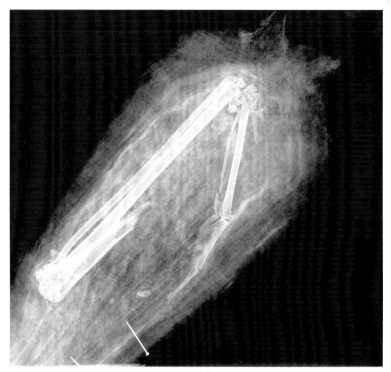

material—in this case, the flax used to make the linen—stopped growing. The date represented is the point in time when the plant was harvested to be processed into cloth. One wonders what the process of reuse was for linen in ancient Egypt. Could linen that was produced in 350 B.C.E. have been saved and reused 320 years later? There are other precedents for re-use in ancient Egyptian society,[5] so in theory it is possible. Although a limited sample size, all of the linen samples sent for analysis as part of our current study came back dating much older than had originally been thought.[6]

Now that the mummies have been examined both from the outside and within, the question of looking at the materials used to create the mummies remains. Sampling of the resins used in the mummification process was a large part of the study done at Brooklyn. Although the historical literature on mummification constantly cites the use of bitumen, as discussed above, none of the samples from animal mummies in Brooklyn's collection sent for analysis were found to contain bitumen.[7] The samples were analyzed using gas chromatography (GC), an analytical method that vaporizes and separates materials during the analysis.

Alfred Lucas, in his landmark early publication on ancient Egyptian materials,[8] including mummification, concentrated on

materials for royal human mummies. How does this compare with mummification methods in later periods of history, on non-royal subjects, or on animal mummies? While researching the animal mummies in the collection, we also looked at the human mummies. Samples of resins from a royal mummy in Brooklyn's collection, Royal Prince, Count of Thebes, Pa-seba-khai-en-ipet (acc. no. 08.480.2d), which dates to 1188–909 B.C.E., were taken as well as samples from a Roman Period mummy, 95–100 C.E., the red shroud mummy of Demetrius (acc. no. 11.600). Two types of gas chromatography analysis were used on the samples: high-temperature gas chromatography, and gas chromatography coupled with mass spectroscopy. Both of these techniques are used to clarify and analyze extremely small samples. On the older, royal mummy, the presence of a fat or oil was detected. On the Roman-era mummy, both a fat or oil and a coniferous resin were detected. On the animal mummies, the single most common material detected using the same methods of analysis was also a fat or oil, followed by a coniferous resin. While it is risky to draw conclusions from the limited number and small size of samples taken, it seems fair to say that the resin used for mummification of animals is the same as was often used for humans.[9]

During our research, multiple samples were taken from twenty different animal mummies in the collection. Results could not be obtained from eight of the twenty mummies, which exemplifies the difficulties that can arise with this kind of analysis. The sample was either too small or too degraded to yield any conclusive evidence. Two of the samples came back with indications of sugar, which most likely came from the linen used in the wrapping and not from embalming material. One sample was found to contain animal fat only and was most likely an indication of the tissue of the animal and not the materials used during mummification. Nine of the samples did contain a fat or oil, as was found on the human mummies. Seven of those nine were found to be mixtures. The mixtures were either fat or oil and coniferous resin, or pitch, but sometimes they were also found to contain a wax.

Sometimes the results of analysis can be very specific, but these results may not be helpful in lending meaning to the objects. Triterpenoid resin was identified specifically on three samples from very different objects. They came from a mummy in the shape of a hawk (figures 89, 105), from remains within a copper-alloy shrine for a bird mummy (figures 21, 106), and

106

106. Animal remains from **Bird Coffin of Iihetek** (see figure 21)
The remains found within a copper alloy coffin for a bird mummy.

107. Ibis-Form Mummy in Jar
An ibis-form mummy in its burial jar.
Notice the white material surrounding
the edge of the ceramic. This was used to
secure the lid, now missing.

From Egypt
Late Period to Ptolemaic Period, Dynasty
27 or later, 510–210 B.C.E.
Pottery, linen
16 × 8 ½ × 7 in. (40.6 × 21.6 × 17.8 cm)
Charles Edwin Wilbour Fund, 37.1952Ea–c

from the rectangular mummy bundle of shrews that we saw earlier (figure 96). Triterpenoid resin is noteworthy as it could be an indicator of the familiar resins mastic, frankincense, or myrrh. Interestingly, however, this very specific data does not necessarily correspond to a special mummy. The hawk mummy, which shows in X-radiographs to possibly contain a bird's wing (figure 105), is beautiful and well wrapped; the copper alloy bird mummy shrine does not contain a recognizable animal mummy, but an odd assortment of hard aggregate (figure 106); and the mummy bundle of shrews is a rough, loosely wrapped lozenge with alternating linen strips and linen thread barely holding the package together (figure 96). The analysis is specific, but may not reveal much interpretive information.

Materials analysis data is not only limited to the tools available to the scientist or researcher. The interpretation of the data is itself limited to the number of comparative samples, and the accuracy and reliability of those samples. One sample from one animal mummy could give specific information, but the value of that information is dependent on context. Both age and deterioration may obscure the amount of reliable data that can be synthesized from analysis. More samples from other animal mummies will need to be obtained and shared in order to make better connections and come to some conclusions about these unusual objects.

Coffins and Containers

Another component of our study concerned the coffins and portable shrines sometimes associated with animal mummies. An example of a common burial housing included in this exhibition is a mummy in the form of an ibis, found in a burial jar (figure 107). Using C14, the linen wrappings date to 510–210 B.C.E., making this one of the older C14 dates obtained. Yet X-radiographs do not seem to confirm the presence of animal remains. The coffin consists of a simple, conical, low-fire ceramic containing the mummy wrappings. Traces of the white plaster material used to seal the coffin are evident.

Whether a shrine, cartonnage, coffin, burial jar, or other container was saved and has remained with the mummy is often a matter of chance. Although not all excavations have found animal mummies in such containers, it is possible that some of the mummies in the collection once had containers, which have

107

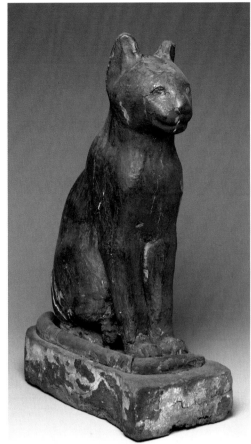

been lost along the way. Many of the animal mummies came into the collection without any container; did they originally have one? Sometimes, containers that had survived were not saved, if it was decided that they were not of value at the time of collection or excavation, or even at some later point. This practice, unfortunately, was not restricted to mummies of animals: the simple wooden coffin that contained the mummy of an anonymous man (acc. no. 52.128) was not collected at the time of excavation.[10]

Nonetheless, many mummies did come into the collection with a container or shrine of some type. Most are simple wooden boxes with minimal pigment. Some of the boxes are shaped like the mummies they contain, such as figure 108; a simple wooden coffin with a snake carved on the lid does in fact contain a mummified snake. The best examples of these types of coffins are the very sculptural standing coffins of cats (figure 109).[11]

Sometimes the container was deemed the only portion of value. In the exhibition, there is a common burial jar that once contained an ibis mummy collected from the ibis cemetery in Abydos (figure 80). The catalogue notation from 1940 indicates that the mummy was in deplorable condition and that it was necessary to destroy it. It is quite possible that the mummification process was not entirely complete and the mummy had started to decay in the ambient conditions of museum storage at that time. However, it was destroyed without producing any written description of the mummy, or taking photographs or X-radiographs, and without retaining any samples for later analysis. In contrast, current museum practices emphasize the importance of such documentation.

Curators and conservators were able to make use of samples from a less well-preserved mummy inside a cat-form coffin (figure 67). Bone samples were taken and sent to Dr. Leslie Lyons at the University of California–Davis to be included in a study looking at whether there is a link between ancient cat DNA

108. **Snake Coffin with Mummy**
A mummified snake with its wooden coffin. The lid shows a simple carved snake.

From Egypt
Late Period, Dynasty 26 to Dynasty 31, 664–332 B.C.E.
Wood, animal remains, linen
1 7/8 × 2 1/2 × 7 7/8 in. (4.8 × 6.4 × 20 cm)
Charles Edwin Wilbour Fund, 37.1358Ea–c

109. **Cat Coffin with Mummy**
Cat-form wooden coffin containing a whole mummified cat.

From Egypt
Late Period, Dynasty 26 to Dynasty 31, 664–332 B.C.E.
Wood, glass, gesso
23 13/16 × 7 1/2 × 14 3/4 in. (60.5 × 19 × 37.4 cm)
Charles Edwin Wilbour Fund, 37.1946E

110

111

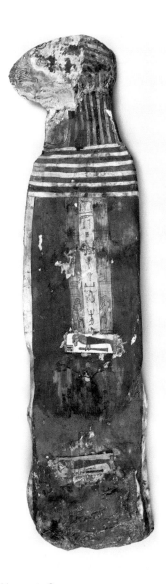

110. Cat Mummy in Cartonnage
Cartonnage for a large mummified cat of the
wild variety (*Felis chaus*).

From Egypt
Third Intermediate Period to Late Period,
Dynasty 25 to Dynasty 29, 760–380 B.C.E.
Cartonnage, animal remains, linen
4 ⅞ × 35 ¼ × 10 in. (12.4 × 89.5 × 25.4 cm)
Charles Edwin Wilbour Fund, 37.1991Ea–c

and the modern cats found in present-day Egypt. Their analysis
indicates that there does in fact exist a genetic link between
modern cats and those used in these ancient Egyptian rituals.
This kind of scientific analysis will not necessarily shed any light
on the purpose and meaning of the object, or add details as to how
the object was made, but it does contribute to how these objects
connect with us now. Although working with ancient DNA can be
even more difficult than working with samples for GC analysis,
and the sample size at present has to be rather large (a whole
femur was needed for the analysis), the curators and conservators
determined that the deteriorated condition of the mummified cat
made it appropriate for such a large sample to be removed and
used for scientific research.

Some containers are quite highly decorated, such as the
cartonnage for a cat mummy (figure 110) and the polychromed
stone coffin for another cat mummy (figures 66, 111). The coffins
of both of these animals have aesthetic elements that are similar
to coffins used for human mummies. This cartonnage was made
from many layers of linen and glue molded around the mummy
and then covered with gesso and paint. This form is common
for earlier period human mummies. The stone coffin is a simple
rectangular shape, not unlike a wooden coffin (such as acc. no.
37.1602E). However, the permanence and durability of stone, as
well as the painted decoration, make this coffin special. In our
study, pigments on the stone coffin were identified using the

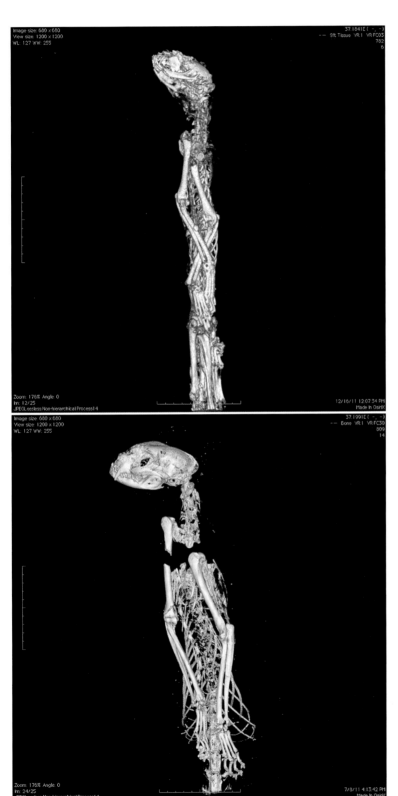

111. Sarcophagus and Cat Mummy
Mummified cat within polychrome limestone
coffin. For a side view, see figure 66.

112. Sarcophagus and Cat Mummy
(CT scan)
(see figure 111)
CT scan of the cat mummy showing only
the bones.

113. Cat Mummy in Cartonnage (CT scan)
(see figure 110)
CT scan of a cat mummy showing only the
bones. The head separated from the body
after mummification.

polarized light microscope for the colorants; the blue is a glass frit known as Egyptian blue. Egyptian blue is thought to be the world's first manufactured pigment and is a mixture of copper, silica, and an alkaline component such as potash. These were materials also used in the making of Egyptian faience, a glass-like material unique to ancient Egypt (see figure 17). The green pigment is also a manufactured frit similar to Egyptian blue, and the yellow is orpiment from the mineral arsenic sulphide.

The cartonnage and the coffin both contain whole cats. The stone coffin holds a domestic species of cat, *Felis sylvestris libyca,* while the cartonnage is for a non-domesticated wild cat known as *Felis chaus.*[12] X-radiographs and CT scans of both mummies show the animal placed within the mummy bundle with the forelegs and paws carefully laid on the belly of the body or crossed over the elongated cat's groin, a placement much like that of human mummies (figures 112, 113). Since these coffins are special containers and the mummified cats are also positioned in exactly the same way as human mummies, one might consider that there is some connection or elevation of these animal mummies to the status of humans. In addition to the placement of the bodies, these cats have more complex resin mixtures for their mummification. Analysis of the embalming materials used with the more simply wrapped domestic cat mummy (figures 66, 112) indicates the presence of fats and oils as well as resins. The GC analysis indicates that resin may have been heated, possibly during the process of preparing the embalming fluids. The C14 analysis from the linens of the wild cat mummy puts the date at 750–390 B.C.E., making this one of the oldest in the collection. The resin analysis for this mummy is unusual, too, in that it is one of the few in this exhibition to contain both a fat or oil and a wax. Most of the other samples collected from mummies in Brooklyn's collection that contained wax as a component of the mixture were of humans. Although it is tantalizing to imagine a correlation between these very special cat mummies and human mummies, the placement of the front legs and paws is probably more a circumstance of wrapping into such a tight bundle than an intentional reference to human mummification. The complex mixtures of the resins could be an indication of the status of these cats with no intentional reference to human mummification. However, it is not definitively known, and science alone will not be able to determine this level of meaning. This is where science ends and the art-historical debate begins.

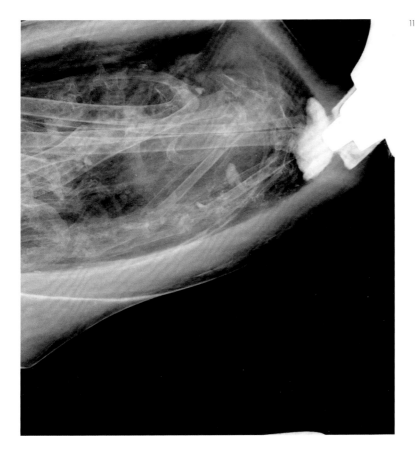

114

114. Ibis Coffin (X-radiograph)
(see figure 78)
In this X-radiograph, bones from the whole mummified ibis are seen within the coffin. Also shown is the join of the silver mount to the coffin. The metal does not fit well, and there is an excess of radiopaque material surrounding the join.

Changes over Time

In examining animal mummies, conservators must consider what alterations may have occurred over time. Some of the alterations are the result of deterioration of materials, which can make analysis difficult. Other alterations were done after the object was collected and can include restorations or additions. These could have been applied to deceive, but they may also have been applied to augment and embellish an object.

The collection provides an example of an ibis mummy with possibly spectacular alterations. The object consists of a gilt wooden coffin in the shape of an ibis body with applied silver-alloy mounts of an ibis head and ibis feet (figure 78). This three-dimensional form is not unlike that seen for some of the cat mummies. Contained within the coffin is a carefully wrapped mummy consisting of a whole ibis (figure 114). The object was catalogued as having the date 305–30 B.C.E. The curious component to this coffin is the silver-alloy mounts. Copper-alloy mounts for ibis coffins are known to exist, and two in the collection are included in this exhibition: a head (figure 83), which has inlaid eyes that appear to be made from ceramic or a porous stone, and outlined in silver metal; and a cast claw foot with articulated skin, knuckles, and talons (figure 84). Silver, however, was an unusual and rare material in ancient Egypt.

Initial examination of the mummy coffin indicated that the wooden portion was in keeping with an ancient object, but the silver mounts seemed suspect, as there was no evidence of corrosion from an archaeological environment. Additionally, this is a large quantity of silver for a period for which there is currently no other evidence of such use. The object was radiographed and the X-rays of the silver mounts were compared to those of copper-alloy mounts (figure 114). Physical features, such as the shape of the tangs and the method of casting, appeared to be inconsistent with those found on the copper-alloy mounts thought to be ancient. Additionally, the attachments of the mounts to the wooden coffin seem to be unrelated to the construction of the coffin, indicating that they were possibly added later. Samples of the silver alloy were removed for elemental analysis. X-ray fluorescence analysis, similar to the analysis discussed earlier of the brown dye of the linen fragment, was performed on samples removed from the metal mounts. The samples were found to be silver containing various amounts of copper, iron, and zinc.[13] The presence of zinc and the absence of gold and lead are curious if the metal mounts are ancient. The state of current research on metal alloys in Egypt indicates that zinc was not found in a silver alloy until the Roman Period; and lead and gold were regularly removed from silver alloys only with the advent of electrolytic refining of the ore in the nineteenth century C.E. This seems to mean the mounts were made much later and placed on an older coffin. Were the mounts added at the time of sale to increase the perceived market value, or were they perhaps added to the coffin as part of the upkeep of a votive object? It will be difficult to make a definitive statement using science alone. Archaeologists and art historians will have to puzzle out what the physical evidence means.

Some ancient Egyptian animal mummies are true oddities. Besides the hawk and ibis mummies mentioned earlier (figures 89, 90), there are other examples in Brooklyn's collection of mummies with only a single bone, or fragments of bone. These may be representations of the animal in a more votive or reliquary sense. One noteworthy object is the small model of a bull mummy (figure 115), which is shaped as a miniature bull from linen and wood and contains a single bone, possibly from a bovine creature (figure 116). Other unusual examples include the mummies with outer forms often associated with one particular animal, but that turn out to contain an entirely different animal than expected: a mummy in the form of an ibis actually contains the remains of two shrews

115

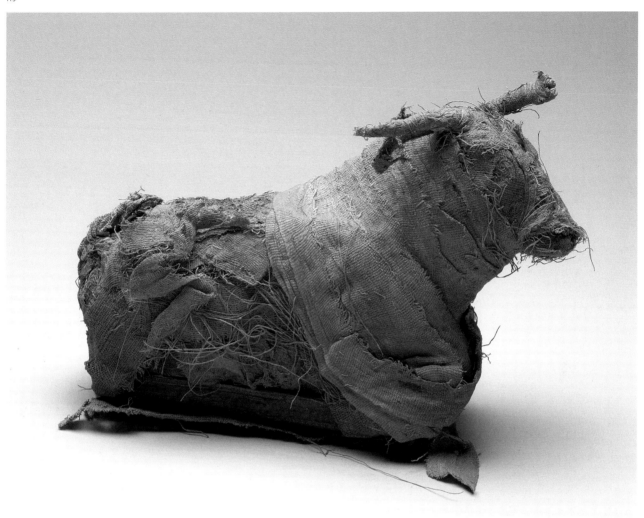

116

115. Model of a Bull
In this object, a bone fragment rests on a small piece of wood with linen scraps wrapped around it to form the shape of a small bull.

From Egypt
Third Intermediate Period or Late Period, Dynasty 21 to Dynasty 31, circa 1075–332 B.C.E.
Reeds, cloth, animal remains
5 $^{11}/_{16}$ × 9 $^{7}/_{16}$ × 2 $^{7}/_{8}$ in. (14.5 × 24 × 7.3 cm)
Charles Edwin Wilbour Fund, 37.1381E

116. Model of a Bull (X-radiograph)
(see figure 115)
The X-ray shows a bone fragment, possibly bovine. (Made using a RayzorXPro Imager from Vidisco)

117

118

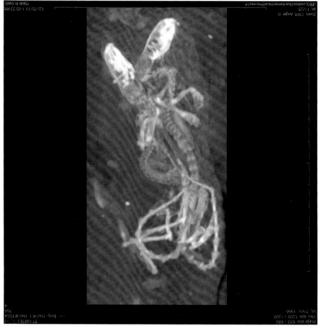

117. Ibis-Form Shrew Mummy (CT scan)
Overall coronal CT scan showing the pair
of shrews in the upper portion of the
mummy bundle.

From Egypt
Late Period, Dynasty 26 to Dynasty 31,
664–332 B.C.E.
Animal remains, linen
5 1/8 × 20 1/4 × 3 1/8 in. (13 × 51.5 × 8 cm)
Charles Edwin Wilbour Fund, 37.1987E

118. Ibis-Form Shrew Mummy
(detail of CT scan)
(see figure 117)
The shrews are clearly visible in this detail
of the scan.

(figures 117, 118). Another mummy is wrapped in a form also most
often associated with birds, but in this case contains snakes (figure
119). What could these mummies have symbolized? Our analysis
provides evidence, but not an answer.

·

We should not expect scientific analysis alone to provide
a definitive answer. The animal mummies are, after all, highly
complex ritual objects that were made with great variety and
creativity, with different methods in different periods and
locations. While some basic principles in their construction
seem to apply widely, such as the use of linen and natural resins
in the embalming process, there is also a lot of unaccountable
variability in their construction: the numerous wrapping styles
with full or partial remains may be markers of a specific time,
place, or function. Or they may be an indication of cost, or specific
symbolism, or some other factor.

The technical data is complex, and its full interpretation
requires knowledge from other disciplines. Indeed, this is true of
our investigation in general. Modern science can provide highly
suggestive evidence about these ancient practices, but on its
own does not give us answers about the animal mummies' role
in the larger context of ancient religion, culture, or commerce.
It does not tell us their meaning or purpose. To develop that

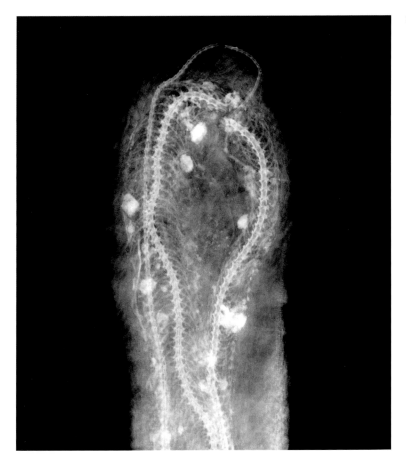

119

119. Ibis-Form Snake Mummies
(X-radiograph)
Typical ibis mummies are shown in figures 52
and 72. Although this mummy shares their
same external form, the X-ray reveals that it
contains snakes and some other radiopaque
materials. (Made using a RazorXPro Imager
from Vidisco)

From Egypt
Late Period to Ptolemaic Period, Dynasty 30
or later, 380–160 B.C.E.
Animal remains, linen
2 5/16 × 12 1/2 × 4 3/16 in. (5.9 × 31.8 × 10.6 cm)
Brooklyn Museum Collection, x1183.2

comprehensive contextual view, the curators writing elsewhere
in this book, and the many others working in this field, take the
scientific evidence into account as part of a bigger puzzle. Yet
one thing is certain: rigorous scientific examination—coupled
with the cultural insight provided by art history and research into
ancient documents, as well as new evidence surfacing through
archaeology—will be essential in helping us to better understand
these enigmatic objects from the past.

Notes

1 A. Lucas, "The Question of the Use of Bitumen or Pitch by the Ancient Egyptians in Mummification," *The Journal of Egyptian Archaeology* (published by the Egypt Exploration Society, London), vol. 1, no. 4 (October 1914), pp. 241–45.

2 Incidentally, Lucas also commented on the use of coniferous resins; see his "'Cedar' Tree Products Employed in Mummification," *The Journal of Egyptian Archaeology* (published by the Egypt Exploration Society, London), vol. 17, no. 1–2 (May 1931), pp. 13–21.

3 Ronald G. Beckett and Gerald J. Conlogue, *Paleoimaging: Field Applications for Cultural Remains and Artifacts* (Boca Raton, Fla.: CRC Press, 2010), p. 22.

4 Deborah Schorsch, "Technical Examinations of Ancient Egyptian Theriomorphic Hollow Cast Bronzes: Some Case Studies," in Sarah C. Watkins and Carol E. Brown, eds., *Conservation of Ancient Egyptian Materials* (London: United Kingdom Institute for Conservation, Archaeology Section, 1988), pp. 41–50.

5 Edward Bleiberg, with an essay by Kathlyn M. Cooney, *To Live Forever: Egyptian Treasures from the Brooklyn Museum* (New York: Brooklyn Museum; London: D Giles Ltd, 2008), p. 137.

6 Ten samples of linen were removed from the mummies and individually wrapped in aluminum foil before being sent to the laboratory, to avoid contamination.

7 The samples were sent to Dr. Richard P. Evershed, Professor of Biochemistry, and Lucy J. E. Cramp at the University of Bristol, England. See Lucy J. E. Cramp and Richard P. Evershed, "Analysis of Romano-Egyptian Human and Animal Balms from the Brooklyn Museum, New York," unpublished report; University of Bristol, June 27, 2011.

8 A. Lucas, *Ancient Egyptian Materials and Industries*, 2nd ed. (London: Edward Arnold & Co., 1934), p. 244.

9 For a discussion of this relationship, see Stephen A. Buckley, Katherine A. Clark, and Richard P. Evershed, "Complex Organic Chemical Balms of Pharaonic Animal Mummies," *Nature*, vol. 431, no. 16 (September 2004), pp. 294–99.

10 An excavation report from the Metropolitan Museum of Art notes that an anonymous man was buried with two other people in a box made from coniferous wood, sawed but not planed. The entire coffin was covered with a pink wash of color. Herbert Eustis Winlock, unpublished excavation report, Deir el-Bahri, 1928; The Metropolitan Museum of Art, New York.

11 This exhibition also includes Brooklyn Museum acc. nos. 37.1947E and 37.1942E (figures 67, 121).

12 The cat was identified as *Felis chaus* by Donald Carter of the American Museum of Natural History when it was first radiographed in 1926. Recent analysis of the CT scans by Carolin Johansson from Uppsala University indicates that much of the data does point to an identification of *chaus* but remains inconclusive.

13 Deborah Schorsch, unpublished report, October 26, 1988; The Metropolitan Museum of Art, New York.

Appendix: Possible Precursors to the Animal Cults

YEKATERINA BARBASH

120. Dish with Two Geese
Geese are frequently consumed in banquet
scenes and appear among the food offerings for
the spirit of the deceased. Many mortuary rituals
were accompanied by the sacrifice of geese,
equating them with the enemies of Osiris.

From Egypt
New Kingdom, Dynasty 18 to Dynasty 19, circa
1539–1190 B.C.E.
Steatite
$^{13}/_{16}$ × 4 $^{15}/_{16}$ × 8 $^{3}/_{16}$ in. (2 × 12.6 × 20.8 cm)
Charles Edwin Wilbour Fund, 05.312

With the sudden rise in animal cults in the Late
Period, a wide range of creatures received the
honor of mummification. These included ibises,
hawks, crocodiles, snakes, shrews, cats, and dogs,
among others (though not every kind of animal was mummified).

The practice of embalming animals that were worshipped,
tamed, or consumed does also occur in earlier periods, however,
albeit infrequently. Let us look at those possible precursors to the
later animal cults.

Types of Mummies
There were several different types of mummies, each with distinct
implications and functions, and each with possible precursors
from earlier periods in ancient Egyptian history.

One type was the food offering (figure 120). In hopes
of eternally extending food offerings for the deceased's spirit,
embalmed portions of cattle and fowl were put in the tomb as
early as the Old Kingdom. But these were more often replaced
with images on tomb walls and funerary stelae.

Another type was the pet mummy. The most beloved
domestic pets, including cats, dogs, gazelles, and monkeys,
were believed to enter the afterlife along with their owners.
The few pet mummies found *in situ* show a very high quality
of mummification, attesting to the honor bestowed on these
creatures. For instance, as early as the Eighteenth Dynasty, the
famous pet cat of prince Thutmose, named Ta-miut, was buried
in a limestone sarcophagus.[1] However, like food offerings, pets
were more often simply depicted on their owner's funerary stelae,
preserving both of their memories (see figure 6).

121

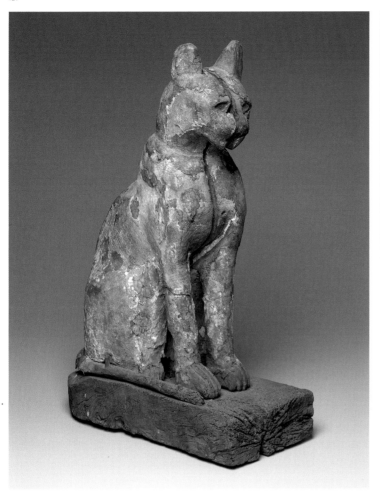

122

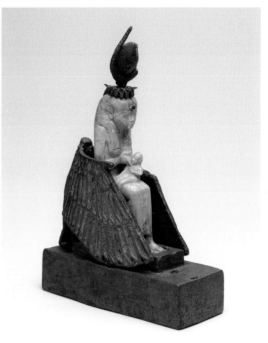

121. Cat Coffin with Mummy
Cats were among the most frequently mummified animals in ancient Egypt. Cat mummies were likely associated with such feline goddesses as Bastet and Sakhmet.

From Egypt
Late Period, Dynasty 26 to Dynasty 31,
664–332 B.C.E.
Wood, gesso, linen
21 1/4 × 7 1/16 × 14 3/16 in. (54 × 18 × 36.1 cm)
Charles Edwin Wilbour Fund, 37.1942E

122. Isis Nursing Horus
Images of Isis nursing her son, Horus, were presented to the gods by ordinary Egyptians. Offerings like these were believed to ensure a favorable response, or a granted wish. The inscription enlists the goddesses Hathor and Bastet to provide protection, life, prosperity, and health.

From Saqqara, Egypt
Third Intermediate Period to Late Period,
Dynasty 25 to Dynasty 26, circa 712–525 B.C.E.
Alabaster, bronze
7 7/8 in. (20 cm) high
Charles Edwin Wilbour Fund, 37.400E

A further type of mummy was the sacred animal, individually deified during life and mummified and buried with great pageantry. The vast majority of preserved animal mummies were bred as offerings to gods in the Late Period— and, very rarely, in the Third Intermediate Period or earlier.[2] Archaeology and historical texts show that millions of animals were embalmed, elaborately wrapped, and interred in animal catacombs, established in certain temples for this purpose. Although the specific reasons behind making these animal mummies remain unclear, the practice of sacrificing and burying sacred or semi-divine creatures may have origins in earlier traditions.

Votive Offerings
One widely accepted explanation for the later animal mummies phenomenon is that they functioned as votive offerings for the gods or the royal cult (figure 121). (For a fuller discussion, see Edward Bleiberg's essay in this volume.) Animal necropolises and cult centers also yield great numbers of bronze statuettes of divinities. Wrapped in linen and at times placed in pottery jars, these bronzes also functioned as votive offerings.

123. Osiris
Mortuary scenes in tombs frequently include the deceased's journey to Abydos in order to worship Osiris, the ruler of the Netherworld, and participate in his festival.

From Saqqara, Egypt
Late Period to Ptolemaic Period, Dynasty 30 or later, 4th century B.C.E. or later
Wood, gessoed and gilded, with inlaid eyes, additional parts of bronze, and electrum
7 ¹³/₁₆ × 2 ³/₈ × 1 ⁹/₁₆ in. (19.9 × 6.1 × 4 cm)
Charles Edwin Wilbour Fund, 37.1374E

124. Corn Mummy
Images of Osiris made of grain, wax, and earth were created in connection with such annual festivals as the Khoiak. The grain sprouted from the earth, symbolizing renewal, rejuvenation, and the cycle of life and death.

From Egypt
Ptolemaic Period to early Roman Period, 332 B.C.E.–150 C.E.
Wood, clay, sand, corn, linen
2 ¹⁵/₁₆ × 19 ¹¹/₁₆ × 6 ⁷/₈ in. (7.5 × 50 × 17.5 cm)
Gift of Caren Golden in memory of Eleanor L. Golden, 2007.1a–c

The practice of making offerings in gratitude for, or in anticipation of, health, life, or a favor for oneself or a loved one is well attested from earlier times. Votive figurines were offered in religious rituals as early as the Middle Kingdom. Already in the Nineteenth Dynasty, the Serapeum contained niches with numerous dedicatory stelae and *shabtis* placed there as votives. Personal dedications, requests, and prayers were generally inscribed directly on the offerings (figure 122). In addition, the rituals likely involved oral prayers, appeals, and adorations that helped convey messages to the gods.

Votive animal mummies functioned as gifts or payments for a divine favor. But texts from the Archive of Hor refer to animal mummies as "god," or "*ba* of god," suggesting that they may have been more than just a payment. Such designations place the animal mummy in the liminal zone between this world and the sphere of the divine, allowing it to act as a messenger or intermediary for the donor.[3]

The concept of spiritual intermediaries was also familiar in earlier Egyptian religion. Priests or the semi-divine were believed to facilitate human interaction with gods. For instance, while the general population was forbidden from entering most areas of a temple, the king and select priests acted on behalf of the entire country, making offerings and performing ritual acts for the gods. As the embodiment of Horus on earth, the king was a semi-divine intermediary between humanity and the gods. The proximity of Old Kingdom cemeteries to royal tombs demonstrates the significant role of the king as an agent allowing deceased officials easier access to the afterlife. Furthermore, a standard offering formula inscribed on stelae, coffins, and other funerary monuments begins with the words, "An offering which the king gives to a god."[4] This phrasing points to a well-established system of reversion offerings, where only the semi-divine persona of the king could present the god with the gift, which was transferred to the spirit of a deceased after the god was finished.

Pilgrimage and Petition
The traditional explanation for the abundance of animal mummies in later Egypt postulates that animals, bred and embalmed within temples, were purchased by pilgrims and dedicated to the local deity. Although the practice of "traveling to a sacred place for a sacred reason," as the term *pilgrimage* may be defined, is evident in ancient Greece, it had a markedly different

123

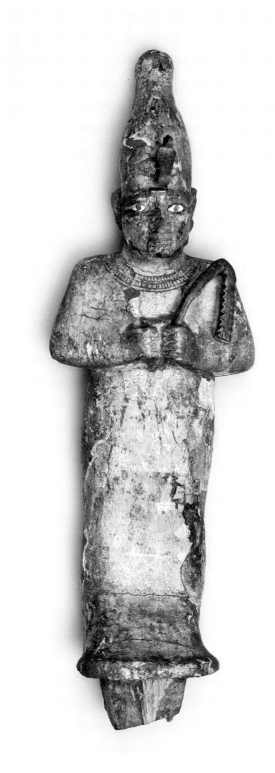

124

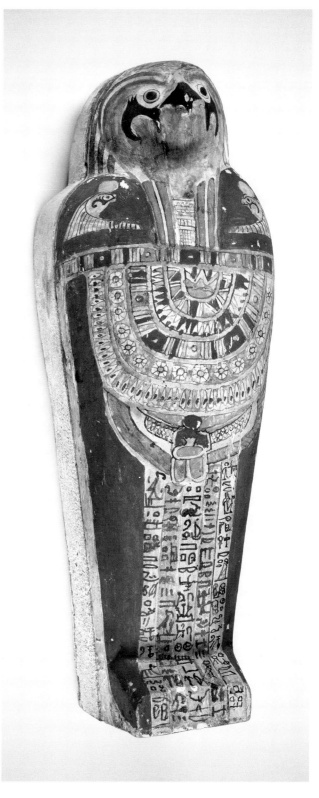

character from the one attested in Egypt. The *Instructions of Any* (from the Twenty-first and Twenty-second Dynasty) emphasize the importance of celebrating annual festivals, without explicitly requiring pilgrimage: "Observe the feast of your god, and repeat its season. God is angry if it is neglected."[5] Indeed, many festivals were celebrated at easily accessible, alternative cult sites that did not require the participants to travel.

The closest possible parallel to mass pilgrimage in earlier Egypt is at Osiris's cult center in Abydos (figure 123). During the Middle Kingdom, people from all over the country set up cenotaphs there. Although a voyage to Abydos is frequently depicted on tomb walls, whether these people made an actual journey during life, or one in the Netherworld, having set up their memorials remotely, is not known. One annual event that likely attracted large crowds was the Khoiak festival for Osiris, the resurrected god of the Netherworld, celebrated in month four of the inundation season. Worshippers came to witness the procession from Osiris's Abydos temple to his alleged tomb at Umm el-Qaab. Again, the worshippers may have been mostly locals (figure 124).[6]

The procession of a cult statue, believed to be a god incarnate, was a typical event at this and other annual festivals. Witnessing such processions allowed the crowds of devoted onlookers to encounter and communicate with the deity in person. More specifically, simple questions were presented to the god's shrine, whose movements were then interpreted as oracular consultations. The use of oracles by royalty and the public may date as far back as the Old Kingdom. Particularly prevalent in the New

125

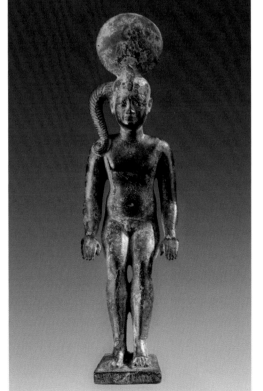

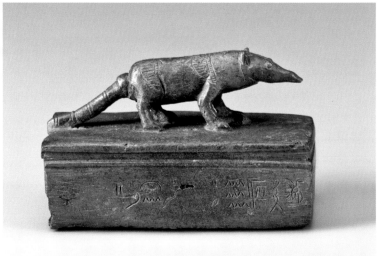

126

Kingdom, oracles were employed for many issues, including official appointments, court verdicts, inheritance, and private matters. Oracular petitions were found in many shrines in and around the Nineteenth Dynasty workmen's village of Deir el-Medina.

Similarly, inscriptions from sacred animal necropolises at Saqqara, Tuna el-Gebel, and other temples record oracle questions addressed to gods. Various animals, ranging from Apis bulls to scarabs, were believed to have oracular abilities in the Late, Ptolemaic, and Roman Periods (figure 125). At this time, animal mummies likely accompanied oracle petitions as votive offerings or in hopes of receiving the desired answer. Seen as an incarnate image of a deity, or its *ba*, animal mummies were thus able to convey a question to the sphere of the divine and encourage a god to respond. While communication with gods was mostly manifested through speech, many appeals came in the form of a written text, accompanying offerings. Short inscriptions on wrappings or containers for animal mummies presented to gods complaints of wrongdoing, or requests for sustenance, health, and eternal life. Similar inscriptions appear on hundreds of bronzes from animal catacombs (figure 126).

Longer letters regarding one's personal matters are also frequently associated with later animal cults. However, written demands and appeals to "supernatural" forces are attested in the much earlier Letters to the Dead. In one notable example, a late Old Kingdom letter to a deceased mother requests that she ensure her son's health: "It is Shepsi, who addresses his mother Iy: This is a reminder of the fact that you said to me, your son, 'you shall bring me some quails that I may eat them,' and I, your son, then brought you 7 quails and you ate them. Is it in your presence that I am being injured so that my children are disgruntled and I, your son, am ill?"[7]

125. The Child Horus
The child Horus, along with images of his parents, Osiris and Isis, is one of the most common types of bronze offerings. Several forms of the god Horus are known as the addressees of oracular petitions.

From Egypt
Ptolemaic Period to early Roman Period, 305 B.C.E.–1st century C.E.
Bronze
8 × 2 1/16 × 3 9/16 in. (20.3 × 5.2 × 9 cm)
Charles Edwin Wilbour Fund, 05.399

126. Shrew Coffin of Pahapy
The formulaic inscription on this coffin states that the god Horus, in his nocturnal aspect of the shrew, gives life to Pahapy, the assumed donor of the coffin. Many inscribed bronze offerings similar to this one were excavated at the animal catacombs of North Saqqara.

From Lower Egypt
Late Period to Ptolemaic Period, Dynasty 26 or later, 664–30 B.C.E.
Bronze
2 1/8 × 3 7/16 × 1 9/16 in. (5.4 × 8.7 × 4 cm)
Charles Edwin Wilbour Fund, 37.411E

Notes

1 This cat's name means "The Cat," and it belonged to the eldest son of Amenhotep III, Thutmose, who died young; S. el Sabban, "The Cat's Coffin of DHwty-ms in the Cairo Museum," *Discussions in Egyptology* 46 (2000), pp. 65–78.

2 Foy Scalf points to late New Kingdom burials of mummified ibises, with further bibliography for them and those of a Third Intermediate Period date; see "Resurrecting an Ibis Cult: A Collection of Demotic Votive Texts from the Oriental Institute Museum of the University of Chicago" (to be published in the festschrift for Ola el-Aguizy forthcoming from the Institut Français d'Archéologie Orientale, Cairo), p. 16, ns. 78–80.

3 Demotic inscriptions associated with animal mummies were primarily written by priests, also acting as intermediaries on behalf of the donor.

4 The named god varies widely.

5 Miriam Lichtheim, *Ancient Egyptian Literature: A Book of Readings*, 3 vols. (Berkeley: University of California Press, 1973–80), vol. 2 (1976), p. 135.

6 Although visitors left numerous inscriptions at other Egyptian temples and tombs during the Greco-Roman Period, these appear to be written by Greeks and Romans living in Egypt.

7 *Letters from Ancient Egypt*, trans. Edward F. Wente, ed. Edmund S. Meltzer (Atlanta, Ga.: Scholars Press, 1990), no. 342, p. 212. Examples of letters associated with animal cults are cited in Edward Bleiberg's essay in this volume.

Selected Bibliography

Bowman, Alan. *Egypt After the Pharaohs.* London: British Museum, 1986.

Davies, Sue, and H.S. Smith. *The Sacred Animal Necropolis at North Saqqara: The Falcon Complex and Catacomb; The Archaeological Report.* London: Egypt Exploration Society, 2005.

DuQuesne, Terence. *Anubis, Upwawet, and Other Deities: Personal Worship and Official Religion in Ancient Egypt.* Cairo: Supreme Council of Antiquities, 2007.

Endreffy, Kata. "Business with Gods: The Role of Bargaining in Demotic Letters to the Gods and Graeco-Roman Judicial Prayers." In András Hudecz and Máté Petrik, eds., *Commerce and Economy in Ancient Egypt.* Oxford: Archaeopress, 2010.

Germond, Philippe. *An Egyptian Bestiary.* London: Thames & Hudson, 2001.

Grier, Katherine C. *Pets in America: A History.* New York: Harcourt, Brace, 2007.

Hendrickx, S., et al. *Egypt at Its Origins: Studies in Memory of Barbara Adams; Proceedings of the International Conference "Origin of the State, Predynastic and Early Dynastic Egypt," Krakow, 28th August–1st September 2002.* Leuven, Belgium; Dudley, Mass.: Peeters Publishers, 2004.

Hornung, Erik. "Die Bedeutung des Tieres im alten Ägypten." *Studium Generale* 20.2 (1967), pp. 69–84.

Houlihan, Patrick. *The Birds of Ancient Egypt.* Warminster: Aris & Philips, 1986.

———. *The Animal World of the Pharaohs.* Cairo: American University in Cairo Press, 1995.

Ikram, Salima, ed. *Divine Creatures: Animal Mummies in Ancient Egypt.* Cairo and New York: American University in Cairo Press, 2005.

Johnson, Sally. *The Cobra Goddess of Ancient Egypt: Predynastic, Early Dynastic, and Old Kingdom Periods.* London and New York: Kegan Paul International, 1990.

Kessler, Dieter. *Die heiligen Tiere und der König.* Wiesbaden: Harrassowitz, 1989.

Lichtheim, Miriam. *Demotic Ostraca from Medinet Habu.* Chicago: Oriental Institute, 1957.

———. *Ancient Egyptian Literature: A Book of Readings.* 3 vols. Berkeley: University of California Press, 1973–80.

Majer, Joseph. "Elephant Hunting at Hierakonpolis." *Nekhen News* 21 (2009); PDF at *www.hierakonpolis-online.org.*

Málek, Jaromír. *The Cat in Ancient Egypt.* London: British Museum Press for the Trustees of the British Museum, 1993.

Martin, Geoffrey. *The Sacred Animal Necropolis at North Saqqâra: The Southern Dependencies of the Main Temple Complex.* London: Egypt Exploration Society, 1981.

Migahid, Abd-el-Gawad. *Demotische Briefe an Götter von der Spät- bis Römerzeit: Ein Beitrag zur Kenntnis des religiösen Brauchtums im alten Ägypten.* Würzburg: Inaugural-Dissertation, 1986.

Mond, Robert, and Oliver Myers. *The Bucheum,* 3 vols. London: Egypt Exploration Society, 1934.

Murnane, William J. "The History of Ancient Egypt: An Overview." In Jack Sasson, ed., *Civilizations of the Ancient Near East*, vol. 2. New York: Scribner, 1995.

Murnane, William J., and Charles van Siclen. *The Boundary Stelae of Akhenaten*. London and New York: Kegan Paul International, 1993.

Patch, Diana Craig, et al. *Dawn of Egyptian Art*. New York: The Metropolitan Museum of Art; New Haven: distributed by Yale University Press, 2011.

Ray, J. D. *The Archive of Hor*. London: Egypt Exploration Society, 1976.

———. "An Inscribed Linen Plea from the Sacred Animal Necropolis, North Saqqara." *Journal of Egyptian Archaeology* 91 (2005), p. 175.

———. *Texts from the Baboon and Falcon Galleries: Demotic, Hieroglyphic and Greek Inscriptions from the Sacred Animal Necropolis, North Saqqara*. London: Egypt Exploration Society, 2011.

Redford, Donald, ed. *The Oxford Encyclopedia of Ancient Egypt*, 3 vols. New York: Oxford University Press, 2001.

el-Sabban, S. "The Cat's Coffin of DHwty-ms in the Cairo Museum." *Discussions in Egyptology* 46 (2000), pp. 65–78.

Scalf, Foy. "Resurrecting an Ibis Cult: A Collection of Demotic Votive Texts from the Oriental Institute Museum of the University of Chicago." In the festschrift for Ola el-Aguizy forthcoming from the Institut Français d'Archéologie Orientale, Cairo.

Smelik, K.A.D., and E.A. Hemelrijk. "'Who Knows Not What Monsters Demented Egypt Worships?' Opinions on Egyptian Animal Worship in Antiquity as Part of the Ancient Conception of Egypt." In Wolfgang Haase, ed., *Principat: Religion*. Berlin: Walter de Gruyter, 1984.

Smith, H.S., Sue Davies, and K.J. Frazer. *The Sacred Animal Necropolis at North Saqqara: The Main Temple Complex; The Archaeological Report*. London: Egypt Exploration Society, 2006.

Strandberg, Åsa. *The Gazelle in Ancient Egyptian Art: Image and Meaning*. Uppsala: Uppsala University Press, 2009.

Taylor, John. *Death and the Afterlife in Ancient Egypt*. Chicago: University of Chicago Press, 2001.

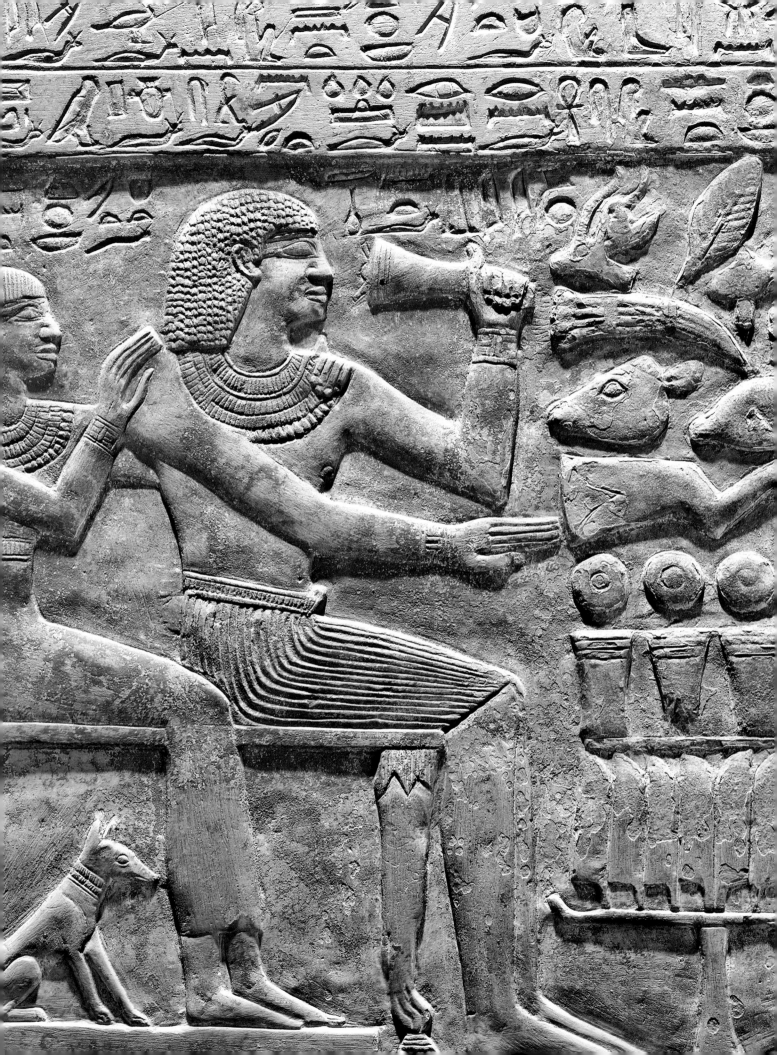

Index of Illustrations

Numbers refer to figures.